18th-Century French Painting

DOMINIQUE JARRASSÉ

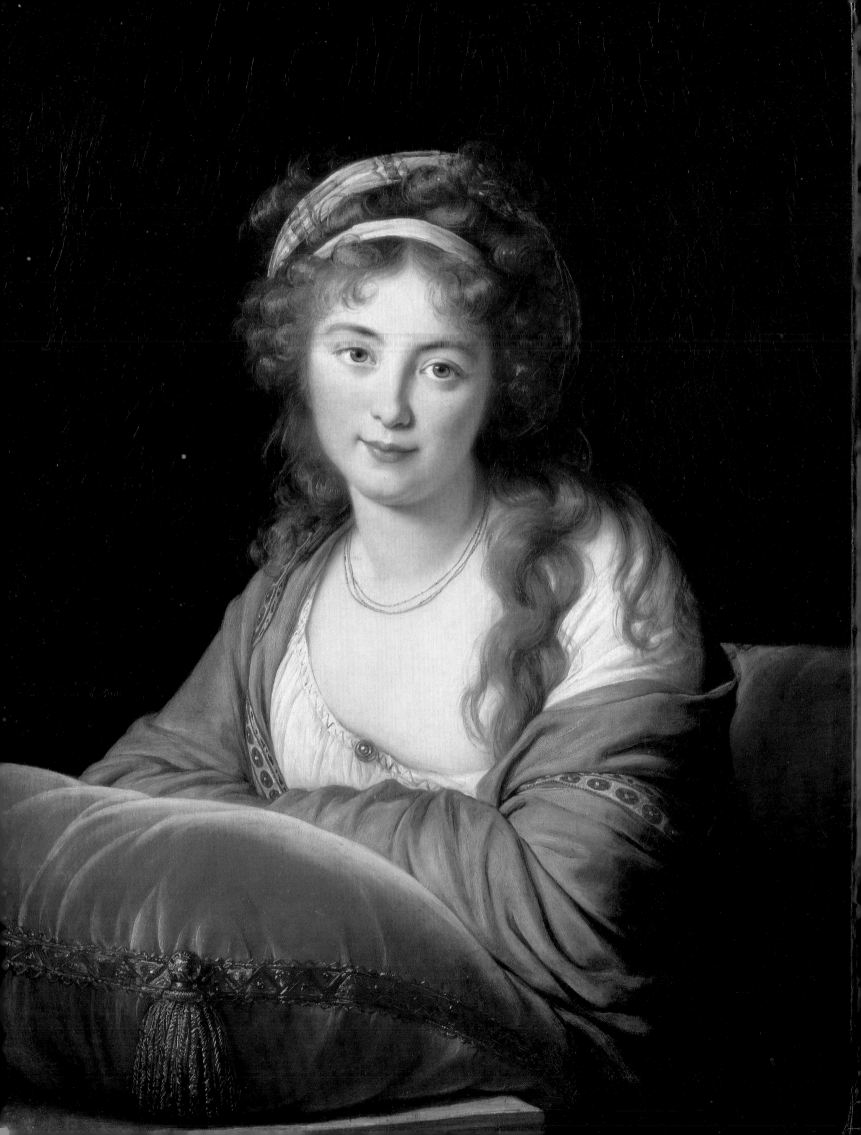

18th-Century French Painting

DOMINIQUE JARRASSÉ

·TERRAIL·

English Translation: Murray Wyllie

Editorial Director: Jean-Claude Dubost
Editorial Assistant: Geneviève Meunier and Christine Mormina
Editorial Aide: Ann Sautier and Béatrice Weité
Cover Design: Laurent Gudin
Graphic Design: Marthe Lauffray
Iconography: Sophie Lay-Suberbère
Typesetting and Filmsetting: Einsatz Goar Engeländer, Paderborn
Photoengraving: Litho Service T. Zamboni, Verona

© FINEST SA/EDITIONS PIERRE TERRAIL, PARIS 1998
The Art Book Subsidiary of BAYARD PRESSE SA
English edition: © March 1999
Publisher's N°: 247
ISBN 2-87939-203-9
Printed in Italy
Published with the assistance of the French Ministry responsible for culture
Centre National du Livre (The National Book Centre)

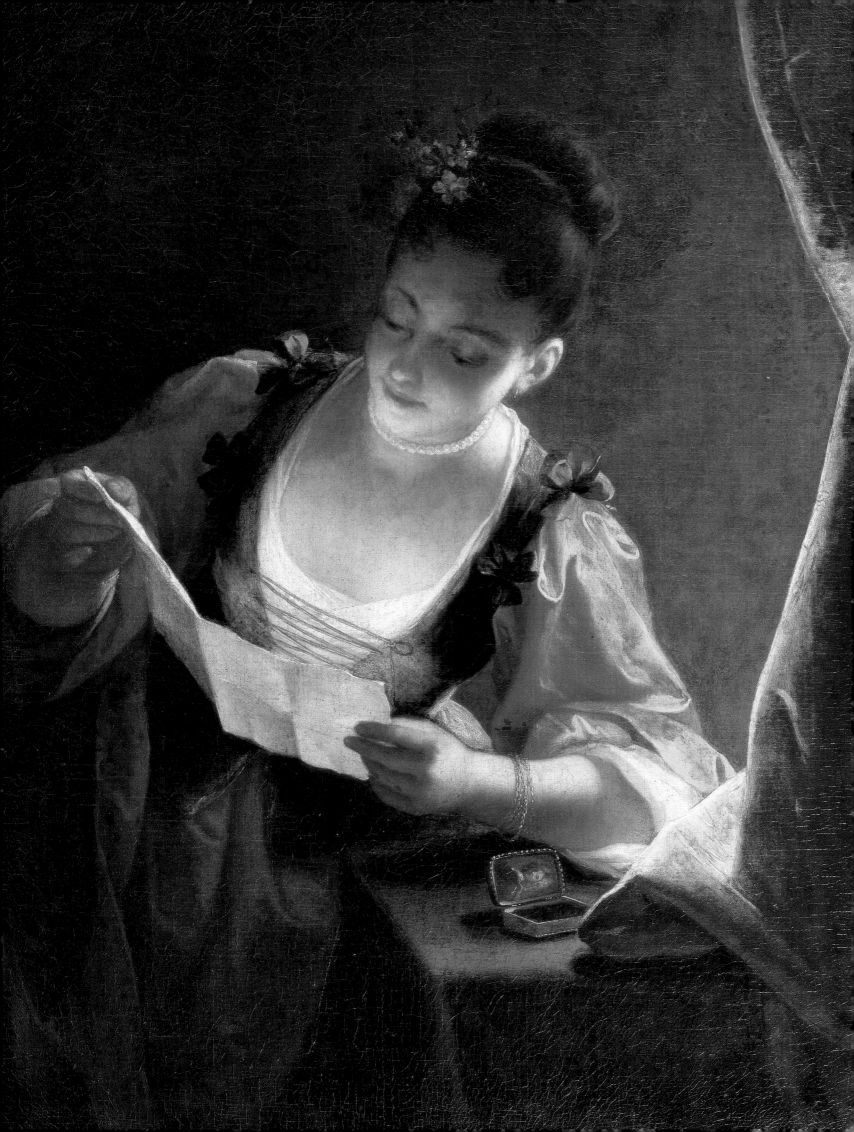

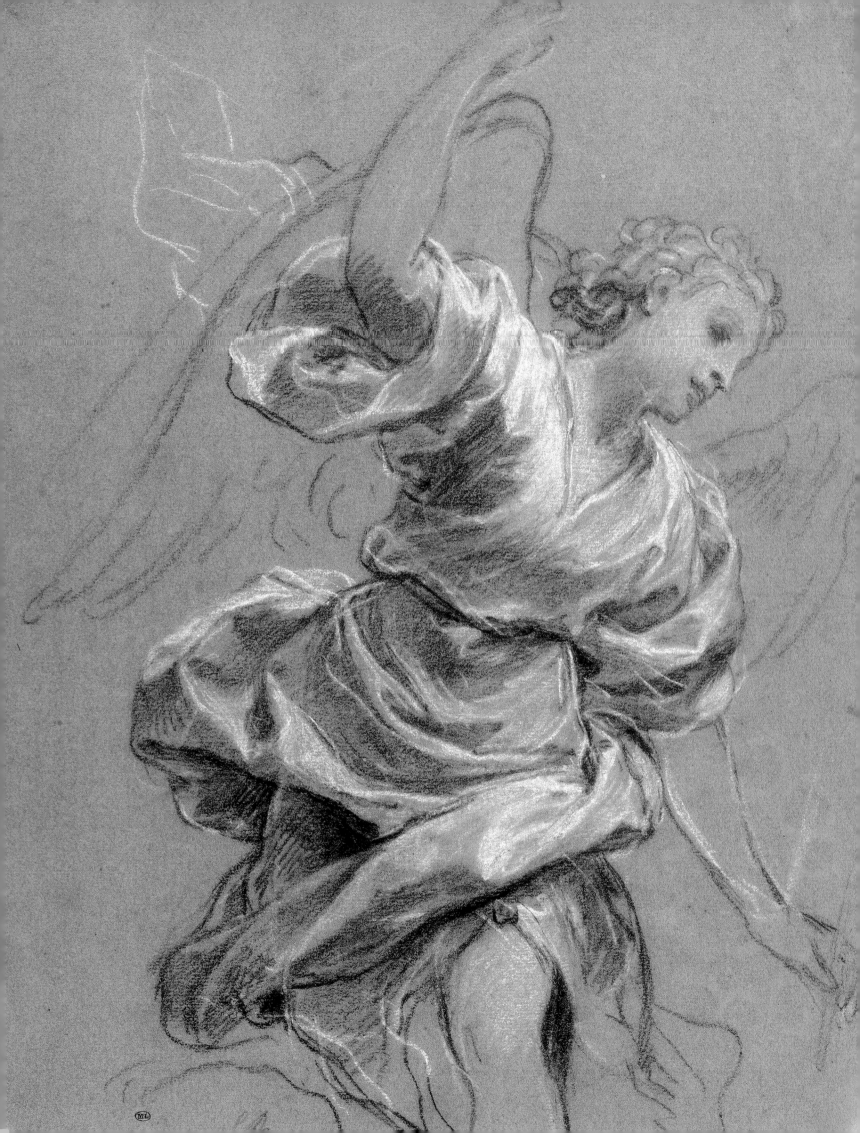

Contents

To my mother

Introduction

On 2 September 1771, Louis XV attended the inauguration of a pavilion which his mistress, Jeanne Bécu, Comtesse du Barry, had recently had built in Louveciennes. Designed by Claude-Nicolas Ledoux, who also erected the Paris mansion of the celebrated dancer, La Guimard, the pavilion featured a fine Ionic peristyle looking onto the garden; its austere style offered a subtle contrast to the whiff of scandal surrounding its illustrious occupant. Louis XV's approval of the classical revival taking place during his reign could be read in the evident delight with which he admired Ledoux's well-proportioned columns. Mme du Barry, however, had second thoughts regarding the decoration of the reception room in the newly-built temple of love. In 1771, like La Guimard, she had initially chosen Fragonard, commissioning him to paint a series of four canvases depicting amorous themes. But two years later, and despite the costly sum of 16,000 livres which she had to pay the artist, Mme du Barry returned the paintings, no doubt considering them no longer fashionable! She turned instead to Joseph-Marie Vien, whose style, rich in classical references, had come into vogue (it is thought that Mme du Barry already owned Vien's famous *The Cupid Seller*, inspired by the frescoes recently discovered near Herculaneum), and charged him to execute a new series devoted to the *Progress of Love in a Young Maiden's Heart*.

Meanwhile, Fragonard had fallen out with La Guimard and his decorative project for the Paris mansion likewise proved abortive. The commission was entrusted instead to the young Jacques-Louis David, who had just won the Prix de Rome and saw himself as destined to revive an austere style, poles apart from the sensuality of the preceding generation of artists. It is difficult not to see these rejections as indicative of a profound change. The confrontation between Fragonard and Vien illustrates two aspects of the 18th century which, although apparently contradictory on an aesthetic level, nevertheless reveal close affinities. Vien could be said to have launched a kind of 'Greek rococo', a new form of sensuality in the manner of the sparkling Mme Vigée-Lebrun who, tiring of theatrical costumes, discovered the unaffected simplicity of 'Greek'[1] dress.

By a curious twist of fate, the four rejected paintings, which Fragonard had, in 1790, installed far from the public eye in his home in Grasse, became, in 1915, the permanent showpiece of the Frick collection in New York. They are now considered one of the pinnacles of French art, whereas the Vien paintings, long neglected, are today dispersed between the Louvre and the Chambéry Prefecture! Fashion certainly played its part in these episodes, as did, no doubt, the whims of royal favourites eager to impose their taste.

Yet, in the many-faceted annals of 18th-century French art, they mark a special, even a crowning moment.

The period which stretches from Watteau to Fragonard, from Jouvenet to Vien and David, includes several different 18th centuries. Rather than following on in linear succession, these overlap, in the same way that the Enlightenment also produced darker progeny or that triumphant rationalism could not prevent the emergence of a new sensibility. This extremely diversified century witnessed the generation of Voltaire and Marigny fascinated by the legacy of its predecessor; it set the stage for the confrontation between aesthetic approaches as contrasting as the magical Flemish-style realism of Chardin and the effervescent light-heartedness of the amorous scenes depicted by the virtuoso talent of Boucher and Fragonard; it mingled classical antiquity and the budding aspirations of the Romantics...

Eighteenth-century art occupies a choice place in our imagination, an auspicious era during which a certain spirit and a refined, learned culture – equally

| Jean-Honoré Fragonard
THE SURPRISE
1771-1772, oil on canvas,
317.5 x 244 cm (125 x 96 in).
The Frick Collection, New York.

Jean-Honoré Fragonard |
THE LOVER CROWNED
1771-1772, oil on canvas,
318 x 243 cm
(125 1/4 x 95 5/8 in).
The Frick Collection, New York. |

The celebrated series rejected
by Mme du Barry represents
the quintessence of 'art galant'
initiated by Watteau and later
developed by Boucher.
The king and his favourite
are said to have recognized
themselves in the protagonists
of these 'pastorals'.

Page 12 |
Joseph-Marie Vien |
**YOUNG GREEK MAIDENS DECK
SLEEPING CUPID WITH FLOWERS**
1773, oil on canvas,
335 x 194 cm
(131 7/8 x 95 5/8 in).
Musée du Louvre, Paris.

Page 13 |
Joseph-Marie Vien |
LOVER CROWNING HIS MISTRESS
1773, oil on canvas,
335 x 202 cm
(131 7/8 x 50 3/4 in).
Musée du Louvre, Paris.

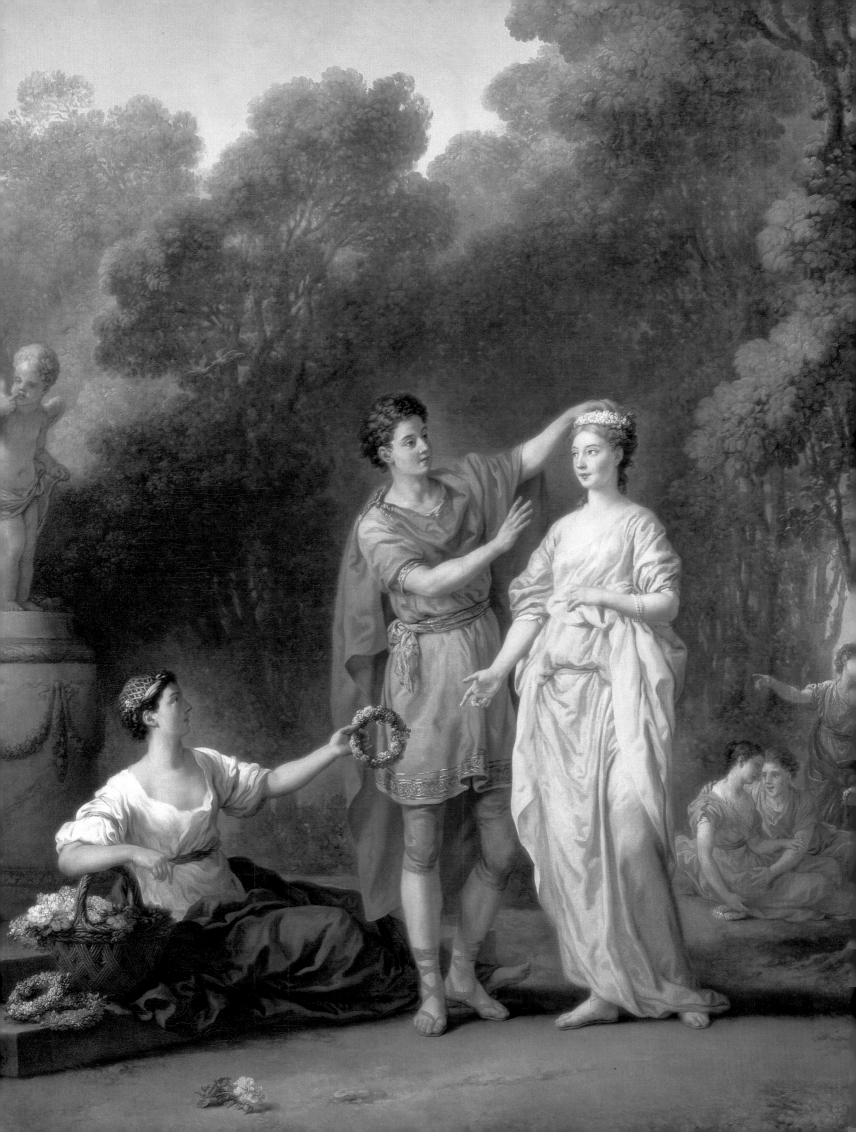

epitomized by Voltaire's smile or some marquise's dainty features – found their expression in an art and a language which conquered the whole of Europe. To foreign observers – as is attested by the acquisitions of major collectors and by general historical accounts, more numerous in English than in French – it may even have seemed to embody quintessential France. But that would be tantamount to equating the 18th century solely with the reign of Louis XV, as the Goncourt brothers managed to do. All attempts to define the century too precisely carry the risk of narrowing it down to the period between 1715 and 1760!

In order to grasp its teeming, evolving diversity might it not in fact be necessary to adopt a panoramic perspective stretching from the 1670s, a decade fraught with fundamental artistic debate, down to the First Empire which witnessed the blossoming of certain forms of neo-classicism and romanticism? Although it is arbitrary to suspend the seamless flow of time and select the period 1700-1800, this nevertheless allows us to understand exactly what transpired between Rigaud's majestic portrait of *Louis XIV* (1701) and Gros's *Sappho at Leucadia* (1801), depicting the poetess leaping into the abyss.

A Salon like the one held in 1763 featured such contrasting works as Carle Van Loo's *Grâces enchaînées par l'Amour* and Chardin's *Jar of Olives,* Restout's *Orpheus and Eurydice* and a *Bergerie [Pastoral]* by Boucher, Vien's *The Cupid Seller* and Greuze's *Filial Piety,* Doyen's *Andromache Weeping Before Ulysses* and paintings by Deshays, "our greatest church painter", as Diderot claimed at the time. The show even included masterly landscapes such as Vernet's *Port of La Rochelle...* Could any single label possibly cover such a range of works, one which mingled rococo grace and pioneering examples of neo-classicism, grand manner and poetic realism, bourgeois domestic scenes and ancient Greece? Obviously not. Although rococo ornamentation has remained the hallmark of 18th-century art, the reality was infinitely more diverse.

These then are the keynotes which must be taken into account if one is to avoid the over-simplified vision of a "period which embellished everything with the conviviality of art, which made *attractiveness* a style, and infused this style into the merest details of its environment, its manners and customs".[2] Without losing the flavour of this imaginary 18th century, all too often diminished to pieces of Dresden china, a more complex reality encompassing a tangle of aspirations, an interplay of light and shadow, can be broached. Among the possible approaches, while retaining the underlying impact of successive generations (a truer reflection of fundamental change than dynastic reigns), we have chosen to emphasize the different genres, the aesthetic implications of which remained decisive in a strictly codified art: the freedom to paint, an indisputable achievement of the 18th century, and one illustrated by unpredictable shifts in technique and use of colour, involved iconographic choices which can provide a deeper insight into the spirit of the age.

1. Vigée-Lebrun, *Souvenirs,* 1984, pp. 85-88.
2. Goncourt, *L'art du XVIIIᵉ siècle, les vignettistes,* 1868, reprinted in *Art et artistes,* anthology edited by J.-P. Bouillon, 1997, p. 135.

1. Art and the State: the 'Grand Manner'

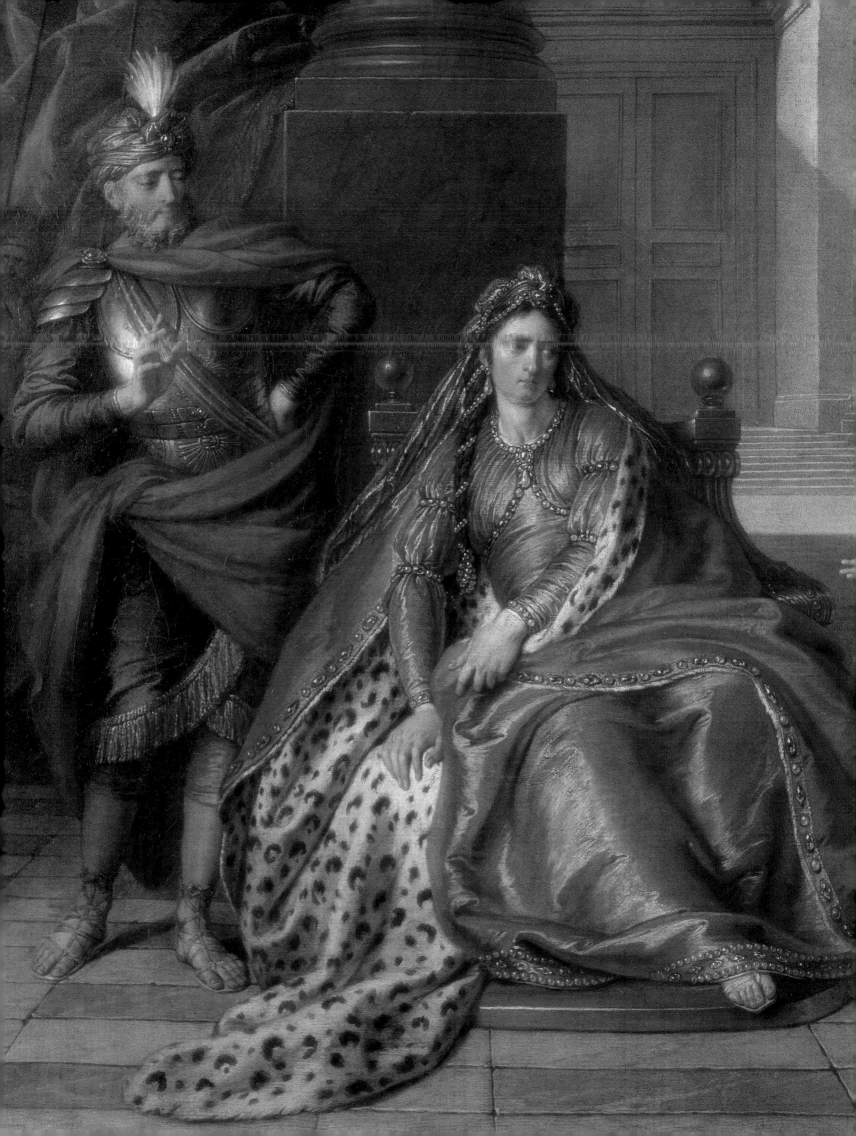

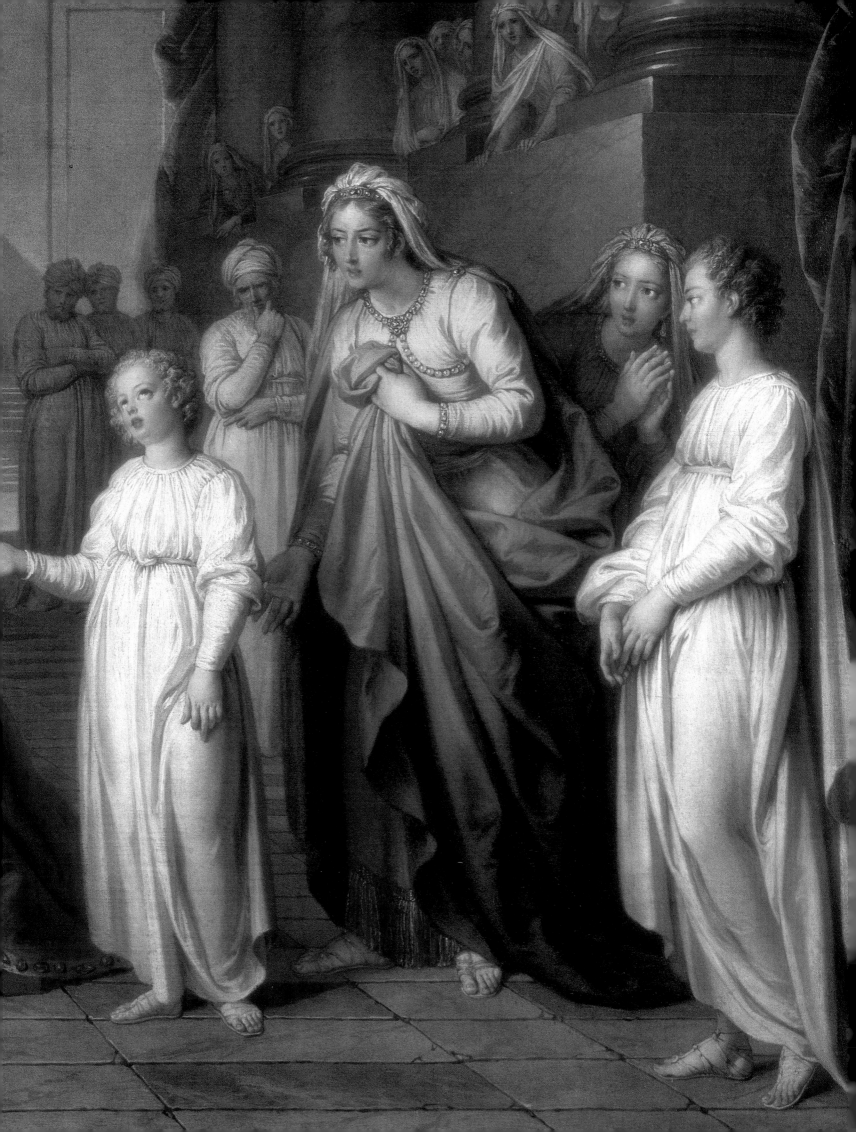

Eighteenth-century painting developed within a framework inherited from the previous century. Despite the constant debate which took place among successive generations of artists, basic institutional and doctrinal tenets remained operative. All artists, no matter how original, had to contend, for instance, with the hierarchy of genres. Not even the French Revolution was to destroy this edifice; although the Revolution did away with the Royal Academy, it retained its traditional teaching methods, prizes and the Salon.

The academic legacy

The 18th century did not merely represent a continuation of its predecessor in the person of artists such as Antoine Coypel (1661-1722) or Nicolas de Largilliere (1656-1746), nor by perpetuating the cherished themes of the 'grand manner'; it was still conditioned by institutions and concepts, the permanence of which is a vital key to understand the changes and rifts characteristic of the Enlightenment. Despite set-backs and spells of inertia, the system established by Colbert remained in place throughout the century.

It should be borne in mind that the 18th century at times felt itself overshadowed by what Voltaire had eulogized as *The Age of Louis XIV.* Du Perron, in a *Discourse on Painting and Architecture*, dedicated to Mme de Pompadour and published in 1753, exclaimed: "O century of Louis XV! Are you no longer a match for the previous century?", and went on to hail Marigny as a "latter-day Colbert".

The royal service included a 'Superintendent and General Director for French Buildings, Arts, Tapestries and Manufactories' in charge, in the words of Henry Lemonnier, of a sort of 'government of the arts' which employed inspectors, clerks, official artists and had premises in the Louvre, a 'first painter to the king', accredited members, etc. This was backed up by a second body, the Royal Academy of Painting and Sculpture which in turn had its own subsidiary outpost, the French Academy in Rome.

In 1725, when the latter body was installed in the Palazzo Mancini on the Corso (it was later – 1804 – transferred to the celebrated Villa Medici) it experienced a revival. The Director, Nicolas Wleughels, in office from 1724 to 1737, overhauled the curriculum; courses were henceforth based around drawing from classical models, or from nude or draped life models, copying paintings by the masters and, in the summer months, outdoor studies of landscapes and ruins; his brother-in-law Giovanni Paolo Pannini – the master of classical *vedute* – taught perspective at the Academy. Some pupils, having already established a reputation, received commissions from the local nobility; others, such as Subleyras (1699-1749), settled permanently in Rome. From 1750, the course of studies in Rome was to play an essential role in steering pupils towards neo-classicism; moreover, Piranesi lived opposite the Palazzo Mancini.

The academic mode of functioning was based on scholarships, privileges and state commissions; on the other hand, it implied submission to an order in which social, commercial and aesthetic values all merged. Since Colbert, the arts had been drummed into the royal service which even fixed the prices of

Pages 16-17
Charles-Antoine Coypel
ATHALIAH QUESTIONING JEHOASH
Exhibited at the 1741 Salon,
oil on canvas,
129 x 163 cm
(50 3/4 x 64 1/4 in).
Musée des Beaux-Arts, Brest.

Coypel often drew
his inspiration from tragedy,
a testimony to the close
relationship between
French classical painting and
French literature.

Nicolas de Largillierre
LA BELLE STRASBOURGEOISE
1703, oil on canvas,
138 x 106 cm
(54 3/8 x 269 1/4 in).
Musée des Beaux-Arts, Strasbourg.

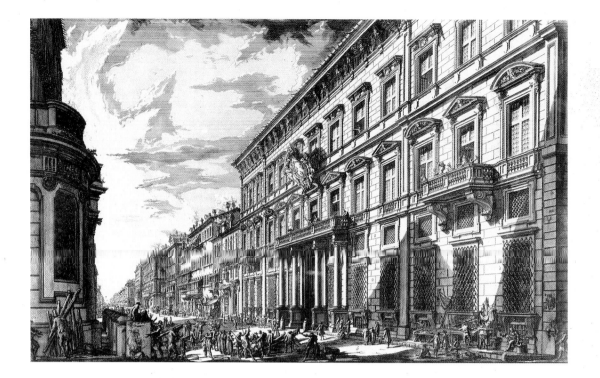

paintings on a sliding scale based on genre rather than format. Thus, in 1747 Lenormant de Tournehem, in an attempt to encourage history painting, raised its going rate while lowering the corresponding fee paid for portraits. Similarly, only history painters were appointed to honorific posts.

Founded in 1648, the Academy determined a new status for artists by emancipating them from the art guild – the Maîtrise de Saint-Luc; it endorsed an intellectualized vision of the arts and proved to be a centralizing force. This policy was pursued throughout the 18th century and the artist became gradually differentiated from the craftsman[1] thanks to royal patronage. Art, fascinated by the status accorded to literature, defined itself as a liberal activity, rejecting the traditional mantle of commercialism. A new mode of selection, no longer based on guild membership or the purchase of a mastership, but on merit, established a learned élite who were soon to dictate official canons of taste. This represented the culmination of a process begun during the Renaissance – to which Vasari, author of *The Lives of the Most Eminent Architects, Painters and Sculptors* (1550) and founder of the Accademia del Disegno (1562) bears witness – by which art gradually assumed an enhanced status.

Colbert had provided the Academy with the means of establishing its authority: in 1663, prizes had been introduced, including the 'Grand Prix' – later known as the Prix de Rome, as the winner was invited to study at the French Academy in Rome at royal expense. This Roman subsidiary, a supplementary training opportunity offered to the most talented students, had opened in 1666; a course of lectures, provided for in the statutes of 1654, had begun in 1667 as Colbert wished an official doctrine to be formulated and propagated. Finally, that same year, the Academy held its first exhibition, the genesis of the Salon. The exhibition, reserved for academicians and accredited artists, took

Jean-Baptiste-Marie Pierre
**MERCURY, ENAMOURED OF HERSE,
TURNING AGLAURE INTO STONE**
1763, oil on canvas,
325 x 329 cm
(128 x 129 1/2 in).
Musée du Louvre, Paris.

**Pierre, First Painter to the King,
was a stalwart champion
of history painting.**

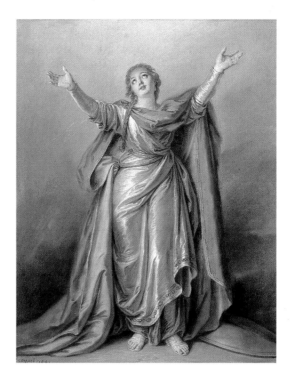

Charles-Antoine Coypel |
**FRANCE OFFERING THANKS
TO HEAVEN FOR THE RECOVERY
OF LOUIS XV**
1744, pastel on grey-blue paper,
59.3 x 50 cm
(23 3/8 x 19 5/8 in).
Musée du Louvre,
Département des arts graphiques, Paris.

place in the Salon Carré in the Louvre, hence the name. The Salon was a crucial event for artists as it introduced them to the public whose influence had become increasingly important over time with the emergence of veritable art criticism (Diderot's *Salons* for instance).

Such measures had occasionally proved short-lived in their effect: lecturing soon fell into abeyance and old lectures were simply reread. However, in the course of the 18th century, attempts were undertaken to re-activate the academic system. Significantly, when Academy Directors such as Charles-Antoine Coypel (1696-1752) sought to give the institution new lustre, they reintroduced lecturing. Similarly, the Salon, suspended from 1704 until 1737 (except in 1725), only became a regular event from the latter date. Organized annually until 1748, it was subsequently held every two years. Finally, the authoritarian attitude of certain Directors did not always prevail at the Academy. Although, to be accepted, artists had to be accredited and to submit a 'reception piece' (somewhat reminiscent of the traditional guild masterpiece) on a predetermined theme, Watteau was received in 1717 with *The Pilgrimage to the Island of Cythera*, a subject which he had chosen himself, thus marking a break with traditional practice.

Although the Royal Academy had durably consolidated its power, the art guild had reacted briskly, contesting certain privileges and itself claiming the right to offer teaching courses. Moreover, in 1705, it assumed the official name of Académie de Saint-Luc. For a long time, artists who were members of the latter body had to be content with exhibiting at Place Dauphine. From 1751, they nevertheless succeeded in showing their works at various venues. The contemptuous attitude of the academicians towards the art guild was unjustified, as the latter body included among its members renowned artists

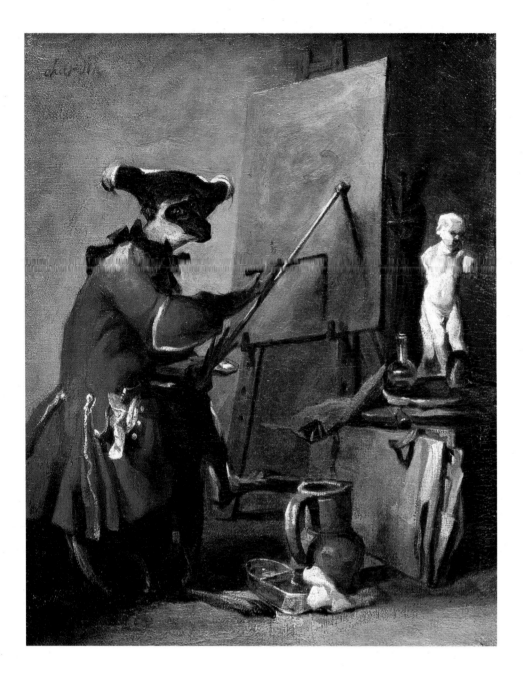

| Jean-Siméon Chardin
THE MONKEY PAINTER
| 1740, oil on canvas,
28.5 x 23.5 cm
(11 1/4 x 9 1/4 in).
Musée des Beaux-Arts, Chartres.

'Singeries' (paintings depicting
monkeys in human roles and
attitudes) became popular as
an ironic image of society and
of artists, imitators of nature.

such as Simon Vouet and Pierre Mignard, and Chardin first exhibited there. Rivalry, however, persisted until the late 18th century when the guild system was abolished on the instigation of Turgot in 1776 and the Académie de Saint-Luc finally closed down.

A key aspect of the Academy's power was its monopoly of teaching: it had its own teachers and the exclusive right to conduct life drawing classes. Although provincial academies were founded, the Paris Academy was nevertheless distinguished by its privileged relationship with the Superintendance of Crown Buildings and its role as arbiter in matters of artistic theory.

In an orderly, centralized society such as that which existed during the reign of Louis XIV, the arts were assigned a social function which went well beyond the mere provision of pleasure. In return for their emancipation, artists and their amateur associates were expected to contribute to the elaboration of aesthetic standards consistent with the established order. Thus, in his preface to

Lectures of the Royal Academy of Painting and Sculpture during the Year 1667, Félibien, the Academy historiographer, set out a series of rules which paralleled those governing literature, the theatre, and even social and political life. This is how he defined art, and his conception, although challenged by more sensualistic 18th-century trends, remained crucial:

"As the education and pleasure which one receives from the works of Painters and Sculptors does not derive solely from drawing and design,[2] the beauty of the colours, nor the cost of the material, but from the grandeur of thought and the perfect knowledge which Painters and Sculptors have of their subjects, it is therefore true that there is a specific type of Art, quite distinct from the Craftsman's material and skill, with which the artist must first create his pictures in his mind, and without which the Painter cannot create a perfect work by means of his brush alone, as this special Art is not like those in which workmanship and a skilled hand suffice to create beauty."

The hierarchy of genres and the debate on colour

There could be no better illustration of the pre-eminence of the intellectual process, a principle which French classical art derived from the texts of antiquity and the Renaissance. This intellectualization had as its corollary the hierarchy of genres which Félibien spelled out with equal clarity:

"To represent a body by merely tracing lines or adding colour is considered a mechanical operation. Accordingly, since in such Art different Workers[3] apply themselves to different subjects, it is invariably the case that the more they concern themselves with the most difficult and noble things, the more they distance themselves from that which is most inferior and common, and dignify themselves by more distinguished work. In this way, the artist who paints perfect landscapes is superior to another who merely paints fruit, flowers or shells. The artist who paints live animals is more praiseworthy than the one who only represents dead, inert things; and, as the figure of man is God's most perfect earthly creation, it is equally certain that the artist who seeks to imitate God by painting human figures is infinitely superior to all others. [...] Nevertheless, a Painter who only paints portraits has not yet attained such lofty perfection of Art and cannot claim the honour accorded to the most learned. To achieve this, it is necessary to progress from the representation of a single figure to that of several together; it is necessary to depict history and legend, to portray great events in the manner of the Historians, or pleasurable themes like the Poets; scaling even greater heights, it is necessary, by allegorical compositions, to enshrine in legend the virtues of great men and the most elevated mysteries."

This explains the subordinate status of someone like Chardin, received in 1728 as a "talented painter of animals and fruit", while his son Pierre, Prix de Rome winner in 1754, was categorized as a "history painter"; it further explains the acute embarrassment of Greuze, received in 1769 as a genre painter although he had submitted *Emperor Septimus Severus Reproaching His Son Caracalla for Having Sought His Assassination*. The Academy was in the service of the Monarch and gave pride of place to history painting which

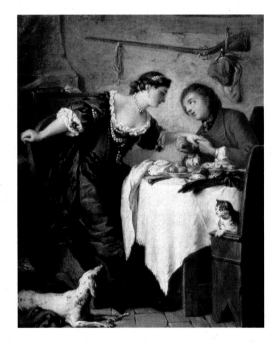

Pierre Subleyras |
THE FALCON
N. d., oil on canvas,
34 x 28 cm (13 3/8 x 11 in).
Musée du Louvre, Paris.

Although inspired by one of
La Fontaine's ribald *Tales*,
this small painting retains
a discreet harmony.

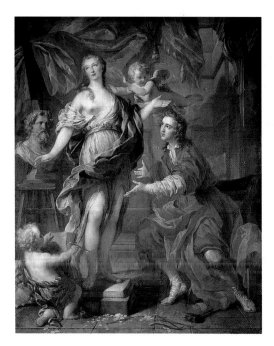

| François Le Moyne
PYGMALION SEEING HIS STATUE COME TO LIFE
1729, oil on canvas,
212 x 168 cm
(83 1/2 x 66 1/8 in).
Musée des Beaux-Arts, Tours.

Mythology remained
one of the most popular sources
for history painting.

Charles-Joseph Natoire |
PSYCHE AT HER TOILET
1745, oil on canvas,
198 x 169 cm
(78 x 66 1/2 in).
New Orleans Museum of Art,
New Orleans. |

Natoire, history painter and
Director of the French Academy in
Rome (1751-1774), particularly
excelled in 'scenes galantes'.

encompassed not only the history and mythology of classical antiquity, the Bible and stirring feats of the day, but also allegory – ideally suited to heroic portrayal. Such a classification was corroborated by the Prix de Rome set subjects, selected from the Bible or Roman history.

Although the academic system remained effective it was constantly the theatre of fundamental debates which introduced a greater degree of flexibility. Public taste and official standards might diverge, yet the Superintendents deemed it their duty to uphold the superiority of history painting: Marigny commissioned paintings of the latter type for the state, even if his own boudoir was decorated with more frivolous works by Boucher, Carle Van Loo and Natoire. Commissions for cartoons for the Gobelins tapestry manufactory were another means of promoting the noble genres: the *Story of Mark Antony* and *Loves of the Gods* provided lucrative employment for the three latter artists. Such classical scenes, however, tended to be treated in a lighter vein and adapted to current taste.

But is it not precisely those 'inferior' genres which reveal the intrinsic qualities of 18th-century painting and its innovative aspects, expressing a budding sensitivity even in the latter years of Louis XIV's reign? Watteau, master of the 'fête galante', Chardin, who confined himself to genre painting and still lifes – in other words, 'ignoble' subjects – Fragonard, who favoured amorous scenes and fanciful portraits, or Vernet, who specialized in landscape, are indeed the great painters, definitely in our eyes, but also in those of perceptive critics like Diderot who, confronted with certain mediocre history paintings, did not hesitate to exclaim (adopting a typically elitist academic stance): "Out of the Salon!" nor to hail Chardin with "It is he who is a painter." In fact, Diderot's prime criterion was emotion which cannot be restricted to grand heroic effects. Nevertheless, like all his contemporaries, he accepted the hierarchy of genres, even though he introduced new values such as the sublime quality of landscape or the human and moral vision of genre painting, which was effectively bourgeois. Universal beauty, held to be the special preserve of the 'grand manner', together with the corpus of rules based on reason rather than sensibility were thus challenged in the name of genius and a cultural relativism which first emerged in 1719 in Abbé Dubos's *Critical Reflections on Poetry and Painting*. The 18th century is fascinating precisely because it made possible this shift in fundamental aesthetic thinking.

Yet here again, the origins of the debate lay in the 17th century. Academic lectures, in the style of Boileau's *Art poétique*, propounded a set of rules – unity of place and time, propriety, the pre-eminence of design and drawing over colour, etc. – and proposed classical antiquity, Raphael and Poussin as models. Antoine Coypel, Director of the Academy from 1714, wrote his work on the art of painting, *Epistle to My Son*, in alexandrine verse, the better to pastiche Boileau. However, in addition to the conventional tribute paid to reason and classical antiquity, other models such as Titian or Correggio, for colour and elegance respectively, were also proposed. It is necessary to qualify a prescriptive vision which was distorted by an over-simplified and excessively hierarchical presentation, as in the *Tables and Precepts of Painting* by

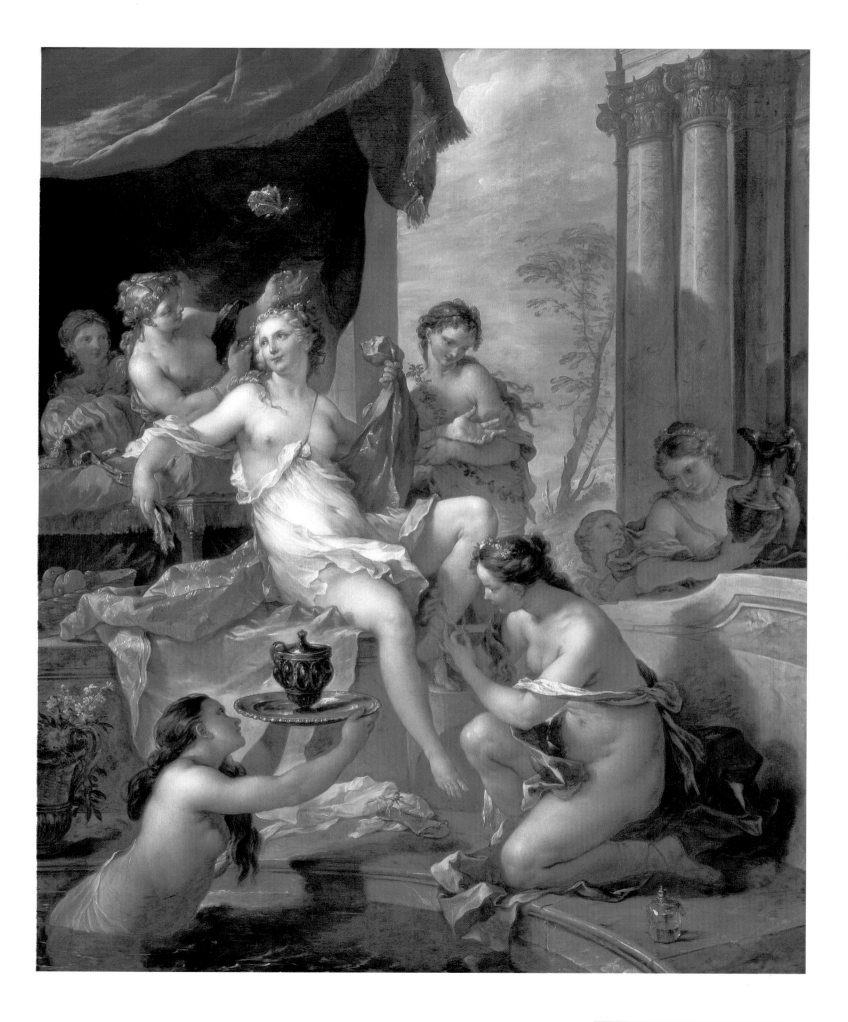

Henri Testelin (1670-1679). The Academy was riven by debates which, although sometimes settled in an arbitrary manner, nevertheless made possible more flexible definitions of art. In 1671, for instance, the institution, barely ensconced in its prerogatives and assured of its doctrine, witnessed a crucial debate on the use of colour which heralded the aesthetic preoccupations of the following century.

For Philippe de Champaigne or Le Brun, the essence of art lay in design and drawing, whereas colour was regarded as a more mechanical, superficial aspect, related to brushwork. The Venetian painters and Rubens, however, did not lack champions in France. Another academician, Gabriel Blanchard, argued in reply that "a painter is only a painter because he uses colours which appeal to the eye and imitate nature", while an enlightened connoisseur, Roger de Piles (1635-1709) defended Rubens and the importance of colour in his *Dialogue on Colour* published in 1672. It was not merely a dispute between 'Rubenists' and 'Poussinists'; indeed, the very nature of painting itself was at stake. In the pursuit of universal rules, painting favoured design and drawing as the expression of the idea, yet, as soon as a more relativist and sensualistic view began to emerge, colour came to be regarded as the specific means to express feeling.

Roger de Piles ushered in the 18th century with his *Idée du Peintre parfait (Abrégé de la vie des peintres)*, published in 1699, and his *Cours de peinture par principes*, published in 1708, in which he furthermore moderated the criteria governing historical accuracy. While associating classical antiquity and Nature, De Piles adopted a less dogmatic stance than Félibien regarding the question of genres. Finally, in the chapter "On Genius", appended to the 1715 edition of his *Idée*, he introduced a new concept which conflicted with the accepted dogma. This was not yet 'genius' as it would be defined by the generation of 1760, but already the narrow rationalism in which imitation and official rules were circumscribed had begun to yield ground.

Thus, by the early 18th century, the influence of Rubens prevailed over that of Poussin, while genre painting was inspired by the Flemish school and Rembrandt. Antoine Coypel, in the preface to his *Speeches Delivered at the Royal Academy Lectures*, published in 1721, noted this new trend, essential to understanding the rococo and the fashionable process which art was henceforth embarking upon: "We have seen contempt, so to speak, showered upon all that was not Poussin; then Albani had his turn: works by Rubens, Van Dyck and Bassano were proscribed; finally, despite their rare beauty, the Poussins were driven away by Rubens …"

Watteau was amazed when he first set sight on the Rubens cycle in the Marie de Médicis gallery in the Luxembourg palace, and for many artists of his day nothing was esteemed more praiseworthy than to follow in the footsteps of the Flemish master. Nevertheless, during the 1760s, a Poussin revival was to occur alongside the vogue for the antique. The argument thus remained unresolved and the 18th century characteristically wavered between two variants of 'grand art'. Masters such as Téniers, fascinated by mundane reality, also have their place in its eclectic pantheon.

| Jean Ranc
VERTUMNUS AND POMONA
C. 1710-1720,
oil on canvas,
170 x 120 cm
(67 x 47 1/2 in).
Musée Fabre, Montpellier.

A pupil of Rigaud, Ranc was inspired by North-European models, and seems to hesitate between mythological painting and portraiture.

History and mythology: allegory or Eros

In his epistle *On the Painter's Aesthetics*, Antoine Coypel wrote:

> "Following thus the shining light of Reason,
> Seek in Correggio a grand manner,
> A noble taste for drawing and design, a timely choice of beauty,
> Elegance, naivety and charming brushstroke."

Now in order to achieve this 'grand manner' the painter, well-versed in the humanities, moral philosophy, various sciences and classical references, had to devote himself first and foremost to the three components of 'history painting' – sacred history, secular history and legend.

Theoretically, history painting was the superior genre, and it remained so during the 18th century because it was best qualified to serve royal power. Mirroring the social order, the hierarchy of genres equated aristocratic values with depictions of biblical episodes, legends, or Roman history. Paradoxically, it was not their historical importance which counted most but rather their exemplary, even allegorical dimension: Alexander the Great or Phoebus were above all sovereign figures. Yet in the course of the 18th century, a new ideological function of history painting can be seen taking shape: there was a growing awareness that it helped foster national values. The French Revolution provided an ideal sphere of activity: the ancients were taken as models and, as the revolution itself was immediately perceived as a historic event, no intermediary stage was required to portray it in a heroic vein. The painting of the revolutionary period found its justification in this characteristic blend of neo-classicism and realism.

Antoine Coypel |
VENUS IMPLORING JUPITER IN FAVOUR OF AENEAS
1702, sketch for
the ceiling decoration
of the Galerie d'Énée
in the Palais-Royal, oil on canvas,
94.5 x 196 cm (37 1/4 x 77 1/8 in).
Musée des Beaux-Arts, Angers.

| Jean-Antoine Watteau
FEMALE NUDE WITH RIGHT ARM RAISED
1718-1719, red and black stone
on buff-coloured paper,
28.2 x 23.3 cm (11 x 9 1/4 in).
Musée du Louvre,
Département des arts graphiques, Paris.

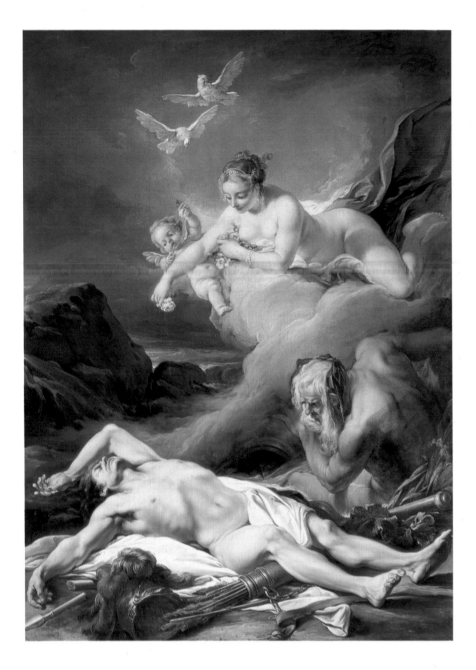

| Jean-Baptiste Deshays
HECTOR EXPOSED ON THE BANKS
OF THE XANTHUS RIVER

Exhibited at the 1759 Salon,
oil on canvas, 244 x 180 cm
(96 x 70 3/4 in).

Musée Fabre, Montpellier.

Jean-Honoré Fragonard |
JÉROBOAM SACRIFICING TO THE IDOLS
Awarded the 1752 Grand Prix, oil on canvas,
111.5 x 143.5 cm (43 7/8 x 56 1/2 in).
École nationale supérieure des Beaux-Arts, Paris.

One of the clearest illustrations of this predominating influence of history – yet also one which was to have the most far-reaching consequences for the academic system which lasted throughout the 19th century – was to be found in teaching methods. It was taken for granted that the annual Grand Prix, the pinnacle of the pedagogical system, ought to promote history. This had been apparent in the very first competition subjects proposed between 1663 and 1673, involving heroic royal feats such as the recapture of Dunkirk, the annexation of Franche-Comté, or the crossing of the Rhine. Then, for almost a century between 1674 and 1761, it was the turn of biblical themes. In 1723, Boucher carried off the Grand Prix with his *Evilmerodach, Son of Nebuchadnezzar, Delivering Jehoiachin from the Chains in which His Father had Imprisoned Him*, while in 1752 Fragonard painted a winning *Jeroboam Offering Sacrifices to the Idols*! After 1762, subjects drawn from pagan antiquity prevailed. Episodes from the stories of Joseph or David alternated with others taken from the lives of Achilles, Alexander or Seneca. From then on, however, reflecting the spread of neo-classical themes in both theatrical and artistic culture, pride of place was given to evocations of the deaths of heroic figures: in 1762, *The Death of Socrates*, in 1769, *Achilles Laying Hector's Corpse at the Feet of That of Patroclus*, in 1781, *Ordeal of the Maccabees*, in 1785 (the year David exhibited *The Oath of the Horatii*) *Horatius Killing His Sister Camilla*, and in 1797, *The Death of Cato of Utica*.

In 1773, as a further illustration of this vogue for classical history, the academicians, weary of repeating the same old lectures, decided to devote their meetings to readings from the *Iliad*! In 1757, one amateur associate, Comte de Caylus, eager to add to the stock of historical iconography, submitted his *Scenes Taken from the Iliad and Odyssey of Homer and the Aeneid of Virgil*.

| François Le Moyne
HERCULES AND CACUS
1717, oil on canvas,
35 x 46 cm (13 3/4 x 18 1/8 in).
Musée du Louvre, Paris.

François Le Moyne |
HERCULES AND CACUS
Detail. N.d., red chalk and
ink on beige paper,
26.5 x 37.5 cm
(10 1/2 x 14 3/4 in).
Musée du Louvre, Département
des arts graphiques, Paris. |

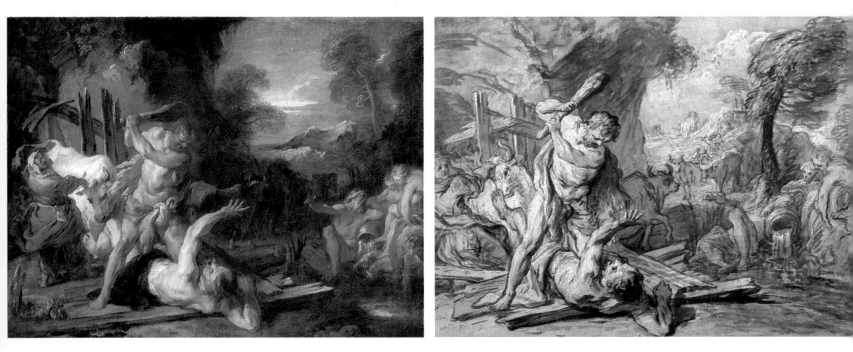

The fact that few women were admitted to the Academy (four, by a decision taken in 1770) was also related to the status accorded to the historical genre. Barred from studying nude life models, lacking in adequate culture (although it should be recalled that the translation of the *Iliad* read at the Academy meetings was the work of Mme Dacier) women artists were confined to portraiture and floral compositions.

The office of First Painter to the King, on occasion occupied by the Academy Director himself, provided an additional bulwark for the dominant genre, as had been the case with Le Brun. This was the official context which governed not only the commissions granted to artists but also the principal genres involved – grand decorative compositions, tapestry designs for the royal manufactories, religious cycles, etc. Following the death of Mignard in 1695, there was a long vacancy until 1716 when Antoine Coypel was appointed to the post with the backing of the regent, the Duc d'Orléans. As First Painter to the Regent, Coypel had decorated the Galerie d'Énée in the Palais)-Royal.[4] Illusionistic distance featured prominently in the central composition on the ceiling vault, a *Venus Imploring Jupiter in Favour of Aeneas*, heralding later works such as those by Le Moyne for instance. Coypel had also been commissioned with the ceiling in the chapel at Versailles. Academy Director from 1714, he delivered a series of lectures, an anthology of which was published in 1721, "by order of the Academy" with an introductory *Discourse on the Excellence of Painting*. His son Charles-Antoine pursued an identical honorific career: appointed First Painter and Academy Director in 1747 by Superintendent Lenormant de Tournehem, he was an extremely influential

figure and attempted to bring new life to the institution through teaching, lectures and competitions. His work, drawing on mythology (*Perseus Rescuing Andromeda*), the classical tragedy of Racine (*Athaliah Questioning Jehoash*), or allegory, contributed, like his administrative policies, to the fostering of history painting. In 1748 moreover, on his instigation, Tournehem founded a special school, the École royale des élèves protégés, which offered literature and history classes intended to equip future Prix de Rome candidates with an appropriate cultural background. Finally, for the academicians, Coypel re-introduced the lectures which had fallen into abeyance under the Directors who had succeeded his father. Jean-Baptiste Pierre (1713-1789), First Painter and Director in 1770, was to take his official role as organizer of the arts so much to heart that he virtually abandoned painting, devoting himself along with Superintendent d'Angiviller to the task of rehabilitating history painting.

The Superintendents launched competitions in an effort to encourage emulation among the academicians. In 1727, the Duc d'Antin had organized a competition[5] dominated by Le Moyne, de Troy and Coypel. The artists, free to choose their own subject, mostly opted for mythological themes. In 1747, Tournehem organized a limited competition in which eleven academicians selected by Coypel took part; as in 1727, all the competitors, by tacit agreement, submitted historical subjects. On this occasion, however, heroic historical themes – *Alexander and His Physician Philip* by Jean Restout, *Mucius Scaevola* by Dumont le Romain, *Coriolanus* by Galloche, *Glaucias Recognising the Infant Pyrrhus* by Collin de Vermont – prevailed over charming mythological episodes, the latter being nonetheless represented by the master of the genre, Boucher himself, with a *Rape of Europa*, a subject also chosen by Cazes. Carle Van Loo presented his famous painting, *Drunken Silenus*, an apparently explicit reference to Rubens. This competition marked the beginnings[6] of a reversion to a more austere style, a return to Poussin and classical antiquity, and the trend was to gather momentum in the course of the ensuing decades (as will be seen in chapter 4). Such competitions, in which Restout and Galloche took part on two occasions, together with the subsequent careers of the winners, François Le Moyne (1688-1737) and Jean-François de Troy (1679-1752), bore witness to the continuity of the grand manner.

Le Moyne specialized in historical themes, obtaining prestigious commissions for Paris churches as well as the Salon de la Paix (1729) and the Salon d'Hercule (1728-1736) at Versailles. For the latter he painted a gigantic 18.5 by 17-metre (over 60 by 55-foot) *Apotheosis of Hercules* featuring one hundred and forty-two figures. As a single composition, it rivalled the work

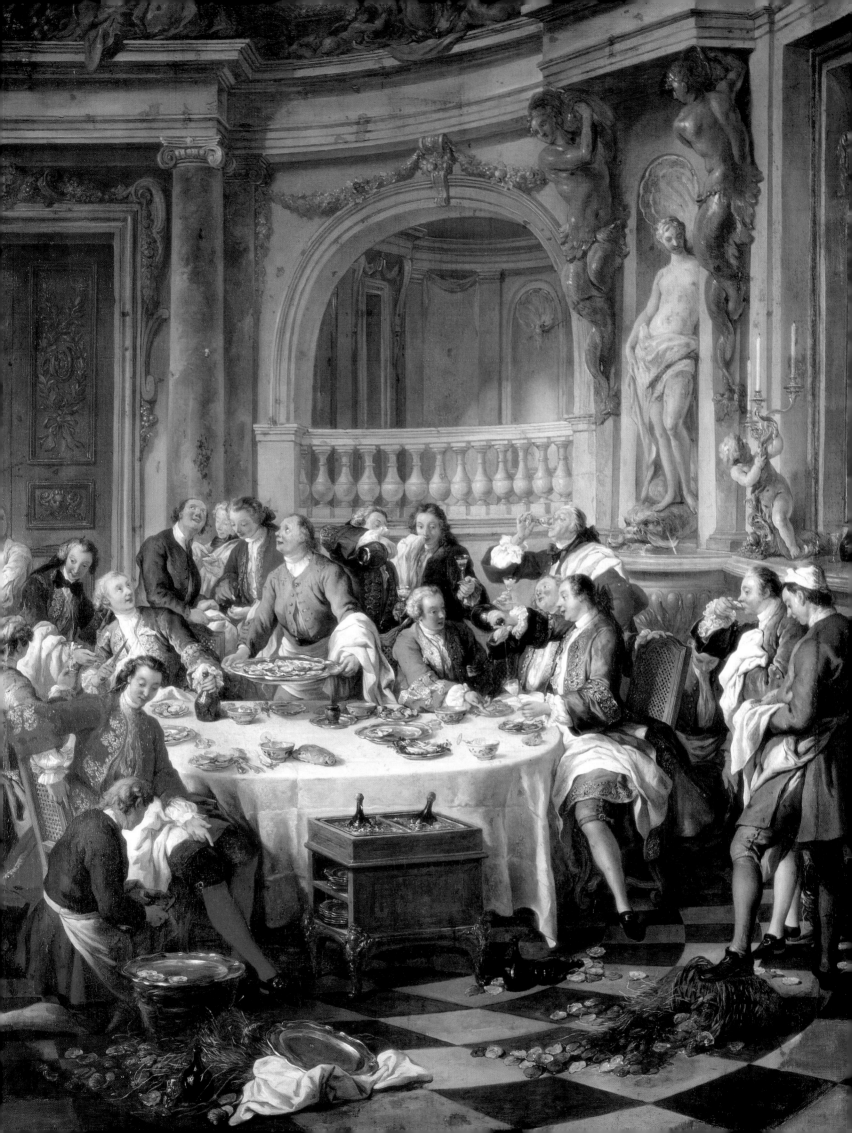

The 1727 Competition

In a bid to encourage history painting, the Duc d'Antin (1665–1736), Superintendent from 1709, set up an open competition in which twelve famous artists exhibited their works in the Galerie d'Apollon in the Louvre. On 30 June 1727, the Superintendent declared Jean-François de Troy and François Le Moyne winners, and also purchased the entry by Charles Coypel which the king had admired. The exhibition was dominated by rococo elegance; the 'history painting' on show included a conspicuous number of mythological scenes featuring nude figures (de Troy, Charles Coypel, *Birth of Venus* by Cazes, *Juno and Aeolus* by Massé, *Hippomenes and Atalanta* by Galloche, *Pan and Syrinx* by Courtin); Noël-Nicolas Coypel's *Rape of Europa* was pure Boucher… before Boucher even appeared on the scene! With the exception of Antoine Dieu's *Horatius Cocles*, even the historical themes (Le Moyne's paintings, Collin de Vermont's *Sickness of Antiochus*, and Jean Restout's *Hector and Andromache Bidding Farewell*) involved poignant episodes.

Charles Coypel |
PERSEUS AND ANDROMEDA
1726-1727, oil on canvas,
131 x 196 cm
(51 1/2 x 77 1/4 in).
Musée du Louvre, Paris.

| François Le Moyne
THE CONTINENCE OF SCIPIO
1726, oil on canvas,
147 x 207 cm
(57 3/4 x 81 1/2 in).
Musée des Beaux-Arts, Nancy.

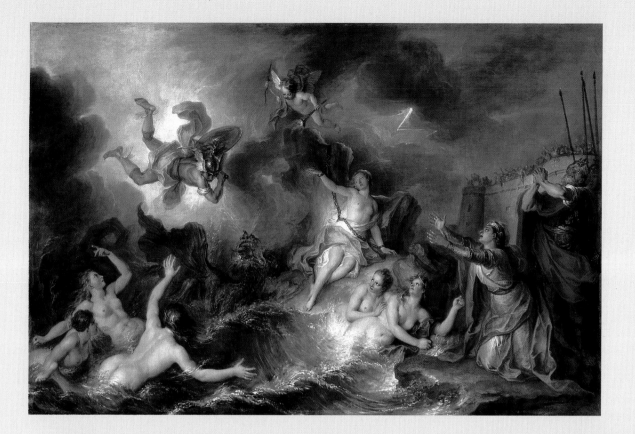

Pages 40-41
Noël-Nicolas Coypel
THE RAPE OF EUROPA
1727, oil on canvas,
127 x 193 cm
(50 x 76 in).
Philadelphia Museum of Art,
Philadelphia.

Jean-François de Troy
DIANA AT REST
1726, oil on canvas,
130 x 196 cm
(51 1/4 x 77 1/4 in).
Musée des Beaux-Arts, Nancy.

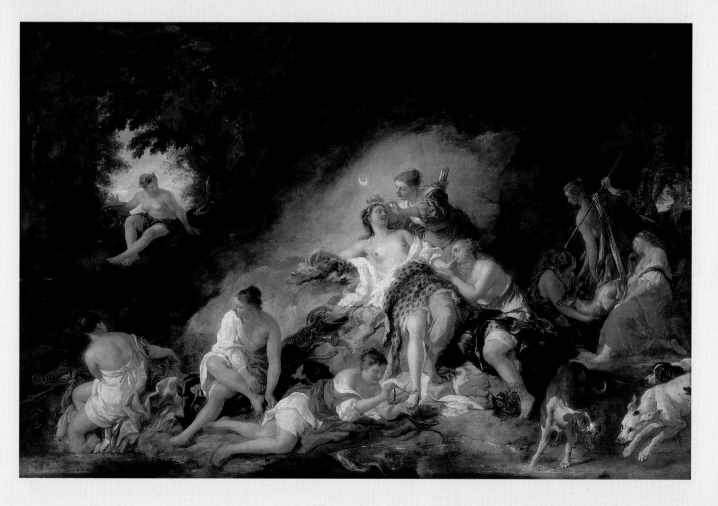

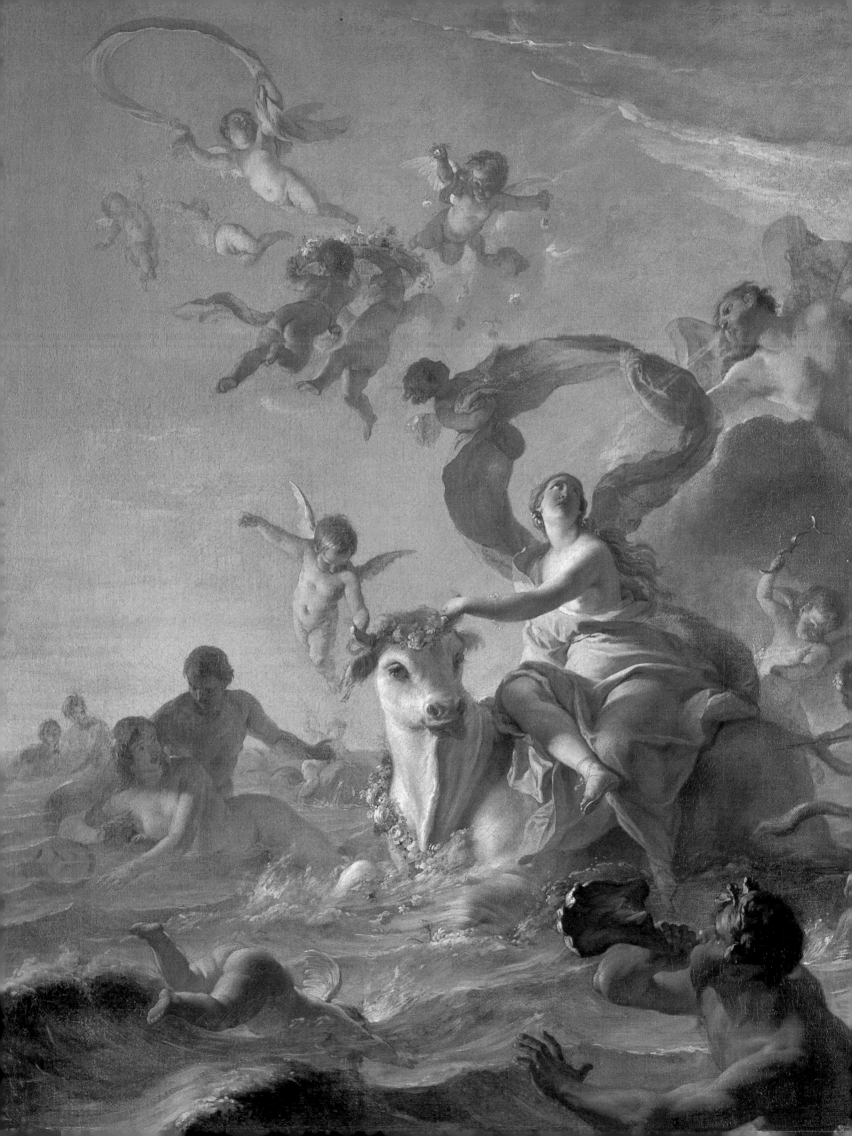

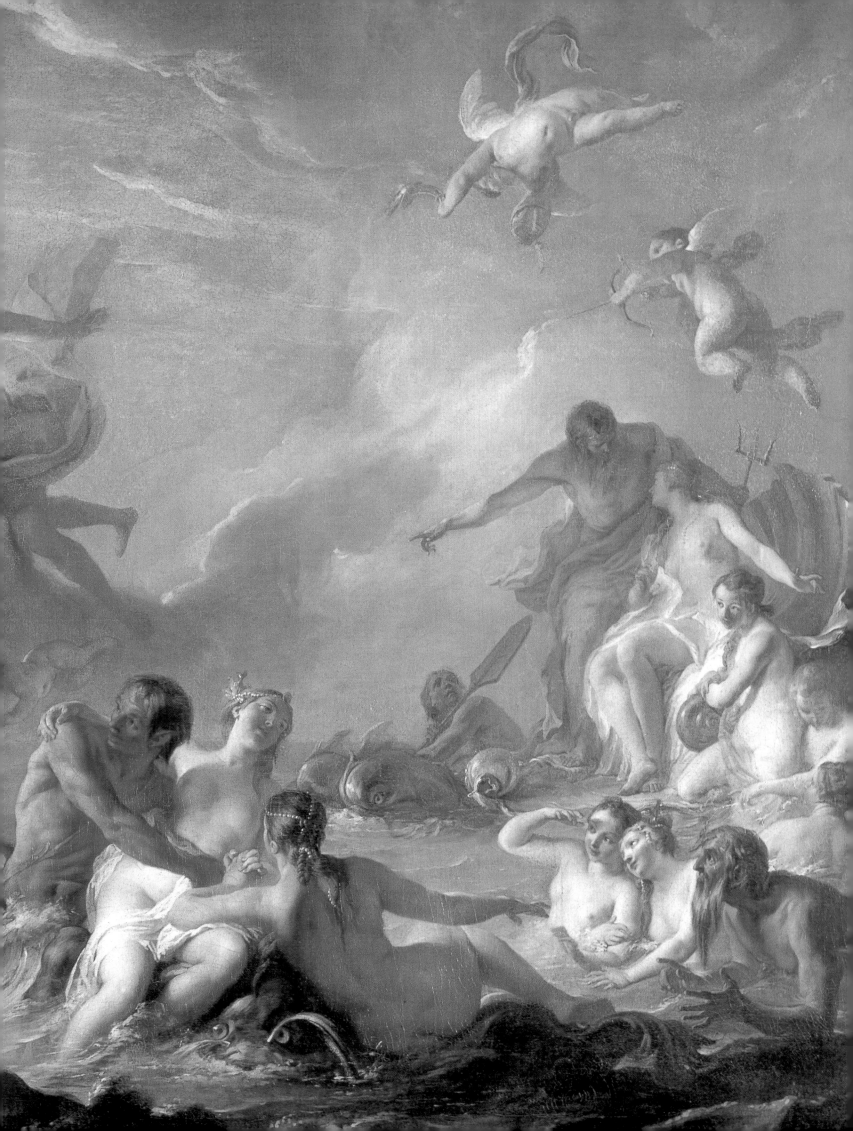

by Pellegrini, master of rapidly executed decorative commissions, who had been granted the privilege of painting the ceiling in financier John Law's mansion. It featured an allegorical treatment of mythology, drawing an analogy between the apotheosis of the classical hero and that of the sovereign himself. Despite his success, Le Moyne, thoroughly worn-out, committed suicide in 1737.

His rival, de Troy, equally capable of producing grand mythological compositions (yet which often lacked dynamism) or lighter genre scenes such as *Reading from Molière* or *A Lunch of Oysters* (painted for Versailles) was commissioned with two series of tapestries for the Gobelins, including *Jason and Medea*, and culminated his career as Director of the French Academy in Rome (1738-1751). Nevertheless, de Troy – like Noël-Nicolas Coypel (1690 1734) whose *Rape of Europa* won public acclaim at the 1727 competition – paved the way for Boucher. History painting, more vulnerable than its religious counterpart, became gradually permeated by rococo elegance.

It is therefore hardly surprising that this period witnessed the triumph of mythological composition since the latter rendered historical grandeur compatible with the vogue for 'galant' subjects. It would moreover be found in the work of painters of feminine grace and pastoral scenes such as Boucher. Yet the modern public, as Pierre Rosenberg has deplored in his introductory *Plea for Mythological Painting* in the catalogue accompanying the *Loves of the Gods* exhibition in 1991, no longer shares this culture which was central to the art of the time: themes taken from Ovid are now barely familiar, and a remarkable work such as *Vertumnus and Pomona* by Jean Ranc (1674-1735), one of Rigaud's pupils particularly active as a portraitist in Spain, is difficult to interpret today. Nowadays, people more readily appreciate a still life by Chardin than a *Psyche* by Natoire. This is not merely a question of aesthetics; it is also symptomatic of a cultural phenomenon. Moreover, academic study of the work of artists who specialized in the genre remains fairly limited. It is known, for instance, that Louis-Jean-François Lagrenée, known as Lagrenée the Elder (1724-1805), exhibited more than one hundred and fifty works at the Salons, including sixty-nine involving mythological themes. Yet his *Pygmalion and Galatea* (a subject to which he was to return eight times) is highly appealing in its simplicity, reminiscent of the famous group by Falconet, and the banality of the myth of artistic creation does not detract from the luminous beauty of the nude figure.

Although, from 1747, mythological painting gave way to a more serious approach to history, neo-classicism, while confirming this shift, did not reject mythology, and the greatest late 18th-century French painter, David, was not only to produce *The Horatii* but also anacreontic works[7] ranging from *Paris and Helen*, painted in 1788, to *Cupid and Psyche* (1817) and *Mars Disarmed by Venus* (1824), both painted in exile. Mythology treated in a more light-hearted vein also remained omnipresent in decorative works; indeed, it represented one of the profoundly symbolic expressions of the century.

Antoine Coypel |
THE ETERNAL FATHER PROMISING TO SEND THE MESSIAH TO EARTH
Detail of the central section of the ceiling. 1708-1709, oil on plaster.
The Chapel, Château de Versailles.

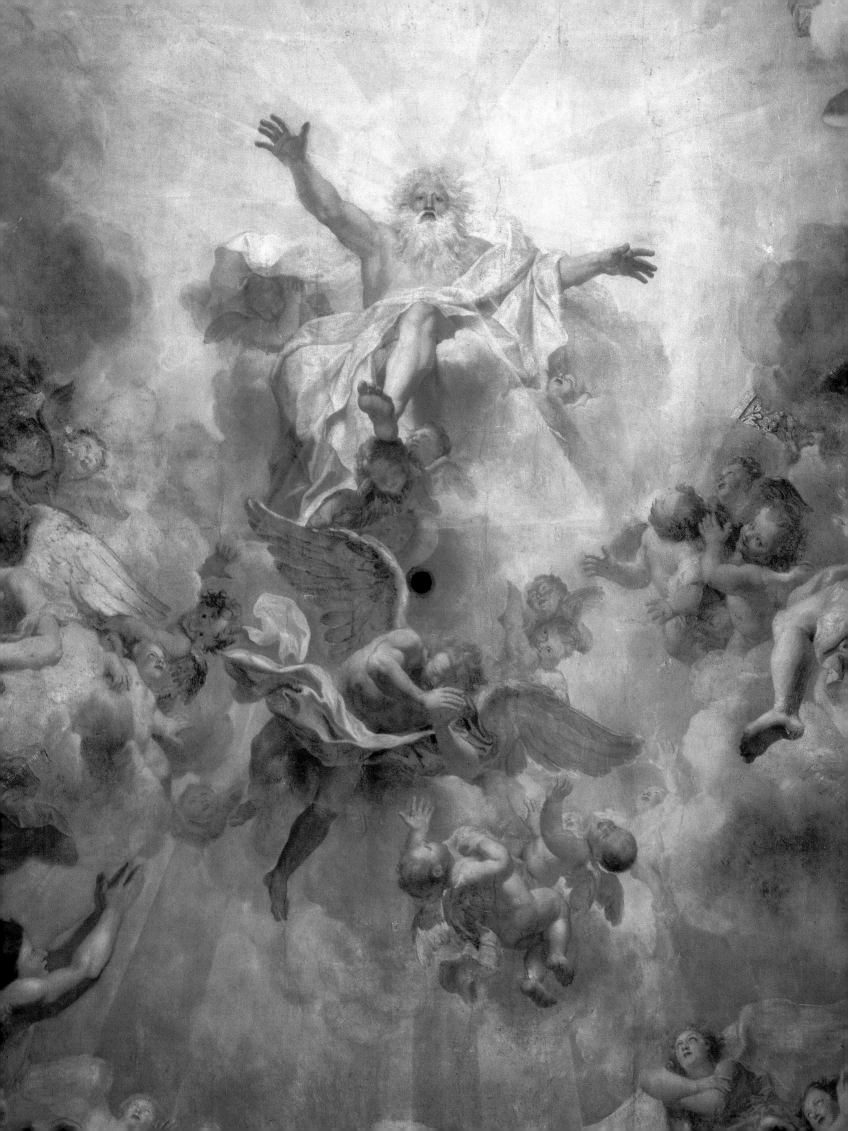

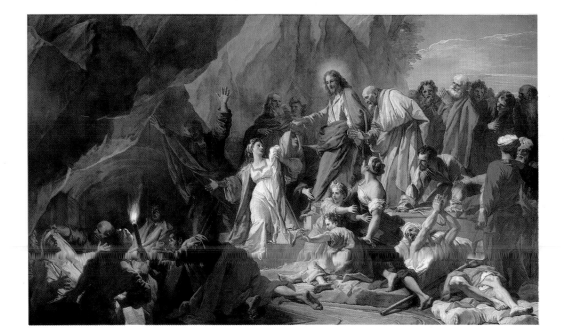

Religious commissions

Because of the formal codification and stereotyped representation governing a genre in which artists enjoyed less freedom than in secular history, and because clients were often mindful of tradition, religious painting underwent relatively little change. Nevertheless, it produced rivalry between the two tendencies already mentioned – 'Poussinism' and 'Rubenism'. Jean Jouvenet (1644-1717) kept alive the classical ideal, mellowed by the influence of Rubens. Some of his scenes from the life of Jesus, although somewhat theatrical, are the worthy heirs of Poussin and Le Sueur, in particular the series painted for Saint-Martin-des-Champs (*The Resurrection of Lazarus*, 1706). Jouvenet painted a *Pentecost* on the vault at the chapel in Versailles, along with Charles de La Fosse (1636-1716), who decorated the apse with a finely-executed *Resurrection*, and Antoine Coypel. These three artists were responsible for some of the most successful work produced during the latter period of Louis XIV's reign and provide a good illustration of the 'grand manner' around 1710, based on continuity with the art of Le Brun combined with Italian and Flemish influences. The admirable decor of this royal chapel was completed by a series of paintings, including *The Annunciation* by Louis Boullogne (1654-1733) and *The Ecstasy of St Theresa* by Jean-Baptiste Santerre (1658-1717), a work which provoked a scandal.

As had been the case with Antoine Coypel and his son Charles, Jouvenet passed on to his own nephew, Jean Restout (1692-1768) – who pursued a successful academic career, ending up Director – an art characterized by its fidelity to the 17th-century manner, a breath of austerity and restraint in the dissolute context of the Regency. Yet the latter qualities did not exclude baroque effects as seen in his *Ecstasy of St Benedict* and *Death of St Scholastica* painted in 1730 for the monastery of Bourgueil near Tours.

| Jean Jouvenet
THE RESURRECTION OF LAZARUS
| 1706, oil on canvas, 388 x 664 cm (152 3/4 x 261 1/2 in).
| Musée du Louvre, Paris.

"What vitality! what forcefully expressive looks! what joy! what gratitude!",
"Once seen, never forgotten", added Diderot (*Salon de 1763*).

Jean Jouvenet |
THE RESURRECTION OF LAZARUS
Detail. |

| Jean-Baptiste Santerre
THE ECSTASY OF ST THERESA
| Detail.

Religious inspiration and depth of feeling, relatively rare commodities in an increasingly secular century, are also to be found in the work of a Toulouse artist who, after having won the Grand Prix in 1727, settled permanently in Rome. The reputation of Pierre Subleyras – re-established fairly recently – led to a commission from Pope Benedict XIV to paint his official portrait in 1740 and to paint *The Mass of St Basil* in 1747 for St Peter's. Both these masterpieces illustrate the successful way in which Subleyras apparently managed to maintain a certain French restraint while adopting Italian pictorial trends. This emerges clearly if one compares his *Mass* with the *Fall of Simon Magus* by Pompeo Batoni (1708-1787), both of which are now in Santa Maria degli Angeli. Subleyras was also the 'painter of canonizations', which were frequent events at that time in Rome.

François Le Moyne, whose grandiose, solemn work has already been mentioned, obviously possessed the requisite qualities to paint religious art. In 1714, he was commissioned to paint a *St John the Baptist* for Saint-Eustache in Paris and, the following year, seven scenes from the life of Christ for the Cordeliers Abbey in Amiens. In 1718, the bishop of Le Puy commanded an *Assumption* which the painter is later said to have wished destroyed, judging it too gracious. He executed ceilings with illusionist effects of depth and

trompe-l'œil balustrades in an attempt to rival Pelligrini and Ricci, adopting their bright colours, as well as a *Transfiguration of Christ* painted in oil on plaster in St Thomas Aquinas church in 1723, and an *Assumption* for the dome of the Lady chapel (which swiftly deteriorated) in Saint-Sulpice in 1731. Le Moyne's work offers a good illustration of the influence of Rubens blended with that of Italian baroque painters such as Pietro da Cortona or Guido Reni, although it borrows its warm colours and lightness from Correggio. Faced with the growing fashion for 'scènes galantes', religious commissions helped to perpetuate the exacting criteria of history painting, as is attested by the work of Carle Van Loo (1705-1765), one of the most celebrated painters of his generation. Although he was presented as being above all passionately interested in mythology and showed no apparent signs of religious inclination, his work included a bewildering profusion of religious paintings. His virtuosity and prolific output may explain the many commissions he obtained right from his early years spent in Italy, but also his undeniable success in this difficult genre. His *Adoration of the Shepherds* in Chartres (1737) has been

Jean Restout |
THE DEATH OF ST SCHOLASTICA
1730, oil on canvas,
338 x 190 cm
(133 x 74 3/4 in).
Musée des Beaux-Arts, Tours.

| Jean-Baptiste Santerre
THE ECSTASY OF ST THERESA
1709, oil on canvas,
267 x 171 cm
(105 1/8 x 67 1/4 in).
The Chapel, Château de Versailles.

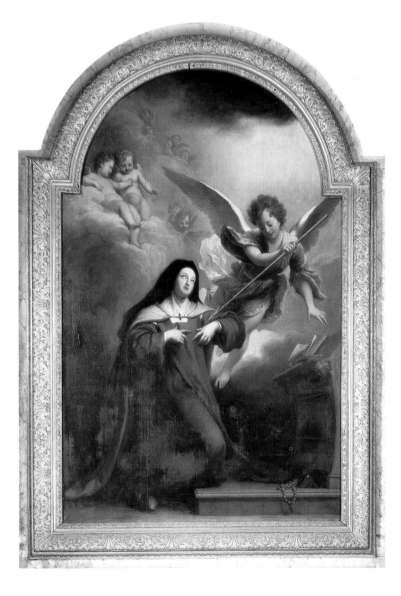

| Pierre Subleyras
THE MASS OF ST BASIL

1747, oil on canvas,
134 x 78 cm (340 1/4 x 177 1/4 in).
Musée du Louvre, Paris.

**This is a version of the painting commissioned by Pope Benedict XIV
for St Peter's in Rome. To protect it from the dampness in the basilica,
a mosaic copy was made as soon as 1748 and the original transferred
to Santa Maria degli Angeli.**

Carle Van Loo |
THE CONDEMNATION OF ST DENIS
Detail. 1741, oil on canvas,
195 x 114 cm
(76 3/4 x 44 7/8 in).
Musée des Beaux-Arts, Dijon.

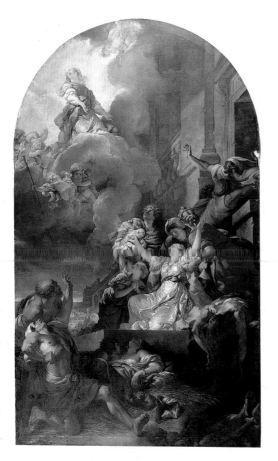

| Gabriel-François Doyen
THE MIRACLE OF THE FERVENT
| Exhibited at the 1767 Salon,
oil on canvas,
665 x 450 cm
(261 3/4 x 177 1/4 in).
| Saint-Roch Church, Paris.

Showing affinities to Domenichino,
this painting has inherited
a baroque dynamism, whereas
Vien's *St Denis Preaching*,
on the opposite side of the transept
is imbued with a neo-classical
balance and clarity.

described[8] as a "masterpiece of the religious art of the period"! In 1746, Van Loo painted four monumental works for the Lady chapel in Saint-Sulpice; although the pictorial programme does not match the outstanding quality of the sculpture (Bouchardon, the Slodtz family, Clodion, Pigalle), the overall effect is nevertheless harmonious. In 1748 and 1755, he was commissioned to paint seven works for Notre-Dame-des-Victoires, founded by Louis XIII – six scenes from the life of St Augustine, to whom the church was dedicated, along with *Louis XIII Dedicating the Church to the Virgin*. Most of these were exhibited at the Salons of 1750, 1753 and 1755. They met with critical acclaim, particularly due to the unity of the artist's compositions, centred on a specific action, and his quality of expression, a concern also found in the work of Charles-Antoine Coypel, and thus reconciled the heritage of Le Brun with the Bolognese models. In 1741, Van Loo painted *The Condemnation of St Denis* and *St George Slaying the Dragon* for the Carthusian monastery of Champmol near Dijon, works imbued with a solemnity which contrasted with the elegant overdoors painted for the Hôtel de Soubise in Paris at the same period.

Although no match for an artist like Poussin, who could treat the *Sacraments* or *The Arcadian Shepherds* with equal mastery, Van Loo managed to capture what was appropriate to each genre. There is an obvious risk of confusion entailed in processes which tend to adopt a similar approach to a swooning Virgin or a fainting Esther, to the Ascension or Phoebus Rising. How is it possible to be one day a master of erotic mythology and the next imbued with sacred feeling? The baroque occasionally succeeded in reconciling the two, the rococo more rarely so. Van Loo showed affinities with Boucher, with whom he had spent his early years in Italy, yet he was capable of representing the life of St Augustine, adhering to the strictest of canons and without confusing genres. Boucher, for his part, only achieved this in subjects which suited his talent. He painted extremely sensitive *Holy Families* (such as *The Halt During the Flight to Egypt*, 1757, the Hermitage museum), and a *Light of the World* (1750, Lyons) in which the blend of elegance and rustic simplicity corresponded to both the theme and the personality of his client, Mme de Pompadour (the paintings were intended for her Bellevue chapel). Nevertheless, at the 1765 Salon, the not exactly impartial Diderot described Boucher's angels as "little libertine satyrs".

The public acclaim for Van Loo's religious cycles or Le Moyne's decorative compositions, to which we are less receptive nowadays because of the subjects involved, proved that the grand manner was holding its own alongside the growing success of genre painting, and that the reaction which set in around 1750 was not faced with the total reconstruction of some forgotten ideal. The ideal was in fact still very much alive in the work of Jouvenet (taken as a ref-

erence) and his pupils, and sufficiently robust to oblige versatile painters, like Van Loo, to have recourse to it in their commissions.

Moreover, the vitality and rich colour introduced by the painters of the so-called 'rococo' generation gave birth to a more expressive style of religious painting than that practised by certain champions of the classical revival. Thus Vien tended to treat both Christian saints and Vestal Virgins in an identical manner.

The reaction against the rococo style was, in the final analysis, hardly favourable to religious painting. Two compositions painted for Saint-Roch, Doyen's *Miracle of the Fervent* and Vien's *St Denis Preaching*, to which Diderot devoted lengthy comments in his *Salon de 1767*, illustrate the two prevalent tendencies: on the one hand, in the painting by Vien – whom certain critics regarded as a latter-day Domenichino – historical fidelity combined with a classicizing restraint, on the other hand, in the work by Doyen – considered a 'Rubenist' – dramatization, by means of somewhat grandiloquent compositions which led to the recrudescence of portrayals of martyrdom. Examples of this latter tendency can be seen in *The Martyrdom of St Andrew* by Jean-Baptiste Deshays (1721-1765) or in Jean-Baptiste Pierre's *Massacre of the Innocents*, painted respectively in 1759 and 1763. The Grand Prix prepared students for such violent portrayals by proposing subjects such as "Jezebel Devoured by the Dogs" (1753), "Nebuchadnezzar Putting Out Zedekiah's Eyes and Slaying his Sons" (1787), "Judith", etc. Nevertheless, late 18th-century religious painting was marked by a certain decadence and when, in 1776-1778, Superintendent d'Angiviller sought to symbolize piety or virtue, he turned not to sacred history but to classical antiquity. Only the cycle painted in the chapel of the École Militaire in 1773 and devoted to the *Life of St Louis* presented religious compositions revitalized by the growing taste for national themes.

Thus, history painting held its ground throughout the years which witnessed the heyday of rococo. The quality of certain works reveals just how mistaken were the students in David's studio who jeeringly lumped together "Van Loo, Pompadour, Rococo".[9] The students, followed by many of those 19th-century art lovers who were nevertheless responsible for the artist's rehabilitation, had forgotten that Van Loo was capable of producing work for both Notre-Dame-des-Victoires and Hôtel de Soubise.

1. Nathalie Heinich, *Du peintre à l'artiste. Artisans et académiciens à l'âge classique*, 1993.
2. The original 17th-century French term 'dessein' combined the present-day meanings of both 'drawing' and 'design'.
3. It should be borne in mind that since the term 'artist', at the time, was not used in its present-day sense, writers had recourse to adjectival expressions such as 'excellent workers' or 'illustrious craftsmen'. The accepted modern meaning of the term in French dates from the *Encyclopédie*, in other words from around the same period that the exceptional status of the artist and the notion of "genius" were being linked together.
4. Antoine Schnapper, "Antoine Coypel: la galerie d'Énée au Palais-Royal", in *Revue de l'art*, n° 5, 1969, pp. 33-42. Completed between 1702-1705 and 1714-1718, it was demolished in 1781 (remnants in Montpellier and Arras).
5. Pierre Rosenberg, "Le concours de 1727", in *Revue de l'art*, n° 37, 1977, pp. 29-42.
6. Jean Locquin chose this date for his *La peinture d'histoire en France de 1747 à 1785* (1912), 1978.
7. I.e. involving anecdotal or amatory themes similar to those dealt with by the poet Anacreon and his imitators in odes such as *Cupid Stung by a Bee*, for instance.
8. P. Rosenberg, in the catalogue *Carle Van Loo, Premier peintre du roi*, Nice, Clermont-Ferrand, Nancy, 1977, p. 14.
9. Quoted in Delécluze, *David, son école et son temps*, p. 421.

2. Rococo Imagination and Elegance

To our eyes, 18th-century France, despite repeated wars (The Wars of the Spanish, Polish and Austrian Successions), food shortages, financial crises (the collapse of Law's 'system') and ultimately revolution, is forever associated with a sparkling culture which, against all the odds, maintained its ascendancy throughout Europe. Nothing could perturb the splendour of the court or wealthy financial circles.

There was no hint of the impending irruption of a new art based largely on what were considered minor genres, nothing at all, except perhaps the prevalent spirit of artistic freedom – or, according to some historians,[1] even anarchy. In a remarkable feat of adaptability, the generation of 1700-1720, whose universe was still circumscribed by structures put in place by Colbert and who continued to uphold the noble genres and the Italian model, embraced new trends, buttressed by the contemporary vogue for Rubens and Flemish painting. The work of an artist like François Le Moyne, less austere than that of Le Brun, reconciled the constraints of the grand manner with charm and the desire to captivate. The arts acquired a new freedom, borderlines between traditional genres became blurred, mythology was treated in an increasingly lighter vein, and even historical scenes occasionally included unexpected graceful notes. The decorative arts assumed a key status and vied with each other in the refined presentation of a way of life where art had become ornament.

Although honour and glory had been the predominant values in the age of Louis XIV, love lay at the heart of social life and helped mitigate the stricter aspects of the ideal. It was not only the influence of the regent, followed by Louis XV – both partial to pleasure – that can explain this artistic shift towards informality, extraneous decoration and refinement. Polite society developed a passion for the arts; connoisseurs like Pierre Crozat or La Live de Jully built up diversified collections of works in which drawings and sketches featured prominently, attesting to the new taste for graphic arts; Mme de Pompadour herself took up engraving. Society life took over the artistic milieu and ended up becoming one of its subject-matters.

Such artificiality is no doubt the central characteristic of the 18th century; based on the high esteem in which culture and aesthetic appreciation were held, it would linger on into neo-classicism despite a return to outward severity. This freedom and this affectation, which can be labelled rococo, were more conducive to profound artistic expression than the moralizing conventions which marked the last thirty-odd years of the century: a 'fête galante' was just as meaningful as any scene from tragic drama. Finally, this freedom found expression in a love of colour and in more imaginative design and drawing. The quivering, fragmented, swirling touch of Fragonard, even though regarded by his contemporaries[2] as 'daubs', represents supreme pictorial achievement and love of art.

Watteau and the 'fête galante'

Although it is true that Jean-Antoine Watteau (1684-1721) did not invent the theme which he was to make his own – before him, Claude Gillot (1673-1722), for a while Watteau's master, had portrayed Italian comedians

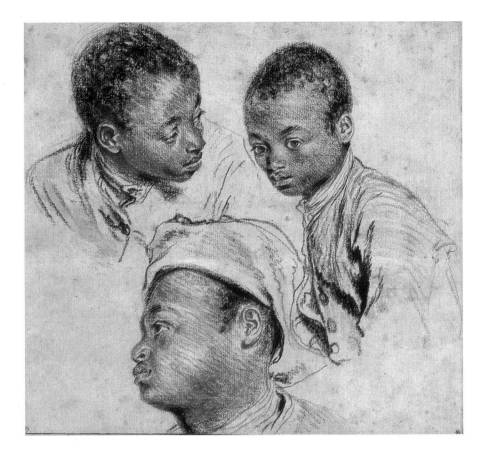

| Jean-Antoine Watteau
**THREE STUDIES OF THE HEAD
OF A YOUNG NEGRO**

1716 (?), black chalk and
red chalk highlights, grey wash
on buff-coloured paper,
24.4 x 27.1 cm
(9 1/2 x 10 5/8 in).
Musée du Louvre,
Département des arts graphiques, Paris.

**This work came from
the collection of Mariette,
a dealer and art historian
who met Watteau at Crozat's
home.**

home from exile and fairground theatre scenes – he turned it into such a personal mode of expression that the academic system itself received him as a 'fête galante painter', an entirely new category which was to prove as universal and profound in its implications as history painting. His originality had been acknowledged as early as July 1712, while Louis XIV was still on the throne. Seeking the means to visit Rome, Watteau had applied to the Academy and was straight away accepted on the recommendation of Charles de La Fosse (1636-1716) who was impressed by his genius. This influential painter, a champion of colour and Rubens like his friend Roger de Piles, introduced Watteau to Crozat with whom he lodged. Watteau was asked to submit a reception piece and, in a highly exceptional move, the theme was left to his own discretion: five years later, the result was *The Pilgrimage to the Island of Cythera*. There could be no better demonstration of the open-minded policy of an Academy capable of integrating innovators without forsaking its ideals or its function.

Up until then the young painter, who had left Valenciennes ten years earlier, had been restricted to hack work which he attempted to break away from by entering the Academy competition in 1709. Once accepted, his personal 'manner' began to blossom. *Partie carrée*, probably painted in 1713, is illustrative of this period and captures the ambiguity of Watteau's art. While the conversation depicted is a prelude to love (Cupid's statue merges into the landscape), its tone is restrained, even melancholic, blending in with the twilight which casts a shimmering glow on the satin costumes. On this occasion

Pages 58-59
Claude Gillot
THE TOMB OF MASTER ANDREW
1716-1717 (?), oil on canvas,
127 x 160 cm (50 x 63 in).
Musée du Louvre, Paris.

The scene was inspired by
a traditional farce in which
Mezzetin and Scaramouch fight
over a bottle while Harlequin,
acting as referee, takes
advantage of the dispute
to drink the contents.

Pierrot, who reappears in *Pierrot* (or *Gilles*) in the Louvre, or as the central figure in *Italian Players*, is portrayed from behind. Could this be the symbolic character into which so many artists and writers have projected themselves down the ages? Many of Watteau's works are variations on the theme depicted in *Assemblée dans un parc* (1716-1717): couples or groups of men and women, disguised aristocrats and actors who mingle together playing music, conversing, dancing and flirting in the shade of tall trees which are often the most prominent compositional feature. Besides, these variations are based on a technique which Watteau, who preferred drawing to the constraints of paint, had perfected: according to Caylus, he kept his drawings of figures in large bound albums and resorted to them when needed, starting his compositions by filling in the background. The figures thus reappear from one painting to the next, reinforcing the unity of an œuvre produced over a dozen years. But the overall harmony derives from the pictorial qualities themselves: the shimmering light, water and costumes are expressed by equally shimmering touch and tonality. Until then, perhaps only

Jean-Antoine Watteau
PARTIE CARRÉE
1713 (?), oil on canvas,
49.5 x 63 cm
(19 1/2 x 24 3/4 in).
The Fine Arts Museum, San Francisco.

Jean-Antoine Watteau,
PIERROT or **GILLES**
C. 1718, oil on canvas,
184.5 x 149.5 cm
(72 3/4 x 58 3/4 in).
Musée du Louvre, Paris.

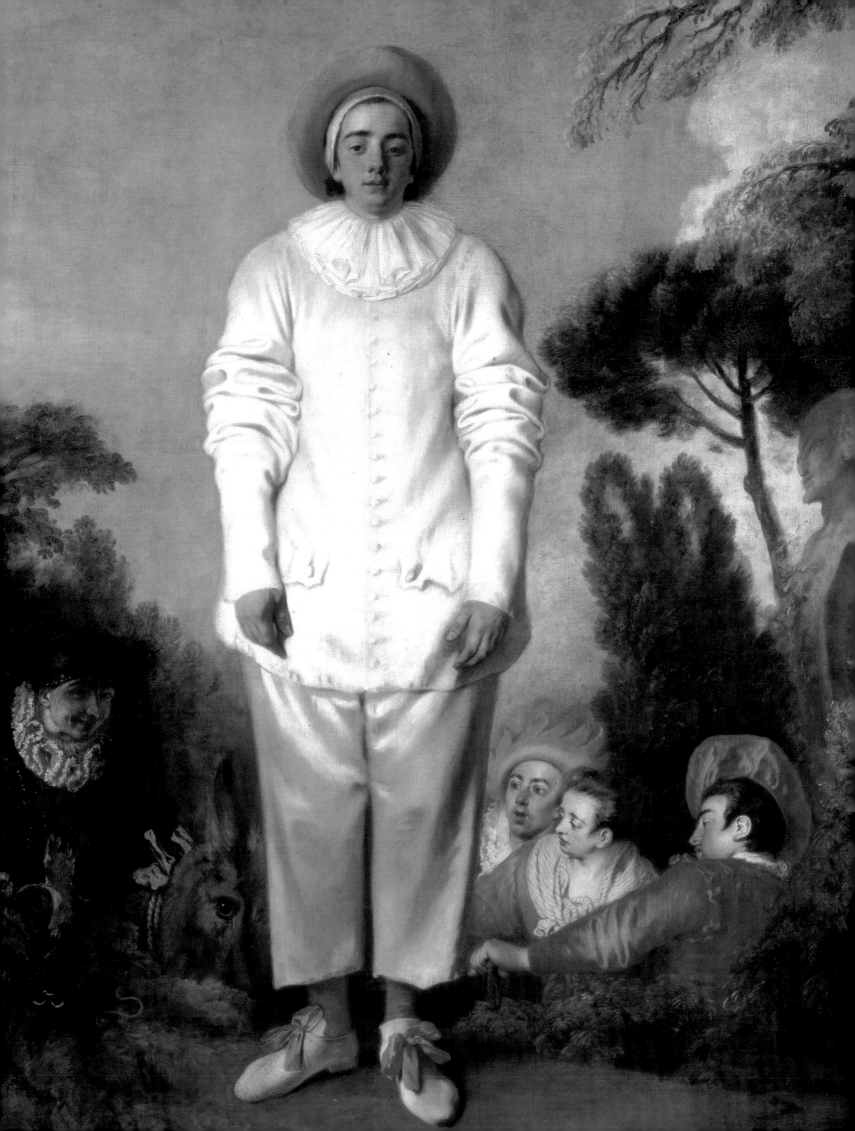

Jean-Antoine Watteau |
ITALIAN PLAYERS
1719-1720 (?),
oil on canvas,
63.8 x 76.2 cm
(25 1/8 x 30 in).
National Gallery of Art, Washington.

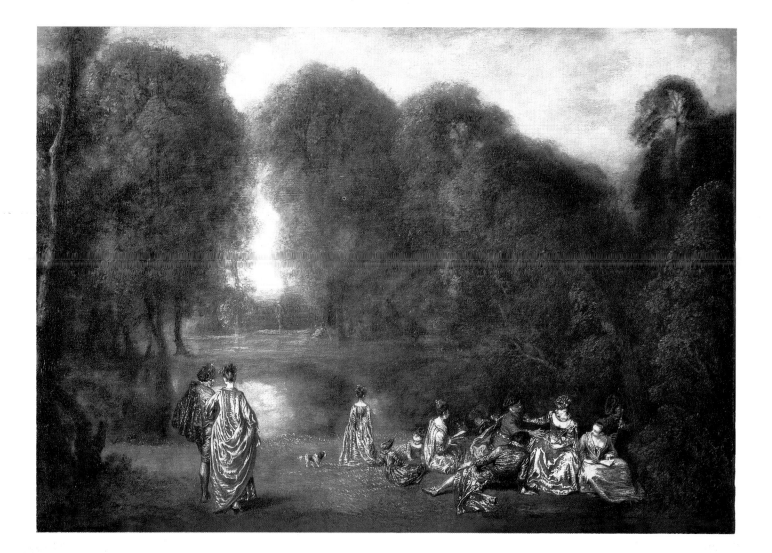

Correggio had brought such sensuality to his brushstroke; *Nymph and Satyr* – sometimes more properly called *Jupiter and Antiope*, like a Correggio painting bearing the same title at that time in the royal collections – immediately springs to mind.

Beyond the conventions of the 'fête galante' genre – which seem to revive the style of Honoré d'Urfé's pastoral romances (as Horace Walpole, for instance, suggested) – the relation which Watteau's works established between sensuality and the natural environment introduced a new sensibility which was to blossom in the subsequent decades, a new attention to nature of which, as contemporaries had already noted, the painter was an "accurate observer"(to quote his obituary in the *Mercure*). This is extremely important, since his figures – with the the exception of *Pierrot* which was probably a shop-sign – always appear in the distance, hence their more enigmatic (and thus more profound) character than those of Boucher, and a psychological dimension that is hinted at rather than analysed. The setting itself is part of the expression. Parkland alleys, ponds and fountains (the charm of which captivated Verlaine and inspired *Fêtes galantes* in which the poet sketched out his own emotional landscapes and fleeting imagery), statues surrounded by greenery, skies that change with the time of day but are always misty, filtering the soft,

| Jean-Antoine Watteau
ASSEMBLÉE DANS UN PARC
1716-1717 (?),
oil on wood,
32.4 x 46.4 cm
(12 3/4 x 18 1/4 in).
Musée du Louvre, Paris.

glowing light which spreads over people and objects, complicatedly-arranged groups where receding perspectives are captured by repeated tones, all these constituted the elements with which the artist composed his work (the musical dimension of Watteau's painting has often been emphasized), leading the spectator's eye to the distant horizons of an unfinished dream. Not all his compositions achieved the refinement and complexity of *The Pilgrimage to the Island of Cythera*, but the latter work, in its twin versions – one in Paris, the other in Berlin – marked a supreme accomplishment.

Although painted in eight months, the picture offers a thematic and visual synthesis of Watteau's most productive years. In fact, in 1709, he had already painted an *Island of Cythera* (Frankfurt, Städelsches Kunstinstitut). In the *Pilgrimage*, the composition is organized as an arabesque (with a larger scroll of cherubs in the Berlin version) and is based on a series of paired figures forming a winding chain in which the actions of each pair of pilgrims are seemingly broken down into individual episodes. As the perspective leads the spectator to read the composition from left to right, it does seem to be the case, as Michael Levey suggested in 1961, that the lovers are about to sail away from Cythera, the island of Venus. This interpretation contradicts the traditional view which has taken the picture to represent *The Embarkation for*

Jean-Antoine Watteau
NYMPH AND SATYR
C. 1715,
oil on oval canvas,
73.5 x 107.5 cm
(28 7/8 x 42 3/8 in).
Musée du Louvre, Paris.

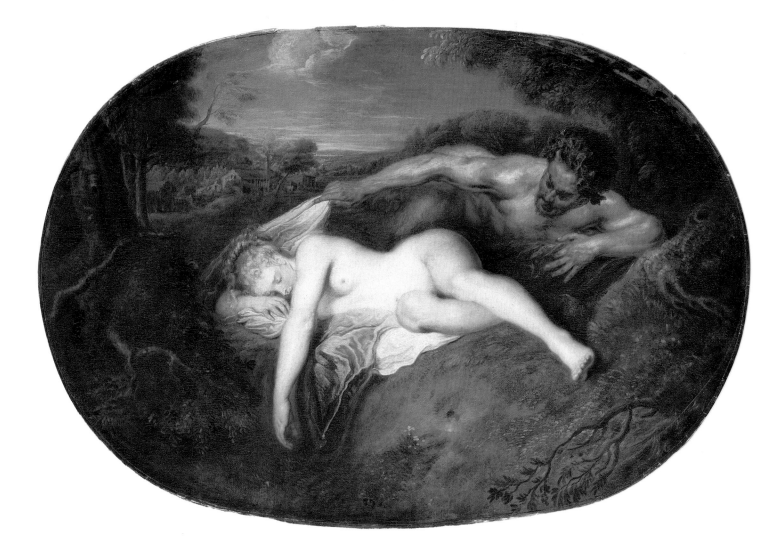

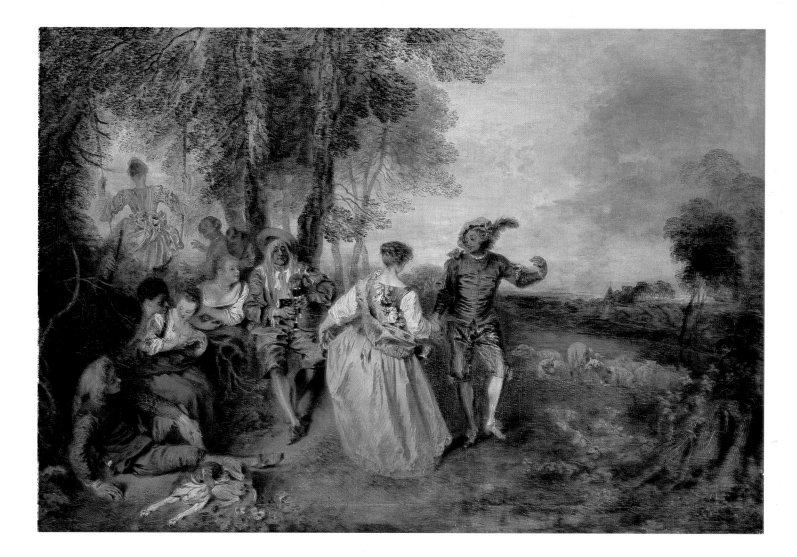

Jean-Antoine Watteau |
THE SHEPHERDS
C. 1717, oil on canvas,
56 x 81 cm (22 x 31 7/8 in).
Schloss Charlottenburg, Berlin.

| Jean-Antoine Watteau
L'INDIFFÉRENT
1717 (?), oil on wood,
25.5 x 18.7 cm
(10 x 18 3/4 in).
| Musée du Louvre, Paris.

Paul Claudel described
the figure in the painting
as an "iridescent messenger,
this harbinger of dawn",
"half-fawn, half-bird".

Cythera, as still attested by the title of the Berlin version, although the latter is an even more explicit expression of the theme of consummated love. Certainly, in the new interpretation, the suggestion of desire, enticement and expectation disappears, but it is replaced by the melancholy of departure: the picture's richness also derives from its ambiguity. In the painting in the Louvre, the landscape features distant, blue-tinted horizons in the style of Leonardo da Vinci which underline the strangeness, the imaginary dimension of this charming setting where Nature rules. A certain iconographical vagueness, the presence of mythological boatmen, the harmonious silvery tones and the softest of touches all contribute to the more poetic quality of this version.

The Berlin version, no doubt painted for Jean de Jullienne (he was to bring out a series of engravings after works by Watteau which added considerably to the artist's reputation), features the same tempo and comparable tonalities but different groups of figures: one additional couple is shown picking roses, as in *Amusements champêtres,* while in the foreground another couple sits next to discarded weapons (Mars). The statue of Venus, shown mutilated in the Paris version, is here at the centre of a theatrical scene in which the goddess is apparently confiscating Cupid's arrows. Although the accumulation of extra details renders it more explicit, the Berlin work is by no means itself unambiguous.

Jean-Antoine Watteau |
LES PLAISIRS DU BAL
1716-1717 (?),
oil on canvas,
52.6 x 65.4 cm
(20 3/4 x 25 3/4 in).
Dulwich Picture Gallery, Dulwich.

Pages 70-71 |
Jean-Antoine Watteau |
L'ENSEIGNE DE GERSAINT
(THE SHOP-SIGN OF GERSAINT)
1720-1721, oil on canvas,
166 x 306 cm
(65 3/8 x 1201/2 in).
Schloss Charlottenburg, Berlin.

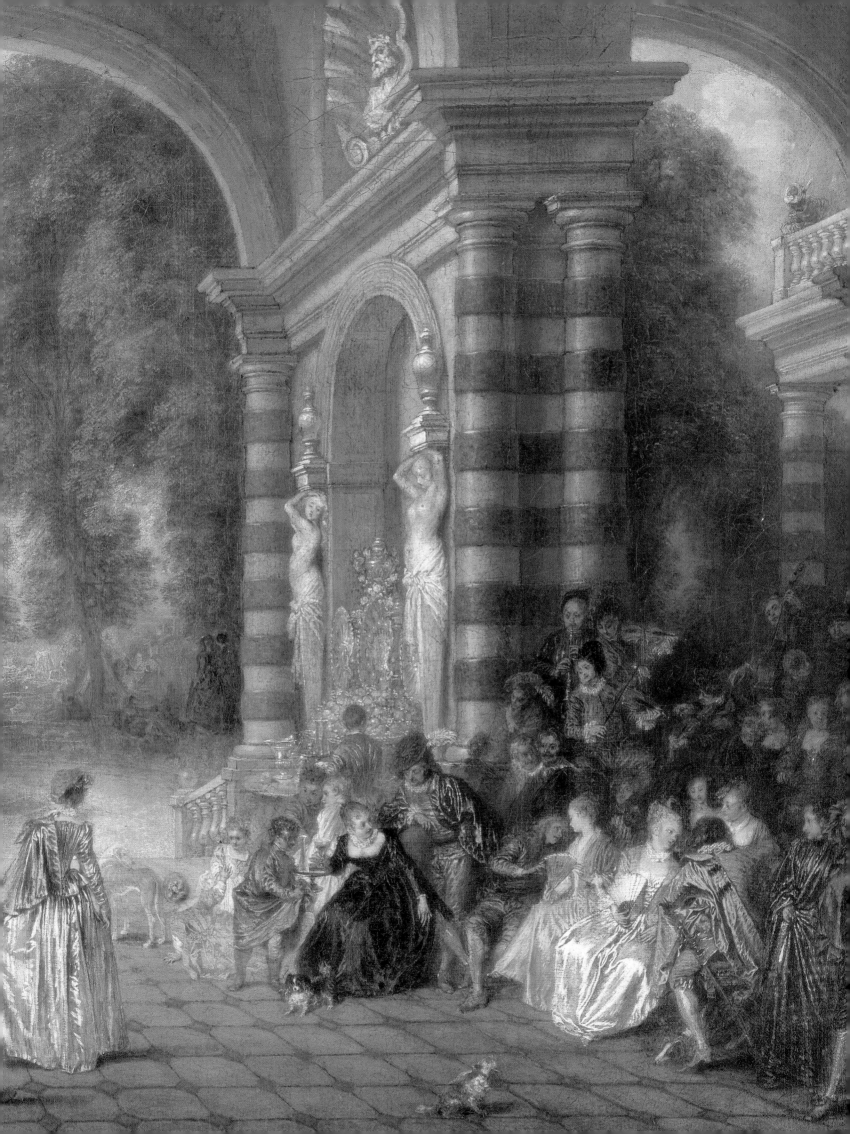

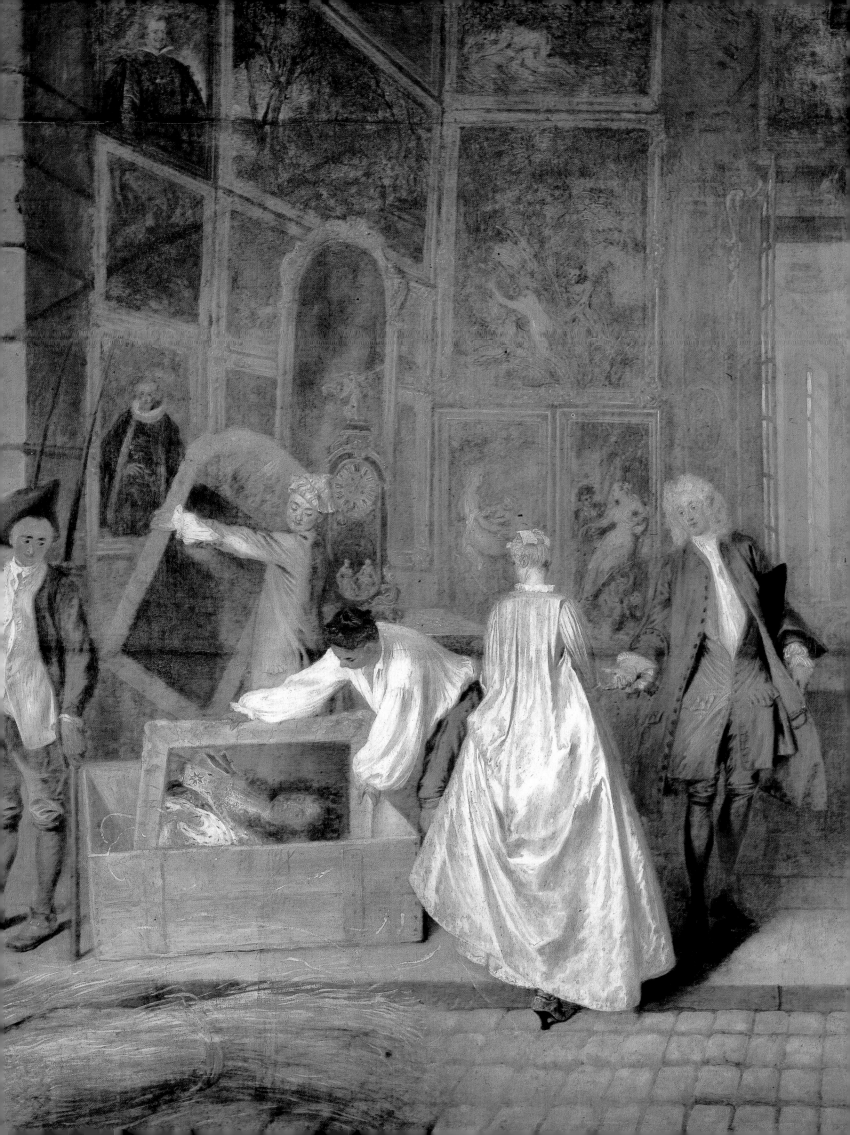

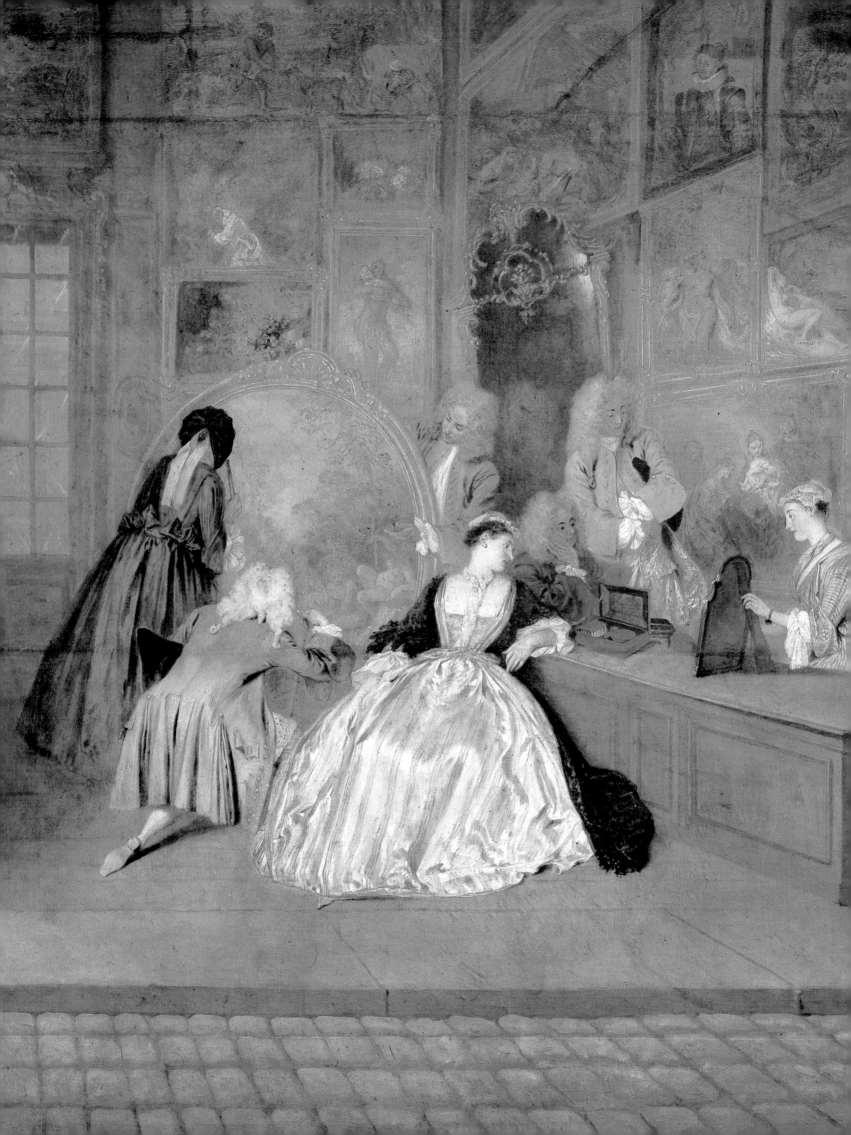

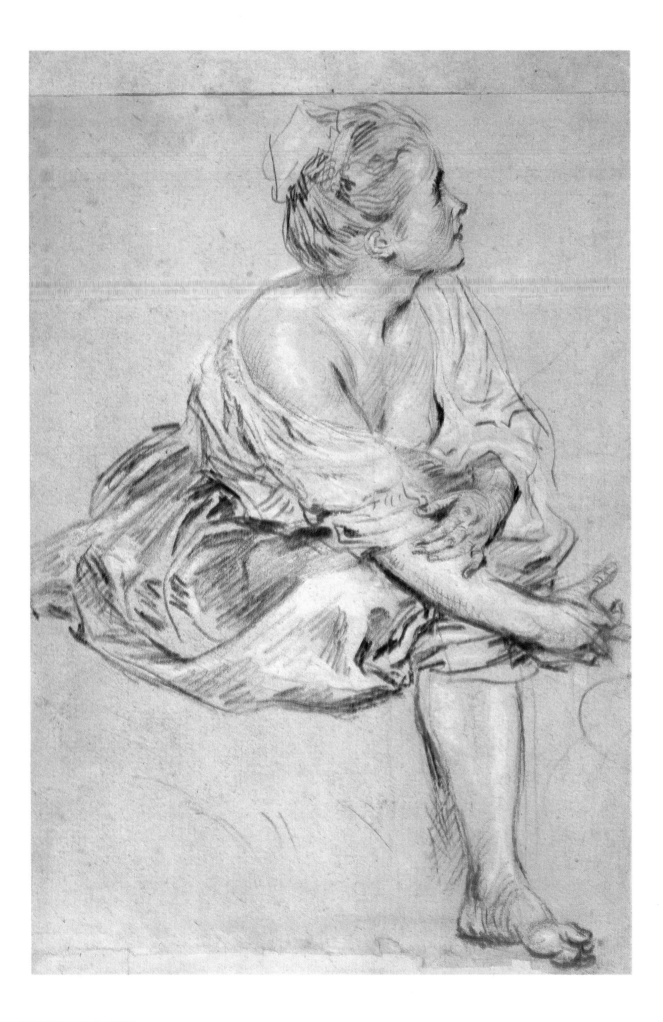

The suggestive titles, rarely proposed by Watteau himself, have more than a little contributed to the fascination his works exercised. Such has been the case with *La Finette* and its pendant *L'indifférent* – the graceful, mysterious figure of a dancer which inspired the youthful Proust with the title of one of his short stories in 1896 – or with *Pierrot* (or *Gilles*). Nowadays, when the allusions to Watteau's contemporaries, his clients, or famous actors of the day are lost on us, the pictures have acquired a timeless aspect, and are charged with a fantastic, dreamlike quality which heightens their appeal. Thus, in the enigmatic *Les plaisirs du bal*, the modern spectator merely surrenders to the charmingly subtle distribution of tonalities and light, to the attitudes, and to the echoes between the architecture, Nature and the protagonists. It is possible to imagine a Marivaux-style plot in each of Watteau's variations on the 'fête galante', to follow the vagaries of love and time, and to think of the protagonists – along with Verlaine in his poem *Clair de lune* – that

> "Tout en chantant sur le mode mineur
> L'amour vainqueur et la vie opportune,
> Ils n'ont pas l'air de croire à leur bonheur."
> [*While singing in the minor mode*
> *Of victorious love and auspicious life*
> *They do not seem to believe in their happiness.*]

The world of Watteau, that "prince of courtly painters" in the words of the English critic Walter Pater who devoted one of his *Imaginary Portraits* (1887) to the artist, opens up to the imagination of each and every one.

It is nonetheless paradoxical that this aestheticism, which might well have seemed restricted to the theme of the 'fête galante', could be applied with extraordinary skill to a virtuoso, swiftly-executed genre scene, *L'enseigne de Gersaint* (*The Shop-Sign of Gersaint*). The setting is a shop where the hanging paintings illustrate the entire range of genres – from kneeling saint to mythological nude, from still life to formal portrait with ruff collar. And in the shop are to be found the same couples, the same graceful gestures, the same tinted, misty atmosphere with figures absorbed in contemplation. In this unexpected context, employing a blend of illusionistic and realistic effects, Watteau succeeds in creating the equivalent of those traditional compositions in which collections of paintings were displayed. Here, however, the emphasis shifts from the 'painting within the painting' (the canvases themselves, but also the explicit references, like the dog which is taken from Rubens's *Coronation of Marie de Médicis*, at that time in the Luxembourg Palace) towards the spectator. Right up to his final work, Watteau continued to pursue this intermingling of art and humanity, of informality and refinement, of the loftiest aspirations and the merely commonplace.

Watteau led a fairly unsettled life (he never had a personal residence) and his teaching activities must have been limited, although his fellow native of Valenciennes, Jean-Baptiste Pater (1695-1736), is sometimes considered to have been his pupil; on the other hand, he had many followers. Besides Pater, who profited from the popular vogue for 'fête galante' themes, there was

| Jean-Antoine Watteau
YOUNG WOMAN SEATED
1715-1716, black, red and white chalk on cream paper, 25.5 x 17.2 cm (10 3/8 x 6 3/4 in). The Pierpont Morgan Library, New York.

| Nicolas Lancret

WINTER

| 1738, oil on canvas,
| 69 x 89 cm (27 1/8 x 35 in).

Musée du Louvre, Paris.

**This painting forms part of a fine series
depicting the Four Seasons, variations
on the 'fête galante' theme.**

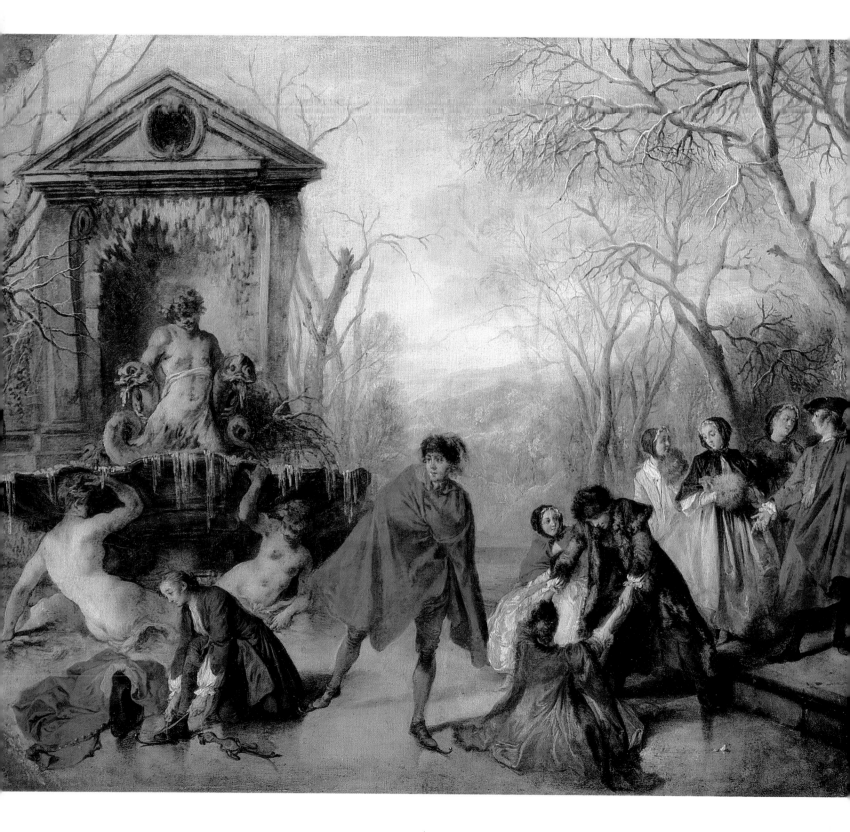

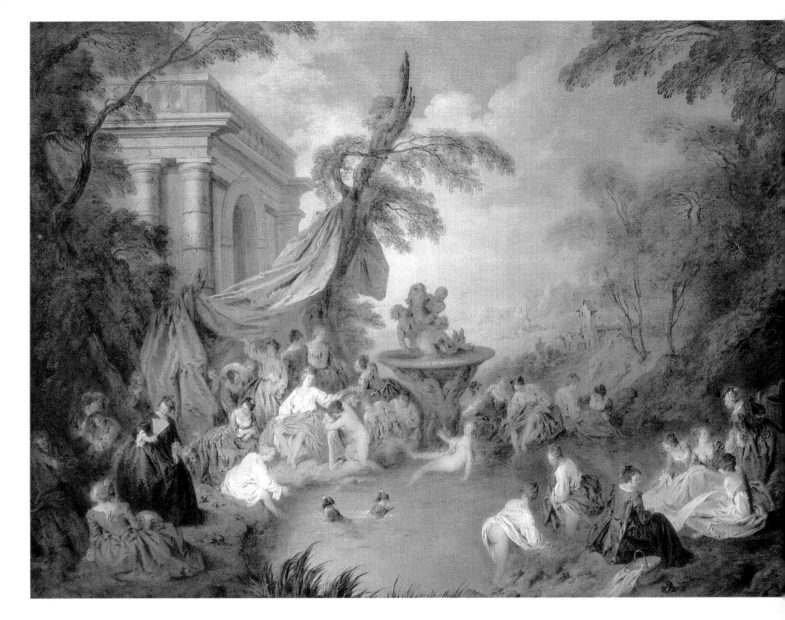

Jean-Baptiste Pater |
YOUNG GIRLS BATHING
C. 1730, oil on canvas,
102 x 143 cm
(40 1/8 x 56 1/4 in).
Schloss Charlottenburg, Berlin.

| Jean-Baptiste Pater
WOMEN BATHING
After 1725, oil on canvas,
50.5 x 61.5 cm
(19 7/8 x 24 1/4 in).
| Musée des Beaux-Arts, Angers.

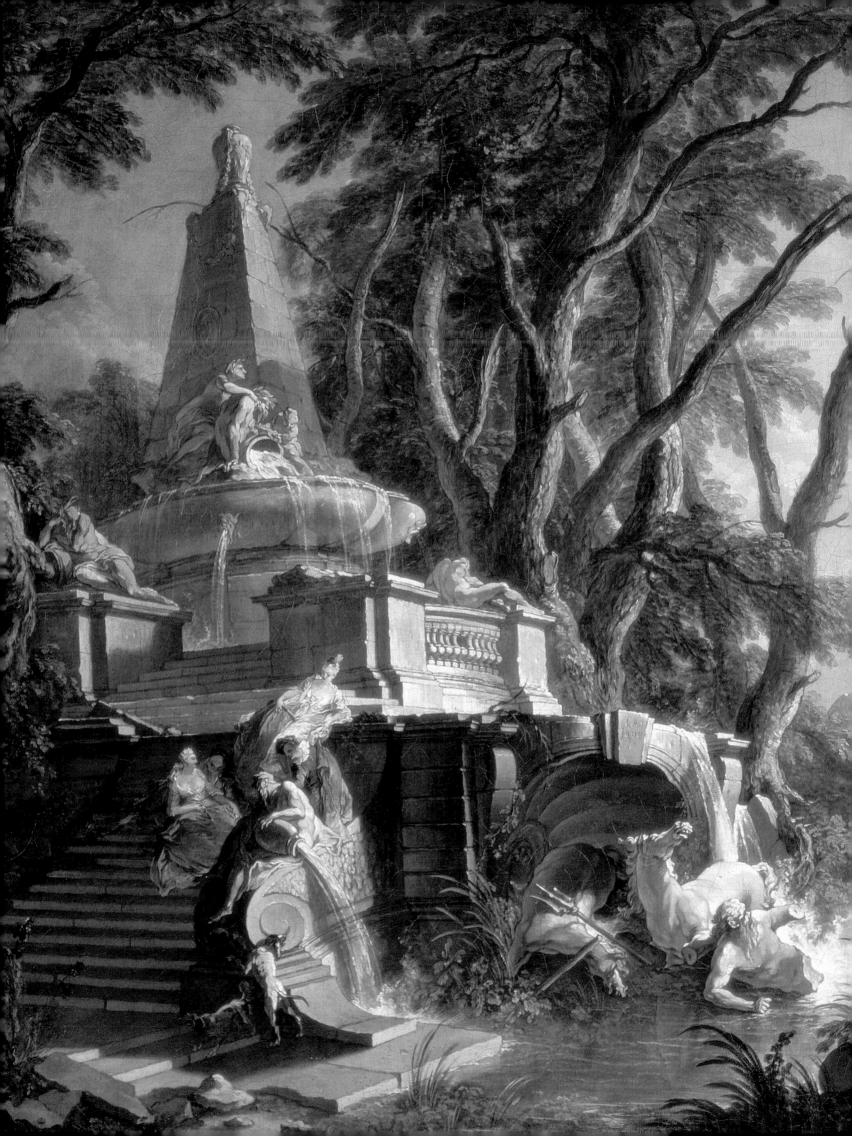

Nicolas Lancret (1690-1737) who also painted allegorical cycles. Pater and Lancret often achieved Watteau's lightness of touch, but never matched his profundity. It is nevertheless significant that Frederick the Great's painting collection included not only twenty-six Watteaus (or at least listed as such) but also thirty-two Lancrets and thirty-one Paters (certainly more easily obtainable). The vogue died out more swiftly in France. By 1745, Dezallier d'Argenville was describing Watteau's works as 'bambochades'.[3] And it should not be forgotten that prior to the fabulous La Caze bequest in 1869, *The Pilgrimage to the Island of Cythera* was the only Watteau in the Louvre collections!

From pastoral to libertine

The artists of the generation which followed on from Watteau also excelled in minor genres and in works which were indisputably decorative in character. Mythology, treated in an increasingly 'galant' vein, tended to the pastoral. The nude female figure featured more commonly, often included on some mythological pretext, but more and more frequently portrayed for its own sake. The visual corollaries of this shift towards a light-hearted, charming style were a brighter palette and a harmonious blend of blue, white and flesh tones, heightened by the occasional red, sensual touch. This tendency prevailed in the painting of the period 1720-1750, alongside the blossoming of rococo decoration, the beginnings of which can be detected in *The Pilgrimage to the Island of Cythera* (the sinuous line of figures and the tortoiseshell motifs of the boat in the Berlin version) as well as in the architecture and decors of Gilles-Marie Oppenord (1672-1742), employed by the Regent, or of Juste-Aurèle Meissonnier (1695-1750), the goldsmith and designer. Painting and decoration were intimately related, the frames and formats of works were moulded according to the whims of designers to suit the vogue for oval forms and fretwork contours. Moreover, an artist like Jacques de Lajoue (1686-1761) was capable of producing both decorative motifs in the purest

| Jacques de Lajoue
Paysage composé: la rivière
[Imaginary Landscape: the River]
Exhibited at the 1737 Salon,
oil on canvas, 81 x 101 cm
(31 7/8 x 39 3/4 in).
Musée du Louvre, Paris.

Carle Van Loo |
Venus and Cupid
Before 1743, black chalk,
23 x 28.5 cm (9 x 11 1/4 in).
Musée du Louvre, Département
des arts graphiques, Paris.

The design and composition
are similar to works executed
for Hôtel de Soubise.

rococo style and paintings such as his *Paysage composé: la rivière* (1737). The figures portrayed in the works by this specialist in architectural views have sometimes been attributed to other artists.

When the Duc de Rohan had Hôtel de Soubise (now occupied by the French National Archives) converted by Germain Boffrand (1667-1754) into a fashionable rococo residence, besides the panelling and mirrors which featured prominently in the new decorative scheme, a group of some of the most representative artists of their generation were commissioned in 1737 to paint medallions and overdoors. The artists involved were mainly pupils of Jean-Baptiste Van Loo (1684-1745) and Le Moyne. Charles-Joseph Natoire (1700-1777) embellished the oval reception room with a cycle depicting the legend of Psyche. Carle Van Loo, Jean Restout, Pierre-Charles Trémolières (1703-1739) and François Boucher produced works such as *Hebe and Hercules, Venus, Castor and Pollux, Mercury Instructing Cupid*, etc. which, although often intended to be allegorical, were nevertheless derived from amorous mythology. There is a perceptible changeover towards an increasingly elegant style of painting and towards the pastoral as represented by Boucher. The latter artist also painted a landscape in which the French countryside rather than the Italian campagna had become the pictorial reference. Boucher (1703-1770) was familiar with Watteau, many of whose drawings he engraved for Julienne, but was not one of his followers. His relatively lengthy apprenticeship, including years of engraving and a journey to Italy in

| François Boucher
DIANA BATHING
Exhibited at the 1742
Salon, oil on canvas,
56 x 73 cm
(22 x 28 3/4 in).
| Musée du Louvre, Paris.

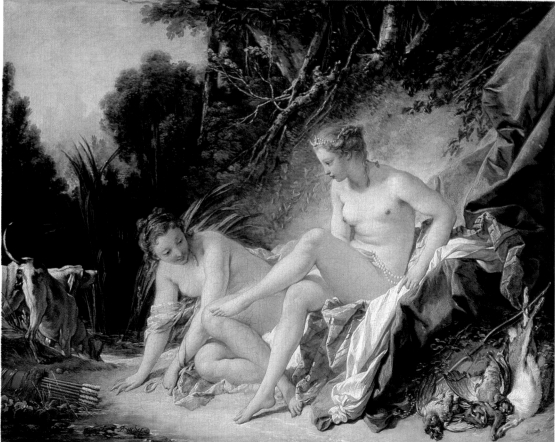

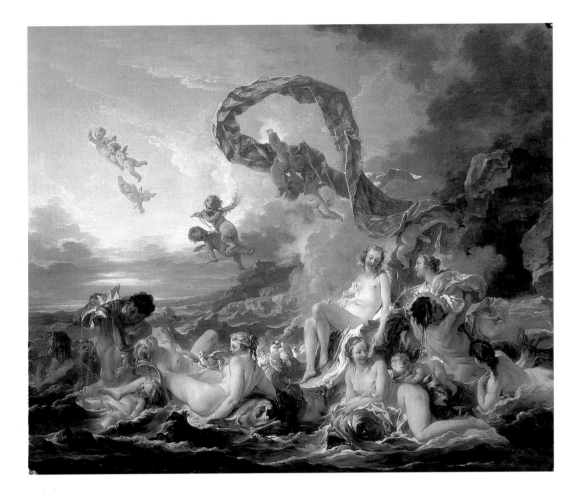

1728-1730, was completed in 1731 when he was accepted as a 'history painter', a testimony to his status. Moreover, his Academy reception piece was a *Rinaldo and Armida* in the tradition of de Troy. However, as such literary themes required conventions and a formal decor he swiftly abandoned them to seek his direction in pastoral and mythological subjects. Boucher carved out a personal style in both his themes and his technique, freer than that of Le Moyne whose bright colour scheme he nevertheless retained. His taste for touch may have derived from Italian (Sebastiano Ricci, to whom his *Gideon's Sacrifice* was long attributed) or Flemish examples (his *Hercules and Omphale* displays a richness of colour and a verve comparable to Rubens).

Sensuality, heightened by an arabesque, subtly asymmetrical composition and an extremely pronounced touch, shone forth in the very first work that can be dated with any certainty – *Venus Requesting Arms for Aeneas from Vulcan* (1732, Louvre). It reappeared in his most famous mythological paintings, *Aurora and Cephalus* (1733, Nancy), *The Triumph of Venus* (1740), *Diana Bathing* (1742), and *Rising of the Sun* and *Setting of the Sun* (1753, bought by Mme de Pompadour and today in the Wallace Collection) where the female nudes attain a rare delicate grace, their pale flesh and fair hair enveloped in folds, drapes, pearls, ribbons, waves or spray which provide emphasis like contrasting highlights. Everything is expressed in a harmonious blend of blues, pinks and whites, while a few lively touches add a cheerful note to the traditional palette. This poetic universe was shortly to be deemed frivolous

François Boucher |
THE TRIUMPH OF VENUS
1740, oil on canvas,
130 x 162 cm
(51 1/8 x 63 3/4 in).
Nationalmuseum, Stockholm. |

Pages 80-81 |
François Boucher |
**THE AUDIENCE OF
THE CHINESE EMPEROR**
1742, oil on canvas, |
41.5 x 64.5 cm
(16 3/8 x 25 3/8 in).
Musée des Beaux-Arts, Besançon. |

This was a project
for a tapestry on
an exotic theme,
common in
decorative schemes
of the day.

Madame de Pompadour

| Carle Van Loo
DRUNKEN SILENUS
1747, oil on canvas,
164 x 195 cm
(64 5/8 x 76 3/4 in).
Musée des Beaux-Arts, Nancy.

Jeanne-Antoinette Poisson, Marquise de Pompadour (1721-1764), born into the milieu of the farmers-general or royal tax collectors, became the king's mistress in 1745. For a brief period she came to embody rococo taste, although her cardinal influence on arts and literature has sometimes been misunderstood. Boucher was indeed her favourite painter and for the pupils of David who coined the expression "Van Loo, Pompadour, Rococo" her name became synonymous with rococo art. But it may also justifiably be associated with the reaction against rococo which took place around 1750. In December 1745, her uncle, Lenormant de Tournehem, was appointed Director of Buildings and, along with Charles Coypel, championed the cause of the 'grand manner', a link in the evolution towards the classical revival. Mme de Pompadour intended to have her own brother, the future Marquis de Marigny, appointed as Tournehem's eventual successor, and sent him to complete his training in Italy (1749-1751) along with Soufflot, Cochin and Abbé Leblanc. The introduction of the new taste is traditionally dated from this Italian journey.

" *Madame, you love the Arts, you cultivate them*
as a matter of taste and protect them
with discernment, thus doing you pave the way
for the high degree of perfection
which they are so close to attaining…"
Dedication by Du Perron in his
Discourse on Painting and Architecture, 1758.

Jean-Baptiste Greuze |
YOUNG SHEPHERD TEMPTING FATE TO SEE
IF HE IS LOVED BY HIS SHEPHERDESS
Exhibited at the 1761 Salon,
oil on canvas, 72.5 x 59.5 cm
(28 1/2 x 23 3/8 in).
Musée du Petit-Palais, Paris.

Commissioned by Marigny
for Mme de Pompadour's
apartments at Versailles,
with a pendant, *Simplicity.*

François Boucher |
PORTRAIT OF
MADAME DE POMPADOUR
1756, oil on canvas,
201 x 157 cm
(79 1/8 x 61 7/8 in).
Alte Pinakothek, Munich.

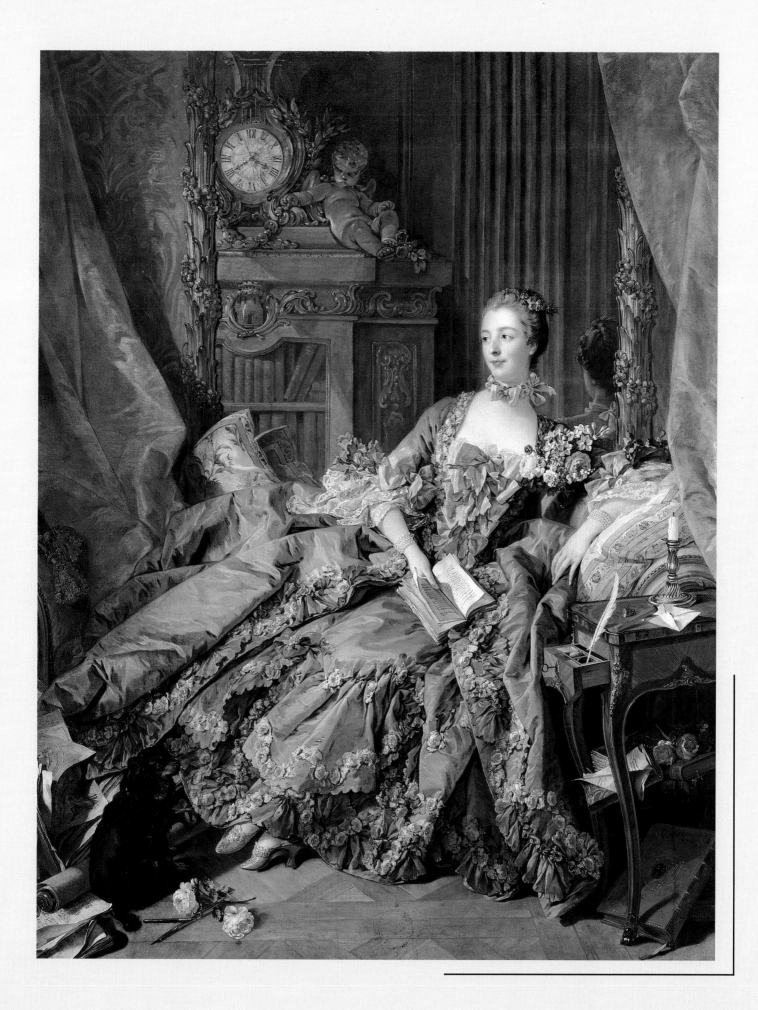

| François Boucher
THE WATERMILL
| 1751, oil on canvas,
66 x 84.5 cm
(26 x 33 1/4 in).
| Musée du Louvre, Paris.

and artificial. It is indeed an improbable world, but, as in Watteau's paintings, one embodying a personal hymn to beauty which Boucher expressed in a format adapted to smaller, more intimate apartments. It is a far cry from the grandiose mythological scenes in the Salon d'Hercule.

Boucher might well have become one of the greatest masters of the genre scene. Paintings like *Breakfast* (1739) and the marvellous preliminary drawing of the young man serving coffee (Art Institute of Chicago), *Lady Fastening her Garter* (1742), *Woman on a Sofa* (1743) and *La marchande de modes* (1746) are sheer masterpieces, meticulously rendered in harmonious tones, and usually featuring the artist's wife and family as models. Although femininity indeed remains at the heart of the seductive process, it is associated with an intimacy which contrasts with the libertine vein represented by the two *Odalisques* – the dark-haired version (1745) which provoked Diderot to claim that Boucher was "prostituting his own wife", and the fair-haired one (1752) which was an opportunity of evoking Louis XV's extra-marital loves. It was the latter type of nude, painted with no mythological trappings and commissioned for the private collections of connoisseurs (such as Superintendent Marigny, who owned a *Young Woman Reclining on her Stomach* by Boucher) which earned the painter his notoriety, a reputation exaggerated even further by 19th-century historians.

This manner of rendering art informal, even in mythological themes, is found particularly in the pastoral, a genre which stands between the senti-

| François Boucher
BREAKFAST
| 1739, oil on canvas,
81.5 x 65.5 cm
(32 x 25 3/4 in).
| Musée du Louvre, Paris.

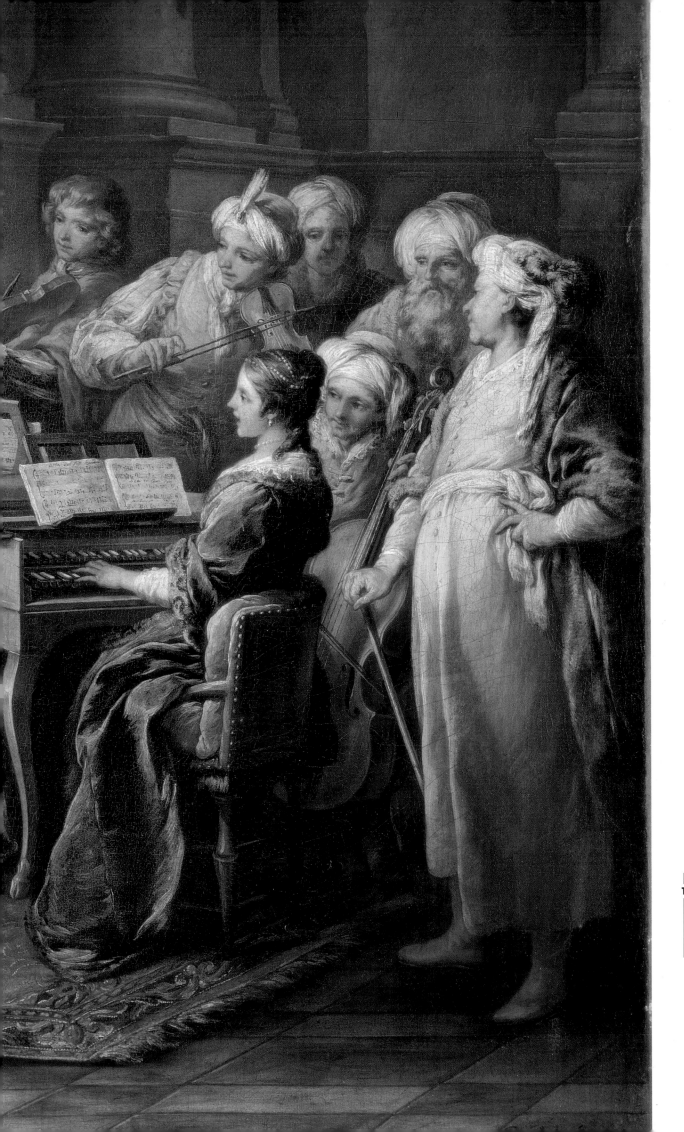

Carle Van Loo
THE SULTAN'S CONCERT
1737, oil on canvas,
74 x 92 cm
(29 1/8 x 36 1/4 in).
The Wallace Collection, London.

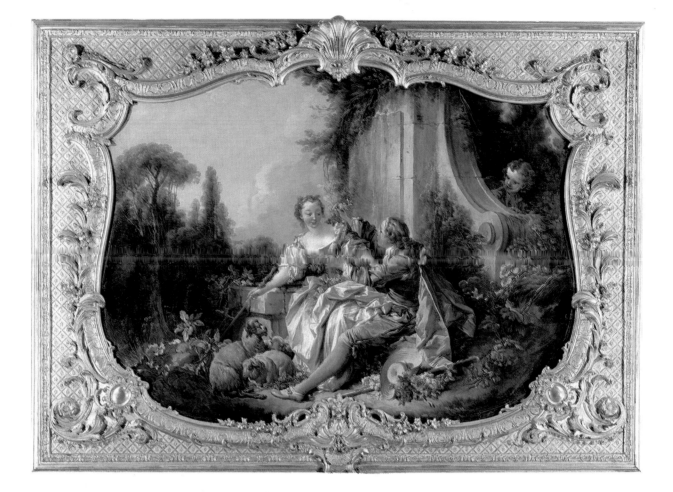

| François Boucher
THE AMOROUS SHEPHERD
1738, oil on canvas,
147 x 198 cm
(57 7/8 x 78 in).
| Hôtel de Soubise, Paris.

Overdoor, engraved
by A. Laurent in 1742
and reproduced in
porcelain in 1752.

mental idyll and the simple overdoor landscape, and of which Boucher is the veritable creator. This type of rural painting also paved the way for another genre, at the time relatively uncommon, the landscape. Boucher painted some fine examples of the latter, thus demonstrating that the artificiality with which he has been reproached did not exclude a genuine feel for nature. *The Amorous Shepherd* (1738), painted for Hôtel de Soubise, sketched out an artistic inspiration which was to develop hand in hand with the success of Charles Favart's Théâtre de la Foire, for which Boucher also designed costumes and sets. The comic operas of Favart (1710-1792), such as *Les amours de Bastien et Bastienne* and *Annette et Lubin*, also featured amorous intrigues involving sentimental shepherds and shepherdesses and indeed one of his dramas, produced in 1748, was actually entitled *Cythera Beseiged*.

Boucher occasionally returned to such themes in his tapestry designs. This was an important activity for the painter, along with that of designer for the Opera or for royal residences such as Versailles, Fontainebleau or Choisy. In 1734, Oudry, Director of the Beauvais Manufactory, commissioned him to execute a series of cartoons entitled *Fêtes italiennes*; he also painted a suite on *Psyche* (1741-1742), the extremely famous series of Chinese wall hangings (the preparatory sketches for which were exhibited at the 1742 Salon), and *Loves of the Gods*, a theme subsequently taken up again for the Gobelins. It was in the latter manufactory that the tapestries based on Mme de Pompadour's *Rising of the Sun* and *Setting of the Sun* were woven. Besides engravings and

reproductions of his themes onto porcelain or biscuit-ware (at the Vincennes, later Sèvres, manufactory), tapestry helped boost the reputation of Boucher, whose works were appreciated abroad, particularly in England and in Scandinavia: he was a friend of the Swedish ambassador in Paris, Count Tessin. The painter's name, like that of his patron, Mme de Pompadour, became synonymous with a certain French style; in a revealing overstatement, the Goncourt brothers wrote: "Boucher is one of those men who represent the taste of a century, who express, personify and embody it." They saw him as a typical example of an artist who devoted his talents to 'attractiveness'. Accordingly, when the reaction against rococo began in Boucher's own lifetime, he became the victim of much sarcasm. As early as 1745, he was disparagingly presented as a painter who excelled in "landscapes, bambochades, the grotesque and the ornamental in the style of Watteau".

Although his portrayal of women – a titillating blend of whites and pinks, amplified into nude figures who seem to epitomize the ideal of an era – may seem artificial, it is nevertheless painted from life. In 1765, Boucher wrote to his pupil Mannlich on the subject of models: "Among the several hundreds I've had undressed, I only ever came across one who possessed this high degree of beauty." This is far removed from the classical ideal which Vien's generation was attempting to launch into fashion at the time. Diderot, although he found many of Boucher's works appealing, claimed to be shocked by so many "breasts and buttocks" and helped to combat his influence on the grounds that it was over-affected.

In the 18th century, swiftly changing fashion brought difficulties for artists like Boucher, Nattier or Fragonard in the latter years of their respective careers, even although Boucher himself became the King's First Painter. A painter like Carle Van Loo maintained his reputation because, from 1745 onwards, he began to produce more ambitious works in the nobler genres, such as his extremely fine cycle depicting the life of St Augustine for Notre-Dame-des-Victoires (1748-1755), or his *Sacrifice of Iphigenia* (1757), now in Potsdam. And although he still submitted a mythological theme in the 1747 competition (*Drunken Silenus*), his ambition was to be the Rubens of his day.

Fragonard, or a passion for painting

Boucher's true heir, and at the same time perhaps the greatest French 18th-century painter, was his pupil Fragonard. In a traditional survey of the century, such as that by Louis Réau, Fragonard would be kept for the end, because he was "the crowning piece in the firework display put on by the French school of painting", the figure who "sums up the entire century". And yet although his career continued until after the Revolution, most of his work was painted in the reign of Louis XV. With Fragonard, the purely imaginary world of the rococo gave way to a sensitivity to what the latter half of the century was to define as 'Nature'. The artist wavered between titillating erotic scenes destined for the love nests of great courtesans and idyllic landscapes in the Dutch style. Trained by Chardin and Boucher, whose manner he initially followed, Fragonard obtained the 1752 Prix de Rome at the age of twenty. But it was

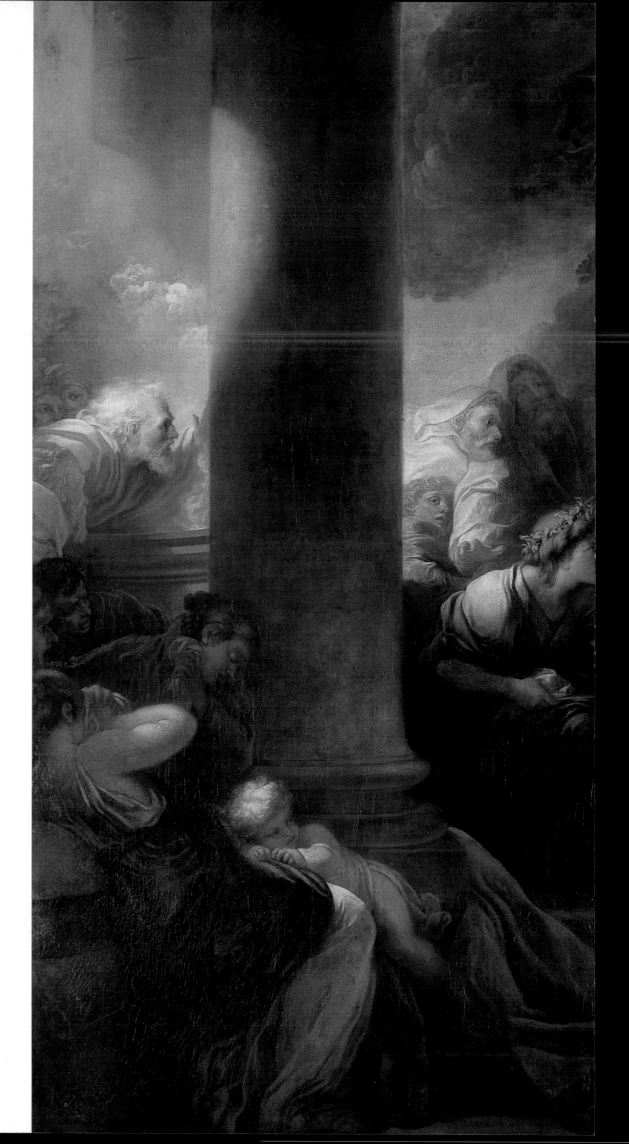

Jean-Honoré Fragonard |
**COROESUS SACRIFICING HIMSELF
TO SAVE CALLIRHOE**
Exhibited at the 1765 Salon,
oil on canvas, 311 x 400 cm
(122 3/8 x 157 1/2 in).
Musée du Louvre, Paris.

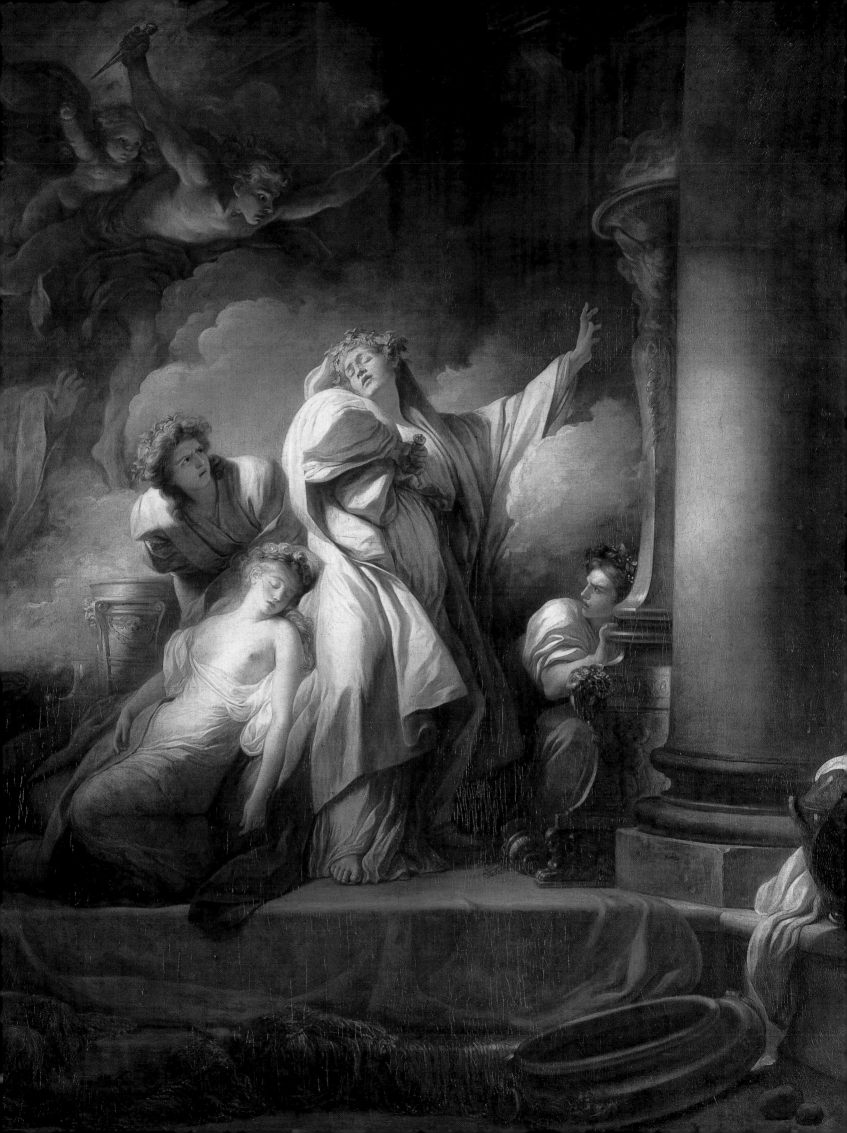

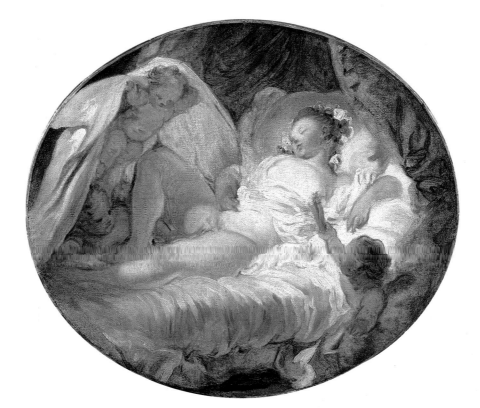

Jean-Honoré Fragonard |
LE FEU AUX POUDRES
Before 1778,
oil on oval canvas,
37 x 47.5 cm
(14 5/8 x 18 3/4 in).
Musée du Louvre, Paris.

not until after a long stay in Italy and extensive travel that he was officially accredited in 1765 as a history painter with his *Coroesus and Callirhoe*.[4] This large, dramatic composition with its striking light effects – a scene of sacrifice in which, according to Diderot in his *Salon de 1765*, "the ideal theme is sublime" – brought Fragonard instant fame… and complimentary accommodation in the Louvre. Yet he cared little for official commissions – he was even exempted from his reception piece, a ceiling for the Galerie d'Apollon in the Louvre – and forsook history painting for amorous, even frankly erotic themes. He also explored genre painting, fantasy portraiture and landscape, in fact every category which allowed him free scope to paint with that unprecedented verve and sinuous touch which revolutionized the art of his day. To his contemporaries, many of his works must have seemed unfinished; yet connoisseurs like the Abbé de Saint-Non, the farmer-general Bergeret, and Mme du Barry (up until 1773) vied to purchase them. Fragonard preferred private clients like these to the uncertainties of the Salon.

He accordingly developed two styles of painting. One, extremely meticulous, featured an accumulation of refined details, and teemed with foliage, flowers, twisted branches, ribbons and accessories which provided spatial density and justified the use of strong, often slightly acid tones. This he reserved for official commissions. In his second style, found in the nudes and the fantasy portraits, the subject-matter was simplified to the extreme, there was a characteristic free-flowing technique, contours and folds were picked out with a conspicuous touch, and colours seemed to melt into each other.

In 1767, he painted a work which fell into the first category, *The Swing*, at the request of a courtier who had initially approached Doyen in the following terms,

Jean-Honoré Fragonard, |
THE SWING
1767, oil on canvas,
81 x 64.2 cm
(317/8 x 251/4 in).
The Wallace Collection, London.

according to the latter painter: "I would like you to paint Madame (indicating his mistress) on a swing being pushed by a bishop. You will position me in such a way that I can see the beautiful child's legs, and even more should you wish to add a touch of gaiety to your painting, etc." The shocked Doyen having refused the commission, it was passed on to Fragonard who was regarded as the specialist in such works. The same refined touch and harmonious blend of colours – greens, blues and pinks – is found in the *The Progress of Love* series, commissioned and then rejected by Mme du Barry for Louveciennes. These large compositions, full of lush vegetation, sculptures and blue-tinted skies, depict episodes in an amorous play. Arguments as to the correct sequence of *Surprise, Pursuit, The Lover Crowned* and *Love-Friendship* are futile since the iconography was above all a pretext to create a unique atmosphere and pictorial luxuriousness which summed up the closing years of Louis XV's reign. Although, thematically, *The Island of Love, Fête at Saint-Cloud, The Swing, Blind Man's Buff,* and *La main chaude* (c. 1775-1780) marked a return to Watteau, they were above all nature studies based on the landscape sketches made by the artist during his travels: in 1773-1774, following the abortive Louveciennes commission, he had returned to Italy with Bergeret.

Fragonard, who also visited Holland – as attested to by his copies of Dutch masters – painted series of rural landscapes in the style of Ruysdael as well as pastoral scenes. Some of his paintings were inspired by the dramatic idyll, *Annette et Lubin* (1761), a 'moral tale' by Marmontel (taken up by Favart): the young protagonists, who have been raised in the country, fall in love, unaware they are brother and sister. In the eyes of society, they are guilty of incest. Fragonard has left portraits of *Annette*, and certain scenes featuring flocks have been interpreted as illustrations of the tale, as in the case of the extremely fine *Returning Flock* in Worcester Museum. His studies of bulls (*White Bull in the Cowshed*, Louvre) also reveal an extraordinary use of colour. Holland helped Fragonard shake off the last traces of academicism.

At his most popular, he remains the painter who illustrated La Fontaine's *Tales* and who explored their libertine scenes – *The Kiss, The Desired Instant, La gimblette, Futile Resistance, The Burning Shirt* and *The Lock* – to create a visual expression of the pleasure and joy of love in which the light, the blurred atmosphere and the brilliant colour tone down the crudity of gesture. Alongside these nudes, these intertwined bodies and sensually arousing foreplay, he composed sentimental scenes, beatific moral visions, which were nevertheless bathed in the same light: *The Happy Fertility, The Happy Family,* or his portrayals of children. Fragonard's complexity can be grasped in his decision to paint the celebrated *Lock* (c. 1776) as a matching piece to an *Adoration of the Shepherds*, daringly associating twin facets of love, the sacred and the profane. Similarly, he was capable of executing concentrated, 'absorbed' pictures where the spectator is excluded. For Michael Fried,[5] this exclusion marks the beginnings of modernity. *Young Girl Reading* (Washington) features a captivating simplicity and use of colour, including Fragonard's favourite yellow which in this instance achieves a radiant intensity highlighted by the red.

Jean-Honoré Fragonard |
YOUNG GIRL READING
N. d., oil on canvas,
81 x 65 cm
(31 7/8 x 25 5/8 in).
National Gallery of Art, Washington.

Yet the sheer pleasure of painting is nowhere more palpable than in his fantasy portraits of friends decked out in extravagant costumes which provide a pretext to deploy swirling colours (the portrait of Diderot can be included among these), or of old men in the style of Rembrandt: his brushstroke – and even the butt-end of the brush is used to plough through the paint – has a restless, feverish flow which constitutes the apotheosis of *fa presto*, the effects of which are again found in the artist's drawings, so intricate that they were often impossible to engrave.

Fragonard's career remains fairly astonishing. As early as 1765, the artist had found in *Coroesus and Callirhoe* a tragic, dramatic subject which chimed in with current taste and which, given the predilection for classical antiquity, offered promising scope for development; and yet he chose a path which, while it ultimately elevated him to the rank of one of the century's greatest painters, made him an isolated figure in his own day and even earned him a reputation of immorality. In relation to Vien's generation he thus became a dissident figure on two counts: whereas the former believed passionately in historical subjects and a more academic technique, Fragonard freely chose his subjects from outside the accepted genres (including Boucher's mythology) and his manner was dazzlingly spontaneous. His work was also poles apart from that of another supreme artist who also cut an isolated figure, whose subjects were judged trivial and whose technique, although slower-paced, was

equally extraordinary – Chardin. In 1785, one writer lamented: "M. Fragonard, born with sufficient talent for several artists, does not appear to us to have fulfilled the whole extent of his obligations to nature."

Portraiture: from the ceremonial to the informal

Portraiture was the lucrative type of painting par excellence. Although its social prestige could not compensate for its subordinate rank in the hierarchy of genres, it had many adepts and was amply represented at the Salons. Hesitating between a conventional and a natural approach, throughout the 18th century it experienced the general changes affecting all painting. It was the classic example of a type of painting which stood at the crossroads between the 'grand manner' and the genre scene; it included, on the one hand, ceremonial portraits and, on the other, informal portraits intended as psychological or social studies. In fact, every artist gifted with a veritable personality of his own created a unique, unclassifiable type of portrait: Fragonard painted fantasy portraits, while the ageing Chardin turned to pastels and Greuze produced realistically sensitive studies of the bookseller Babuti (1759) and the engraver Wille (1765)…

Two masters of the genre, Nicolas de Largillierre (1656-1746) and Hyacinthe Rigaud (1659-1743), perpetuated the style of the grand ceremonial portrait prevalent under Louis XIV. Rigaud's celebrated, sumptuous, full-length portrait of *Louis XIV* was painted in 1701 and exhibited at the 1704 Salon: with

its symbolic imagery and motifs extolling royal majesty it epitomized the monarchical portrait. The virtuoso brushwork produced a brilliant rendering of both physical features and the luxurious robes and regalia. Rigaud defined the style which would subsequently be applied, in a rather less rigid manner however, by Louis Tocqué (1696-1772) for *Queen Marie Leszczynska* (1740), Louis-Michel Van Loo (1707-1771) for *Louis XV* (1761) and Antoine-François Callet (1741-1823) for *Louis XVI* (1779). Whereas Rigaud painted portraits of magnificently-robed cardinals and ministers, Largillierre, whose clients were often of lower rank, could afford to be less formal, bringing the sitter closer to the spectator and introducing natural backgrounds (he also painted a few landscapes). Although both painters owed much to Van Dyck, part of their success and appeal derives from the free colouring borrowed from Rubens. Adapting themselves to the quality of the sitter, they were capable of passing from a profusion of frills and flounces to a stark simplicity worthy of Philippe de Champaigne. Michael Levey[6] has quite rightly noted the extremely subtle nuances of colours and transparencies in Largillierre's portrait of *Elizabeth Throckmorton* (c. 1729).

Both artists also painted literary or mythological portraits, much in vogue during the rococo period. Largillierre painted Mme de Gueidan as Flora while Rigaud portrayed her husband as Céladon, the shepherd-hero of Honoré d'Urfé's pastoral romance, *Astrée.* Jean-Marc Nattier (1685-1766) proved

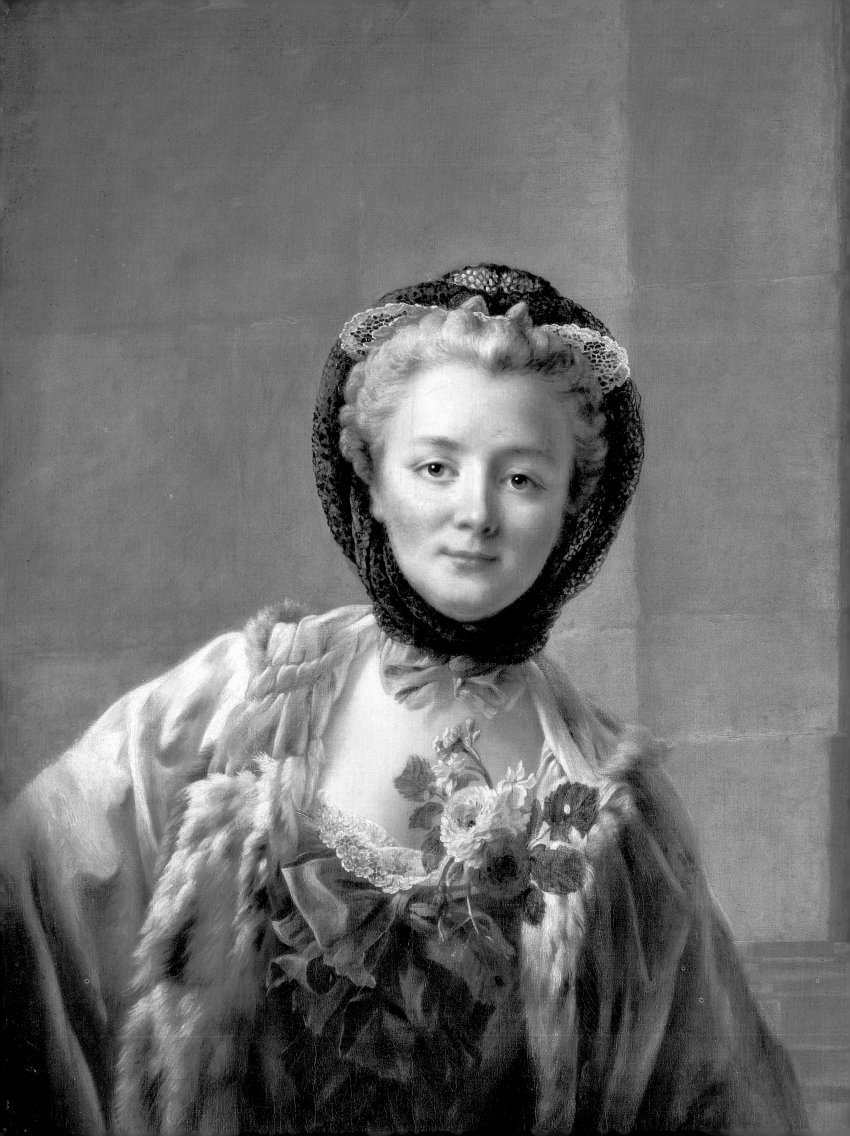

François-Hubert Drouais |
**THE MARQUIS DE SOUCHES
AND HIS FAMILY**
1756, oil on canvas, |
324 x 284 cm
(127 1/2 x 111 7/8 in).
Musée national du château,
Versailles.

| François-Hubert Drouais
**THE COMTE D'ARTOIS
AND HIS SISTER,
MADAME CLOTILDE**

Exhibited at the 1763
Salon, oil on canvas,
129.5 x 97.5 cm
(51 x 38 3/8 in).
Musée du Louvre, Paris.

himself to be the master in this field, particularly in his female portraits: he portrayed members of the royal family, *Madame Henriette as Flora* (1742), and the daughters of Louis XV or the high-ranking aristocracy, such as *Mademoiselle de Clermont as a Water Goddess*. And even if the fourteen-year-old Marquise d'Antin was not portrayed as a nymph, she was given a similar garland of flowers to the *Duchesse d'Orléans as Hebe* (1745). Beyond its conventional aspects, the quality of the young girl's portrait derives from its soft iridescent technique: it is understandable why the Musée Jacquemart-André has chosen it as the symbolic image of refinement and grace. This type of flattering portrait long remained current as can be seen in the work of François-Hubert Drouais (1727-1775), the true heir of Nattier, who painted *Madame du Barry as a Muse* in 1771 and *Marie-Antoinette as Hebe* two years later. Drouais furthermore assured his celebrity through portraits of children, yet another illustration of a new sensitivity also found in the work of Chardin and Greuze. Nevertheless, Nattier was capable of employing a natural pose and avoiding pomp, even in a royal portrait, as can be seen in his astonishing *Marie Leszczynska* (1748, Versailles) which shows the smiling queen as she pauses in her reading of the Bible. Could this painting have been the inspiration

Pierre Lacour |
**YOUNG WOMAN AND HER CHILDREN
IN A LANDSCAPE**
Year II (1794-1795),
watercolour and gouache
on ivory,
diameter 7.4 cm (2 7/8 in).
Musée des Arts décoratifs, Bordeaux.

behind the vogue for much simpler portraits of grand ladies, captured in real-life everyday situations? This is what both Boucher (1756) and Drouais (1764) were seeking in their quasi-official portraits of Mme de Pompadour. In the case of Boucher, even if the composition and the dress are strewn with roses, the sitter is again portrayed as she breaks off from her reading, while Drouais portrays her in front of her tapestry. Although the posture is spontaneous, the setting is carefully chosen, the drapes and luxurious material and furniture express both the lady's character and her role as patron of the arts. Boucher's 1758 portrait of Mme de Pompadour (London, Victoria and Albert Museum) again shows her reading, but is more natural. The scene is set in a grove, only two roses remain symbolically placed at the sitter's feet, and the effect is closer to that of a sensitive portrait.

Many bourgeois clients also commissioned portraits. Wishing to avoid the ridicule of aping the aristocracy they favoured a certain realism which nevertheless did not exclude virtuoso brush or pastel work. More than any other genre, portraiture involved a variety of techniques and formats adapted to specific clients and purposes. Formats ranged from life-size portraits to medallions only a few inches in diameter, while techniques included enamel, painting on ivory, and pastel which became extremely fashionable.

The latter medium, particularly suited to portraiture, was popularized by the Venetian Rosalba Carriera (1675-1757) during her stay in Paris in 1720-1721, although according to Leonardo da Vinci it was actually French in origin: Joseph Vivien (1657-1734) had in fact been received into the Academy as early as 1701 as a 'pastellist'. His portraits confirmed the new status of the pastel, no longer a preparatory sketch but a finished work sometimes executed in large format – almost six feet in the case of La Tour's portrait of Mme de Pompadour. The celebrated Rosalba used it dry for its gossamer lightness and bright tonalities. Although both a woman and a foreigner, she was received into the Academy. The Geneva painter Jean-Étienne Liotard (1702-1789), whose international career led him as far as

| François-Hubert Drouais
MADAME DU BARRY
N. d., chalk and charcoal on paper,
16.5 x 13.2 cm (6 1/2 x 5 1/8 in).
Private collection.

Women Painters

The 18th century, imbued with feminine grace, witnessed an increasing number of women pursuing brilliant artistic careers. Although they were indeed themselves often the daughters or wives of painters, some of them, like Rosalba Carriera or Angelia Kauffmann, acquired an international reputation. A very small number of them were admitted into the Academy, but as they were not eligible to receive training in history painting their output was usually confined to minor genres, floral compositions or still lifes, as in the case of Anne Vallayer-Coster (1744-1818) – whose work, according to Diderot was "superior to that of a woman" and who also painted portraits, like Adélaïde Labille-Guyard (1749-1803) and Élisabeth Vigée-Lebrun (1755-1842). Nevertheless, Anna-Dorothea Therbouche (1721-1782), who was born in Berlin, displayed astonishing talent in historical subjects and was admitted into the Paris Academy in 1767 and later returned to join the Berlin Academy. The Marseilles painter Françoise Duparc (1726-1778), who produced genre scenes, pursued a more provincial career, while Marguerite Gérard benefited from the lessons of her brother-in-law Fragonard.

| Élisabeth Vigée-Lebrun
Self-Portrait
 1790, oil on canvas,
 100 x 81 cm
 (39 3/8 x 31 7/8 in).
 Uffizi, Florence.

Commissioned by the
Grand Duke of Tuscany,
the painting shows the artist
sketching the portrait
of Marie-Antoinette.

| Rosalba Carriera
Nymph from Apollo's Retinue
 1721, pastel,
 61.5 x 54.5 cm (24 1/4 x 21 1/2 in).
 Musée du Louvre, Paris.

**This work was submitted by Rosalba Carriera
in October 1721 as her Academy reception piece.**

Marguerite Gérard |
Young Woman and Child
1799, oil on canvas,
64 x 53 cm
(25 1/8 x 20 7/8 in).
Musée des Beaux-Arts, Dijon.

Adélaïde Labille-Guyard |
**PORTRAIT OF MADAME
LABILLE-GUYARD
AND HER PUPILS**
Exhibited at the 1785
Salon, oil on canvas,
210 x 152 cm
(82 5/8 x 59 7/8 in).
Metropolitan Museum
of Art, New York.

**Mme Vigée-Lebrun's
rival.**

*" Mme Labille-Guyard and Mme Le Brun are competing for the laurels of Roslin and Duplessis, or rather ask to share them.
They are worthy of them. The two pitfalls that Mme Le Brun should beware of are a weak brushstroke and hesitant forms, and excessively
unnatural bright colours. She should go far in her art. Mme Guyard should beware of the opposite pitfalls: she has become masculine."*
L'Impartialité au Salon, 1785.

Constantinople, used pastel to create strikingly realistic effects which rivalled oil painting. He even went to the length of attempting to erase all trace of pictorial touch because that "no *strokes* are to be seen in the works of nature" – or so at least he claimed in his *Treatise on the Principles and Rules of Painting*, published in 1781. This kind of view demonstrated the scale of the anti-rococo reaction in the last third of the century.

However, the unchallenged master of pastel was Maurice Quentin de La Tour (1704-1788). Preoccupied with creating detailed character studies, he used pastel for portraits usually reduced to the sitter's face alone (except for the large full-length portrait of Mme de Pompadour which he had difficulty in finishing). La Tour was also seeking a natural effect and succeeded in capturing not so much the grace (which he deliberately exaggerated) as the true nature of his sitter. He achieved unrivalled technical supremacy and his virtuosity is best described in the words of the Goncourts who admired above all his preparatory work, his 'rough outlines': "The transparencies beneath the nose are rendered by touches of pure carmine, dashes of Troyes white mark a marble complexion with fragmented, shelving gleams, the flatness of a tone is broken by lashing crayon strokes of pure blue or yellow, furrowed muscles cut across the plumpness of a cheek like a curry-comb, all sorts of audacities inspired by the sitter on the spur of the moment, and which capture on paper, much better than a brush on canvas, the vivacity, intense movement and miraculous illusion of features and living flesh" (*L'art du XVIIIᵉ siècle: Latour*, 1867).

Although other pastellists were overshadowed by La Tour's reputation, Jean-Baptiste Perroneau (1713-1783) proved to be a more brilliant colourist, admired throughout Europe, and many women painters, emulating Rosalba Carriera, exploited the technique to produce subtle effects. Pastel, with its fragile, powdery nature reminiscent of cosmetics, has been taken as a symbol of the 'age of Louis XV', of an immortal art based on the ephemeral.

And is it not also this very quality, linked to an innate sensitivity, which explains the great development of the portrait in female painting in the latter half of the century? Among the most celebrated portraitists and pastellists, Élisabeth Vigée-Lebrun (1755-1842), following in Rosalba Carriera's footsteps, pursued a successful career throughout Europe painting numerous portraits in which natural expression vied with the conventions invariably required in such a codified, client-based genre. She even had to produce several versions of her *Self-Portrait*; the one in which she portrays herself with her daughter and wearing 'Greek-style' costume (1789) also seeks to express the naturalness associated with this new aestheticism. Her virtuosity is revealed in her portraits of *Comtesse Catherine Skavronskaia*: the one painted in 1790 fea-

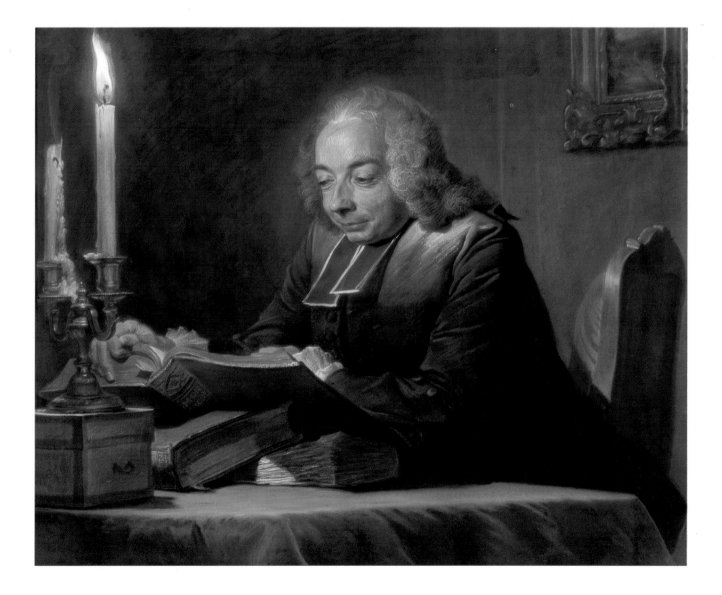

tures an astonishing harmony of cold colours – blue, green and pearly white. The work of Adélaïde Labille-Guiard (1749-1803) displayed similar qualities but expressing a vivacity and virtuosity corresponding to the rank of her most famous sitters, Louis XV's daughters. Significantly, Marie-Antoinette preferred Élisabeth Vigée-Lebrun whom she befriended. They shared a common vision of motherly tenderness, and the painter portrayed the queen in attitudes so natural that they almost infringed the rules of propriety.

Another fundamental aspect of portraiture, which made it virtually indistinguishable from the domestic scene (many of these portraits of now anonymous people have become in effect genre scenes), was that the pursuit of naturalness and sensitivity led to the adoption of compositions and techniques which heightened concentration and maintained the protagonists at a respectable distance. Michael Fried has discerned the successful use of such 'absorption' in Fragonard's *Young Girl Reading*; it is also to be found in Chardin's *M. Le Noir's Son Amusing Himself Building a House of Cards* – part of the *Houses of Cards* series rather than a portrait – in the portrait of M. Godefroy's son, or *Child with a Top*, and in *The Young Drawer*. Greuze used the same approach in his *Schoolboy Studying His Lesson* which, although reminiscent of *Titus at his Desk* by Rembrandt, the master of the genre, is nevertheless simultaneously a portrait and a sensitive genre scene. This signalled a profound change: like the psychological portrait, for instance La Tour's pastels, this type of painting expresses "the mystery of a subjectivity which invites interpretation yet refuses to reveal itself".[7]

It can be seen as a variant of the sensitive portrait, so appealing to Diderot's generation: did not Diderot himself reproach Alexandre Roslin (1718-1793) who used wooden model figures and could not portray his figures in a true light? Indeed Roslin was commissioned to paint a number of Swedish, Russian or Austrian sovereigns, often in effect ceremonial state portraits hardly conducive to developing a natural approach. Similarly, Diderot disliked his own portrait by Louis-Michel Van Loo, who turned him into a "handsome philosopher" (*Salon de 1767*). He made a point of warning his grandchildren that he was not at all like his portrait: "My features used to change a hundred times a day depending upon whatever was affecting me. I could be calm, sad, dreamy, tender, violent, passionate, enthusiastic and so on." But how could Van Loo have possibly portrayed such multiple emotions worthy of Parrhasius' celebrated *Athenian People* to which Diderot apparently enjoyed referring?[8] Such a requirement supposed a new relationship between art and feeling.

| Maurice Quentin de La Tour
PORTRAIT OF CRÉBILLON
Exhibited at the 1761 Salon, pastel, 31 x 22 cm
(12 1/4 x 8 5/8 in).
Musée Antoine-Lecuyer, Saint-Quentin.

1. A. Schnapper, *Jean Jouvenet et la peinture d'histoire, Paris*, 1974, p. 15.
2. P. Rosenberg, "Ce qu'on disait de Fragonard", in *Revue de l'art*, n° 78, 1987, pp. 86-90.
3. The French term 'bambochades', like the Italian 'bambocciati', meaning small paintings representing scenes of street or peasant life, derives from 'Il Bamboccio', the nickname given to Pieter Van Laer, a Dutch painter who specialized in such scenes.
4. Jean Starobinski has given a brilliant analysis of this painting and of the "dream" with which it inspired Diderot in his *Salon de 1765*; republished in *Diderot dans l'espace des peintres*, 1991.
5. Michael Fried, *Absorption and Theatricality: Painting and the Beholder in the Age of Diderot*, Berkeley and Los Angeles, 1980.
6. *Eighteenth-Century Art*, 1975, pp. 8-9.
7. J. Starobinski, *Diderot dans l'espace des peintres*, 1991, p. 51.
8. Pliny, *Historia Naturalis*, XXXV, 69: "He indeed portrayed him fickle, angry, unfair, inconstant and, at the same time, easily swayed, lenient…"

3. A New Sensibility

Pages 114-115
Jean-Baptiste Greuze
**L'ACCORDÉE DE VILLAGE
(THE BETROTHAL)**
Detail, 1761, oil on canvas,
92 x 118 cm
(36 1/4 x 46 1/2 in).
Musée du Louvre, Paris.

The fantasy world of the pastoral and the 'fête galante' provided artists with one escape route from the constraints of the nobler genres. But it was not the only way of circumventing academic norms. Masterpieces were also produced in the minor genres of still life or domestic painting, or in intermediary genres such as animal painting or portraiture. Painters like Chardin or Oudry, who trained at the Académie de Saint-Luc, established reputations and even obtained royal commissions, professional advancement which would have been unthinkable without the Dutch example, or again without the emergence of a new sensibility.

The 17th-century quarrel between ancients and moderns had paved the way for a reinterpretation of beauty. The debate on colour had led to a redefinition of both 'sentiment' and 'intellect'. But it was not until half-way through the following century that critics would postulate the subjective nature of taste.[1] Both organic and inorganic realities were imbued with a poetry which, for some, still derived from a corpus of cultural classifications while, for others, it involved above all a new perception of the world, people and life.

The celebration of sensibility and the birth of art criticism

In his *Essay on Taste* (1757), written for the *Encyclopédie*, Montesquieu argued: "The sources of beauty, goodness, and pleasure are therefore within ourselves; and to seek their causes is to seek the roots of our spiritual pleasure." The way was thus open for the emergence of both aesthetics – with the German philosopher Baumgarten's *Aesthetica* (1750) – and art criticism which, although brought to prominence by Diderot, dated back to a text of 1746. It also explains the increasing recourse to the notion of 'sensibility' as a universal yardstick: art, the ideal medium for the expression of feeling, lay at the very heart of this process. In response, painting – like the novel and the theatre – was swept by a demand for feeling, shared by a figure like Chardin himself who, as his friend Cochin records, was to claim: "We use colours, but we paint with feeling." This signalled the dawn of a period which was prepared to abandon Cartesian logic as its credo in favour of Bernardin de Saint-Pierre's "I feel, therefore I exist", as formulated in the latter's *Studies of Nature* (1784). Certain genres – Greuze's domestic scenes or Vernet's landscapes – were to prove ideal vehicles for this wave of sensibility.

Amateur connoisseurs had already aired their views on painting and pamphlets were common; as early as 1730 Charles-Antoine Coypel, in his *Discourse on the Necessity of Receiving Opinions*, had delivered a lecture on the importance of sounding amateur opinion… providing the latter received official approval. Somewhere around 1750, due to a combination of factors, a more rational approach to art appreciation began to take form. The preceding decades had witnessed a growing tendency for aesthetic judgement to be based on the yardstick of sensibility rather than on familiarity with academic canons and conventional references or on technical skill. This new aestheticism of feeling was first expounded in 1719 in Abbé Dubos's *Critical Reflections on Poetry and Painting*, in which the author also related sensibility to 'national character' and to a certain historical relativism.

In 1746 the art connoisseur La Font de Saint-Yenne, convinced that an exhibition could be judged in the same way as a published book or a play, wrote his *Examination of the Principal Works Exhibited at the Louvre in August 1746*. Yet however much he claimed to be a "disinterested, enlightened spectator who, though not a painter himself, bases his judgement on natural taste without slavishly bowing to rules", or argued that he was a mere interpreter for the general public, and distributed more praise than adverse criticism, painters were offended by his remarks and contested his right to make them. Had he not dared call one of the angels in Carle Van Loo's *Louis XIII* "mediocre", and described Boucher and Natoire's flesh tones as "insipid"? The official rejoinder to La Font de Saint-Yenne came a year later, on 5 August 1747, when Charles-Antoine Coypel, First Painter to the King and Academy Director, read his *Dialogues between Dorsicour and Céligny* on the eve of the opening of the new Salon. Although asked to comment on the 1747 Salon, La Font de Saint-Yenne had meanwhile abandoned reviewing, considering his initiative to have been misconstrued. But he continued to write and that year published his excellent *Reflections on some of the Causes of the Present State of Painting in France*, deploring the decadence of French art, and especially the sorry state of history painting of which he liked to think himself a champion. His critique thus chimed in with the neo-classical condemnation of rococo art. In a similar vein, in *The Shadow of the Great Colbert*, published in 1749, La Font de Saint-Yenne evoked the shades of the grand century only two years before Voltaire published the completed version of his own *Age of Louis XIV* on which he had been working since 1739. It was not until Diderot that art criticism really began to flourish, although it should be borne in mind that as he himself was writing for Grimm's *Correspondence* he only enjoyed a very limited readership.

Diderot justified criticism and the key issue of competence by distinguishing between the 'technical' – design, chiaroscuro, perspective, etc. – and the 'ideal' – i.e. characters, proprieties, historical and political knowledge, etc. – of which the man of letters was the best judge. Although anxious to invoke common principles, the driving force behind artistic judgement was, in his opinion, personal emotion. As taste became a subjective matter, this in turn led to an emphasis on the creative individual. The notion of genius, "this pure gift of nature", as Diderot wrote in the *Encyclopédie*, then fully assumed its role as antidote to conventions and key to the sublime. The influence of Edmund Burke's *Philosophical Inquiry into the Origin of our Ideas of the Sublime and Beautiful*, published in 1757 and translated into French in 1765, was swiftly taken up by Diderot. In his *Salon de 1767* he launched a veritable campaign in favour of the sublime, writing: "Everything which astounds the soul, everything which imparts a feeling of dread leads to the sublime." He went on, paraphrasing Burke, to enjoin poets (and artists) to explore new themes such as the infinite, darkness, forests, thunder, lamentations, ruins, and caves. The work of art was no longer based on feeling alone; it involved sensation carried to fever pitch, and sprang from a sublime beyond.

Jean-Siméon Chardin |
THE COPPER CISTERN
Detail. 1733 (?),
oil on wood, 38 x 43 cm
(15 x 16 7/8 in).
Nationalmuseum, Stockholm.

| Louis-Michel Van Loo
PORTRAIT OF DIDEROT
Exhibited at the 1767 Salon,
oil on canvas, 81 x 65 cm
(31 7/8 x 25 5/8 in).
| Musée du Louvre, Paris.

Diderot and the Salon

Diderot (1713‑1784) was a brilliant practitioner of virtually all literary genres, from his magnum opus, the *Encyclopédie* (1746-1765), to his novels, *La religieuse* and *Jacques le Fataliste* (not published until 1796), and his attempts to renew drama; he was also the first great art critic. The reviews of the Salon which he was commissioned to write for Grimm's *Literary Correspondence* reveal a profound sensitivity, and Diderot, despite the fact that his ideas were published in fragmentary form in various works – his *Salons* (1759-1771, 1775 and 1781), his *Essay on Painting* (1765), or his *Impartial Thoughts on Painting* (1777) –, elaborated a discerning aestheticism. While respecting the conventions established by the academic system, he was aware of the subjectivity of taste and attached prime importance to emotion.
He was enthusiastic about the work of Chardin, Joseph Vernet and Greuze and condemned Boucher's immorality, wavering between defending artistic freedom and calling for art to observe moral imperatives.

" *It's that the porcelain vase is made of porcelain; that the olives are really separated from the eye by the water in which they float; that you merely have to pick up these biscuits and eat them; the bitter orange, open it and squeeze it; the glass of wine and drink it; the fruit and peel it; and carve into the pâté with the knife. It is this artist who understands the harmonious colours and reflections. O Chardin, it is not white, red or black that you mix in your palette but the very substance of things, it is air and light that you catch on the tip of your brush and fix to the canvas.* "

Diderot, *Salon de 1763*.

Gabriel de Saint-Aubin |
THE 1765 SALON
1765, pen, ink and
watercolour wash,
25 x 46.5 cm
(9 7/8 x 18 1/4 in).
Musée du Louvre, Paris.

| Jean-Siméon Chardin
THE JAR OF OLIVES
1760, exhibited
at the 1763 Salon,
oil on canvas,
71 x 98 cm
(28 x 38 5/8 in).
Musée du Louvre, Paris.

Obviously, Diderot's redefinition of beauty and of the purpose of art led him to reappraise the whole issue of genres although he did not actually challenge their legitimacy. Responding to the mediocre quality of the 1767 Salon, he reproached Boucher, who had just been appointed King's First Painter, for turning his back on the Salon and thus striking "the first blow at one of our most beneficial institutions".

Like La Font de Saint-Yenne, Diderot continued to defend history painting, but was forced to change the way he defined it; first of all, because he was partial to the so-called minor genres exemplified by Greuze and Vernet, but also in order to render his views consistent with an aestheticism of the sublime no longer restricted to history in the narrow sense, even if, at the same time, as we shall see subsequently, a revival of stern, moralizing history was under way. Disagreeing with La Font de Saint-Yenne, however, when the latter declared that "the history painter alone paints the soul, the others merely paint for the eyes", Diderot formulated the following revised definition in his *Essay on Painting* in 1765:

"It seems to me that the division of painting into genre painting and history painting is sensible; but in making this distinction I would have preferred a little more consideration to have been given to the nature of things. The term genre painter is a label applied indiscriminately to both those who depict flowers, fruit, animals, woods, forests, and mountains, and those who borrow their scenes from everyday and domestic life; Téniers, Wouvermans, Greuze, Chardin, Loutherbourg, even Vernet, are genre painters. Yet I protest that Greuze's *Father Reading to his Family*, *Ungrateful Son*, and *Betrothal*, or Vernet's *Seascapes*, which depict a wide variety of episodes and scenes, are to my mind every bit as much history paintings as Poussin's *Seven Sacraments*, Le Brun's *Family of Darius*, or Van Loo's *Susanna*.

There it is. Nature has differentiated beings into those who are cold, immobile, lifeless, unfeeling and unthinking, and those who live, feel and think. The distinction has been drawn from time immemorial: the term *genre painters* should have been applied to those who imitate raw, inanimate nature, and the term *history painters* to those who imitate sentient, living nature; and the argument would have been settled."

The distinction, in other words, no longer depended so much on iconography as on artistic genius. Without wishing to take the plunge himself, Diderot paved the way for the overthrow of the hierarchy of genres, for the supremacy of visual and imaginative, rather than social, values. Yet this objective was accompanied by a moral concern. In the same essay, he spelled out his famous platform: "To render virtue congenial, vice odious and to expose the ridiculous, that is the aim of every cultivated man who takes up pen, brush or chisel." This new ideal was also combined with another element which, although secondary, had remained present throughout the first half of the 18th century: a fascination with the animal world and inanimate objects, a tradition nurtured by North-European references.

| Jean-Baptiste Oudry
PORTRAIT OF GAMEKEEPER LA FORÊT AND TWO BITCHES FROM THE ROYAL PACK
Detail. 1732, oil on canvas, 132 x 164 cm (52 x 54 5/8 in). Château de Compiègne.

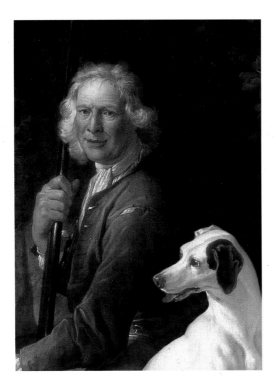

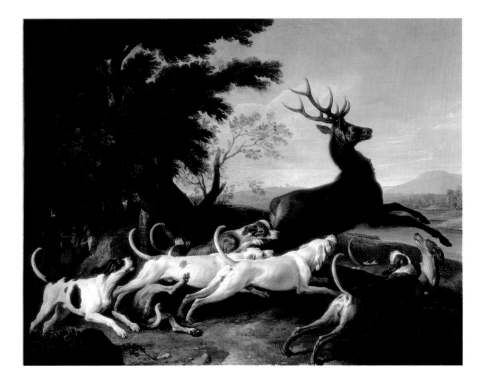

| François Desportes
STAG DRIVEN FROM COVER
| 1718, oil on canvas,
| 113.5 x 146.1 cm
| (46 5/8 x 57 1/2 in).
| Musée des Beaux-Arts, Rouen.

Poetic reality: animal painting and still life

Alexandre-François Desportes (1661-1743) was a pupil of the Flemish painter Bernaerts who had settled in Paris in 1644 and had introduced animal painting there. Desportes himself became a successful practitioner of both the latter genre and still life, in a style which showed affinities with the art of the 'Grand Century'. Admitted to the Academy in 1699 as an "animal painter", he catered to the extensive demand from royalty for whom the hunt remained an important symbol. In 1701, he obtained the commission to paint hunting scenes for the Versailles menagerie where Bernaerts had previously worked. His portrayal of animals was extremely forceful (*Stag Driven from Cover*, 1718). He observed his subjects closely, following hunts and, on occasions, even acted as 'dog portraitist' to the immense satisfaction of the masters of the hounds who often doted on their packs. And, quite naturally, he was commissioned to decorate royal castles and aristocratic mansions. He also applied his talent to theatre sets and tapestry designs: his famous *New Indies* cycle (1737-1741), produced by the Gobelins, introduced an exotic note which was to become one of the key features of 18th-century decoration, whether in chinoiseries, *singeries* by Huet, or in animal scenes such as *Louis XV's Exotic Hunts*. The personal artistic contribution of Desportes, one which was quite unique in relation to current models and practices, lay in his landscape backgrounds which he sketched from nature and which displayed a rare verisimilitude for their time.

Jean-Baptiste Oudry (1686-1756), for his part, was admitted to the Academy as a history painter, testifying to a wider-ranging ambition than Desportes whose themes he nevertheless adopted. A pupil of Largillierre, the renowned

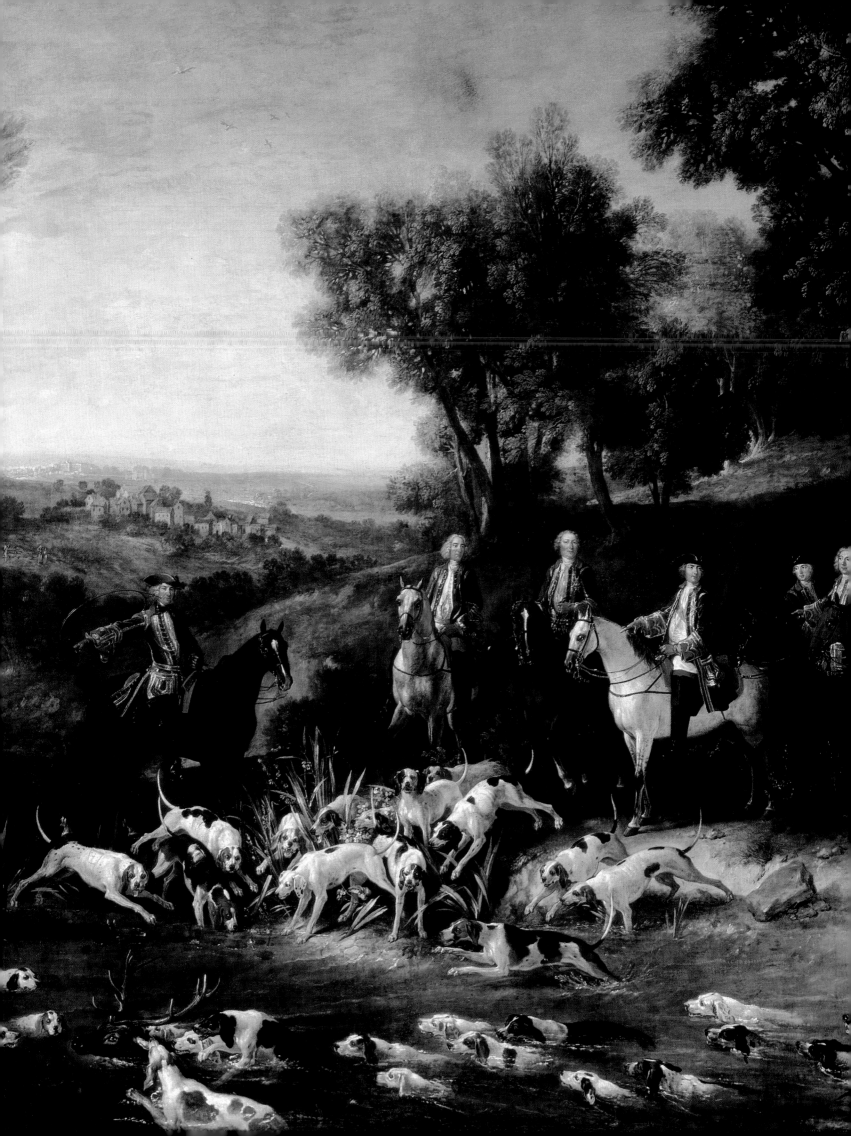

portraitist who had also painted magnificent still lifes, Oudry practised portraiture and history painting. Tsar Peter the Great tried to entice him to Russia, but the artist preferred to stay in France where, after having become Inspector of the Beauvais Manufactory in 1726, he was appointed Director in 1734, a decisive step in his career. He was so successful in his new post that he was also made Inspector of the Gobelins in 1748. The most famous series of tapestries woven from his designs and under his direction at Beauvais remain *Louis XV's Hunts* (1734-1745). He also produced work in the pastoral vein, creating the series of *Amusements champêtres* (*Country Pastimes*) in 1730 and, as an illustrator, came into his own with book illustrations for La Fontaine's *Fables* (1755).

Still life, particularly pictures of game bagged in the hunt, was yet another genre practised by Oudry: his *White Duck* (1753), with its virtuoso handling of nuances of white, may be considered his veritable pictorial testament, as if the artist were offering a practical illustration of his own academic lectures: *On the Manner of Studying Colour by Comparing Objects* (1749) and *On the Manner of Painting* (1752). He displayed a sophisticated understanding of colouring and light nurtured by the lessons of Largillierre and the Flemish masters, and also defended the obligatory confrontation between Nature and the masters.

It was, above all, the central role of the hunt and animals in the setting and staging of royal distractions which made the careers of these animal painters possible. Yet their respective sons, Claude Desportes and Jacques-Charles Oudry, who followed in their footsteps, were indifferent and relatively unsuccessful painters. Quite significantly, in 1736 and 1738 the commissions for the *Exotic Hunts* destined for Louis XV's new apartments in Versailles, were awarded to history painters such as de Troy, Carle Van Loo, Boucher and Charles Parrocel, or to 'fête galante' painters like Lancret and Pater, rather than to specialists like Desportes or Oudry. It is doubtful whether the latter could have achieved the forceful virtuosity and colouring of Van Loo or Boucher, whose *Leopard Hunt* and *Crocodile Hunt*, although copied from engravings rather than drawn from nature, nevertheless displayed a tension and movement worthy of Rubens. Oudry adopted a more naturalistic approach and sketched his lions at the royal menagerie.

The Dutch vogue enabled painters specializing in still life to make a career for themselves, but very few acquired the skill or reputation of Chardin who towered over the genre. A figure like Roland Delaporte (c. 1724-1793) seems no more than a pale shadow of the latter painter; Diderot described him as a "victim of Chardin" in his *Salon de 1763,* while author Régis Michel[2] has called him a "poor man's Chardin". Nevertheless, several artists of the following generation managed to revive the genre. These included the brothers Gérard (1746-1818) and Cornelis (1756-1840) Van Spaendonck, Dutch painters who had settled in Paris and specialized in floral compositions, and above all a woman painter, Anne Vallayer-Coster (1744-1818), admitted to the Academy in 1770 "in the genre of flowers, fruit, bas-reliefs and animals". The achievement of Vallayer-Coster, who was also a successful

| Jean-Baptiste Oudry
LOUIS XV HUNTING STAG IN THE FOREST OF SAINT-GERMAIN
Detail of the central section. 1730, oil on canvas, 211 x 387 cm (83 x 152 3/8 in). Musée des Augustins, Toulouse.

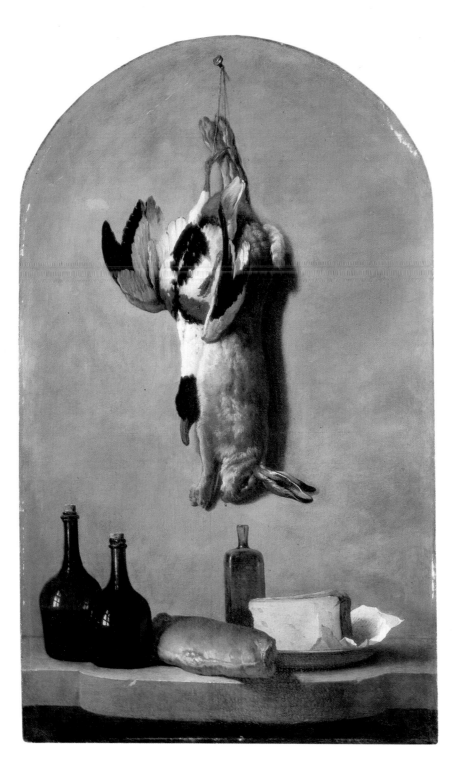

| Jean-Baptiste Oudry
STILL LIFE: HARE, DUCK, LOAF OF BREAD,
CHEESE AND FLASKS OF WINE
N. d., oil on canvas,
143 x 87 cm (56 1/4 x 34 1/4 in).
Musée du Louvre, Paris.

Anne Vallayer-Coster |
STILL LIFE WITH TUFT OF MARINE
PLANTS, SHELLS AND CORALS
1769, oil on canvas,
130 x 97 cm
(51 1/8 x 38 1/8 in).
Musée du Louvre, Paris.

| Jean-Baptiste Oudry
STILL LIFE WITH A MONKEY,
FRUIT AND FLOWERS
| 1724, oil on canvas,
142 x 144 cm
(55 7/8 x 56 5/8 in).
The Art Institute of Chicago,
| Chicago.

portraitist, was to move still life away from the starkness of Chardin and to infuse it with a fresh spirit based on the richness of objects and colours and the rendering of rare materials. Her *Still Life with Minerals* (1789) or her *Shells, Crystals, Sponges and Madrepores* are almost like sumptuous specimens from some curio collection. Just as she incorporated works of art into her compositions as a tribute to mankind and culture, she portrayed nature through its marvellous creations.

Chardin, or time suspended

Along with Watteau or Fragonard, Jean-Siméon Chardin (1699-1779) is, paradoxically, another supreme figure in French 18th-century art. Chardin's work, although restricted to the minor genres and executed in a slow, painstaking style poles apart from the fleeting touch of Fragonard, was a major contribution which explored a new direction in the art of painting. His appeal lies in the way he de-emphasizes the role of the subject-matter, adopting a minimalist approach yet respecting the most demanding pictorial standards. Diderot thought highly of Chardin, expressing his admiration in typically mock naive manner in his *Salon de 1763* : "O Chardin! it is not

white, red or black that you mix in your palette but the very substance of things…" It is true that, at the same time, the critic deplored the fact that Chardin chose to apply the "magic of colours" to humble subjects, but surely, to our eyes, this is precisely the merit of his paintings. Chardin created a concentrated, self-enclosed, secret world and in doing so, by means of some fruit and a few utensils, or rare figures – almost invariably women or children – made it timeless. In a way that history painting seldom managed to achieve, he infused banal objects and humble people with a poetic aura, a sense of eternity and permanence. While respecting the law of genres, Chardin surpassed it. Similarly, rather than adopting a submissive, naturalist attitude to reality, he reconstructed and re-organized its components, often depicting the same objects from one painting to another.

In his genre scenes, order is not only revealed in the composition itself, but also in the moral values attached to occupations: work, good upbringing, self-restraint, etc. The spectator is ushered into interiors where typical Dutch

Jean-Siméon Chardin |
THE SKATE
1728, oil on canvas,
114.5 x 146 cm
(45 x 57 1/2 in).
Musée du Louvre, Paris.

The French Example

Foreign monarchs, fascinated by the example of French culture, invited artists from France to decorate their palaces and direct their academies and commissioned works by the most prestigious French painters. Writing in 1765, the architect Pierre Patte proudly noted: "Paris is to Europe what Greece used to be in the heyday of Greek art; it supplies artists to the rest of the world." Indeed, among others, Michel-Ange Houasse (1680-1730), Jean Ranc and Louis-Michel Van Loo were invited to Madrid, Louis-Joseph Le Lorrain, Louis Tocqué and Lagrenée the Elder to Russia, Antoine Pesne (1683-1757) to Berlin, and Jean-Louis Desprez to Stockholm. French architects, draughtsmen and designers were also sought after and their work found throughout Europe. Just as many artists had left France following the Revocation of the Edict of Nantes, the Revolution drove Doyen and Élisabeth Vigée-Lebrun into exile.

| Jean-Marc Nattier
PORTRAIT OF LOUIS TOCQUÉ
| 1739, oil on canvas,
| 81 x 63 cm
| (31 7/8 x 24 3/4 in).
| Academy of Fine Arts, Copenhagen.

Nattier offered the Danish Academy this portrait of his son-in-law who went to St Petersburg and Copenhagen to paint royal portraits.

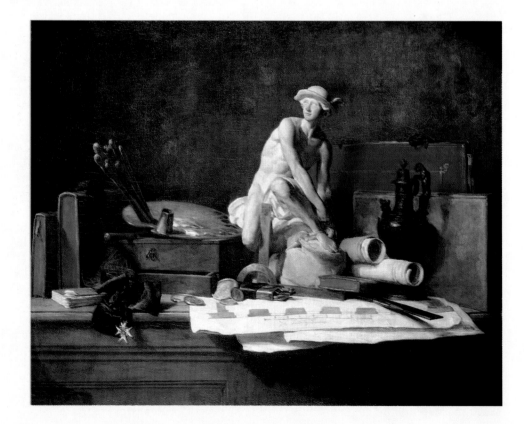

Jean-Siméon Chardin |
THE ATTRIBUTES AND REWARDS
OF THE ARTS
1766, oil on canvas,
112 x 140.5 cm
(44 x 55 3/8 in).
The Hermitage, St Petersburg. |

Commissioned by
Empress Catherine II in 1766.

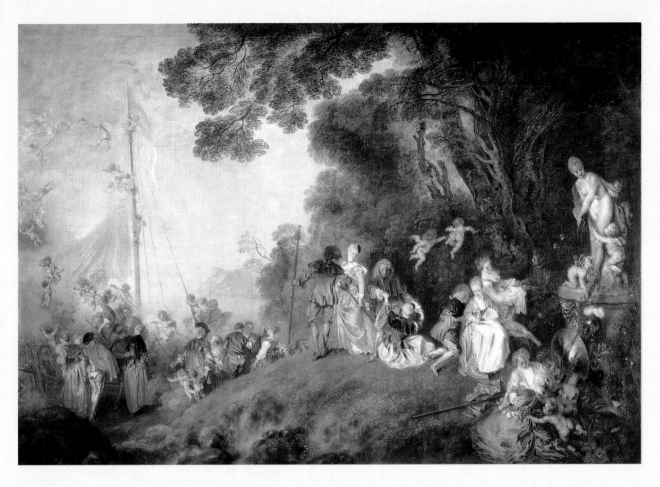

Antoine Watteau |
THE EMBARKATION FOR CYTHERA
1718-1719,
oil on canvas,
129 x 194 cm
(50 3/4 x 76 3/8 in).
Schloss Charlottenburg,
Berlin.

Purchased by Frederick II of Prussia c. 1760.

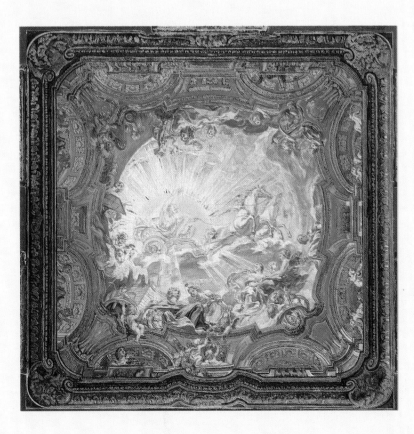

" Travel throughout Russia, Prussia, Denmark, Wurtemberg, the Palatinate, Bavaria, Spain, Portugal and Italy, everywhere you will find French architects in leading positions. (…) Our sculptors are also everywhere to be found(…). In succession, MM. Le Lorrain, Tocqué, Lagrenée, painters from our Academy, have been invited to Russia (…) Paris is to Europe what Greece used to be in the heyday of Greek art; it supplies artists to the rest of the world."

Pierre Patte,
Monuments érigés à la gloire de Louis XV, 1765.

| Juste-Aurèle Meissonnier
APOLLO'S CHARIOT
| Ceiling project. C. 1736, pen,
watercolour and gouache,
32.1 x 32 cm (12 5/8 x 12 5/8 in).
| Cooper-Hewitt Museum, New York.

Commissioned for Prince Byelensky's reception room in Warsaw.

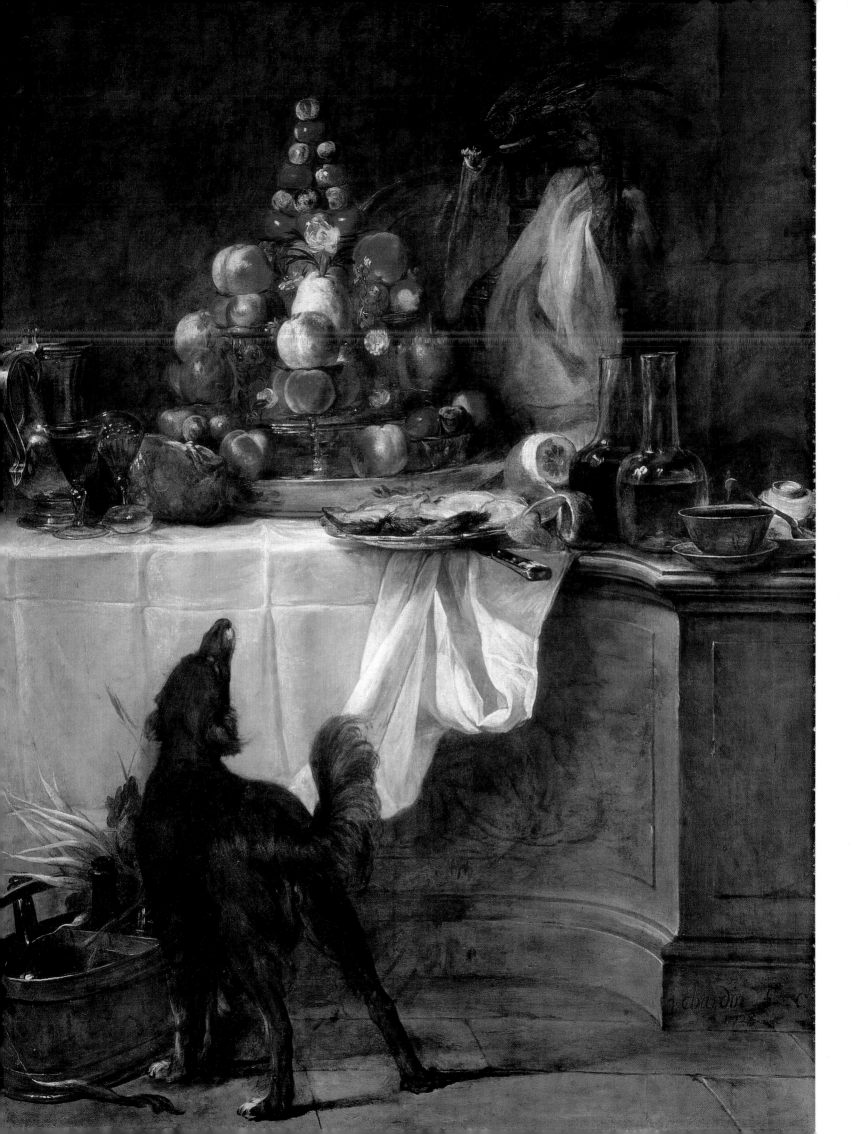

meticulousness, serenity and cleanliness reign – a far cry from Fragonard's unmade beds, the teeming accumulations of frivolous objects in the style of Boucher, or Greuze's animated scenes. Chardin's world resurrects Watteau's uspended time and silence. In 1728, he submitted *The Skate* and *The Sideboard* as his Academy reception pieces, two large canvases of a more complex composition than the hunting scenes and still lifes that he had painted up till then. The inclusion of a cat and a dog was proof of his attachment to the traditional convention of adding a lively touch to still life as well as his skill in painting hunting scenes – Oudry's speciality, and one from which Chardin soon turned away. But the two paintings already possessed such a quality of colouring and verisimilitude that the academicians, once again showing their open-mindedness, immediately decided to admit Chardin and accept the works as reception pieces. Subsequent generations of fervent admirers have confirmed their choice. Marcel Proust regarded them as the very embodiment of poetic representation of the trivial reality of eating; Soutine, not surprisingly, was fascinated by *The Skate*. Features such as the bare, brown backgrounds, the quivering, pearly colour of the gutted fish, the oysters which appear in both paintings, the light captured by the crumpled table-cloths, the sparsity of objects – in contrast to the typical piles found in Snyders' works – and the pyramid-shaped compositions combined to create two works of rare balance. Quite soon, Chardin abandoned the living, anecdotal inclusions like the cat, and attained both a sense of timelessness and a reconstruction of the presence of objects, not so much by illusionistic effect as by hinting at their material essence.

In 1733, despite his undeniable success, Chardin turned to the genre scene with *Lady Sealing a Letter* (Berlin). The affinities between genre painting and still life – objects, people absorbed in their tasks, the reduction of space to the bare essentials – led to the introduction of a similiar atmosphere and grave serenity. Thus, Chardin's children are not portrayed as the plump, chubby-cheeked, mischievous little angels so often found in genre painting of the period but are instead depicted assiduously saying *Grace*, spinning their tops, or building their house of cards. All movement and expression are suspended, replaced by a sense of absorption or dreaming which excludes the spectator. The soap bubble in *The Laundress* (1734) and *Soap Bottles* (1739) is the very symbol of this: inflated to bursting-point yet never bursting. The same feeling of suspension re-occurs in all Chardin's informal scenes, like the woman in *Woman Peeling Turnips*, lost in her thoughts. Nothing seems to perturb the balance of such compositions, whether they are set in the servants' quarters, like *The Young Innkeeper*, *Woman Cleaning Turnips* (1738) and the famous *Pourvoyeuse* (1739), or in the drawing room with the masters, like *Lady Taking Tea* and its pendant *House of Cards* in Nuneham Castle, *La serinette*, painted for the king in 1752, or *The Pleasures of Private Life* (1745-1746, Stockholm), commissioned by Princess Louise-Ulrique of Sweden for whom Boucher also painted *La marchande de modes*. Although Chardin painted an intimate vision of a bourgeois world – often no doubt his own home – his work by no means appealed solely to the middle classes.

| Jean-Siméon Chardin
THE SIDEBOARD
1728, oil on canvas,
194 x 129 cm
(76 3/8 x 50 3/4 in).
| Musée du Louvre, Paris.

The latter paintings, like those the artist offered to Louis XV in 1740 – two deliciously simple scenes, *The Hard-Working Mother* and *Grace* – are testimony to his success among royalty, a popularity confirmed by the numerous copies painted by him or by others, and by the fact that during his own lifetime his paintings were dispersed abroad, although Chardin was careful to keep at least engravings in France. He also obtained decorative commissions. In 1765, he painted three overdoors on the traditional themes of *Attributes of the Arts, Sciences and Music* for the royal Château of Choisy, and the following year received a similar commission from Empress Catherine II of Russia.

Strangely enough, around the time he was appointed to the posts of treasurer to the Academy (1755), and 'tapissier' (literally, 'upholsterer'), responsible for organizing the Salon exhibitions, Chardin returned to still life, exhibiting five of them in 1753. This coincided with the arrival on the scene of Greuze, soon about to introduce a new genre.

Although Chardin's still lifes often included dead animals such as rabbits or pheasants which, unlike those in his hunting scenes, were depicted with a sort of compassion, the dominant features were fruit and household utensils. His technique evolved towards more blended colours, a more blurred design and an interplay of simplified masses and light. For instance, in *Two Rabbits* in the Amiens collection, the two animals merge into a bluish-grey shape and the soft light mitigates the horror of death. The backgrounds became even starker; the paintings endeavoured to capture the transparency of decanters and jars, even the texture of grapes, the glint of copperware, the velvet-smooth skin of fruit, the paleness of porcelain highlighted by the occasional blue or red spot, the golden hue of breadcrust or brioche, but also the bright colour of a few cherries or the resplendent *Basket of Wild Strawberries* (1761). Chardin can skillfully break dull, monochrome nuances by an abrupt vivid tone which serves to underline the dense atmosphere in which the objects are immersed: light becomes tangible and matter is infused with the "substantial gravity" of which André Gide[3] has spoken.

This aspect of Chardin's work has been construed by historians as the very basis of an astonishing modernity. Yet we should beware of misinterpreting his pictorial objectives. Although doubtless aware of its specific characteristics, it is highly unlikely that the thought of dissociating art from subject-matter ever even crossed his mind. It is all too easy for the contemporary eye, familiar with Cézanne or Morandi, to discern with hindsight startling analogies in Chardin's painting. One renowned collector, the couturier Jacques Doucet (1853-1929), who was selling off his marvellous collection of 18th-century paintings in order to finance the purchase of works by contemporary artists, jokingly hung Manet's *The Rabbit* in his gallery between versions of *Soap Bottles* and a *House of Cards*. And visitors fell for it.[4] Indeed there was a direct affiliation: Manet also painted a work entitled *Soap Bottles* in 1867. Anyone can appropriate Chardin. Not surprisingly, "at the evening of a fine day" – to quote M. Roland-Michel – when his eyesight began to fail, he turned to portrait painting in pastel. Here again Chardin belonged to a dif-

Jean-Siméon Chardin |
THE HOUSE OF CARDS
1737, oil on canvas,
82 x 66 cm
(32 1/4 x 26 in).
National Gallery of Art, Washington.

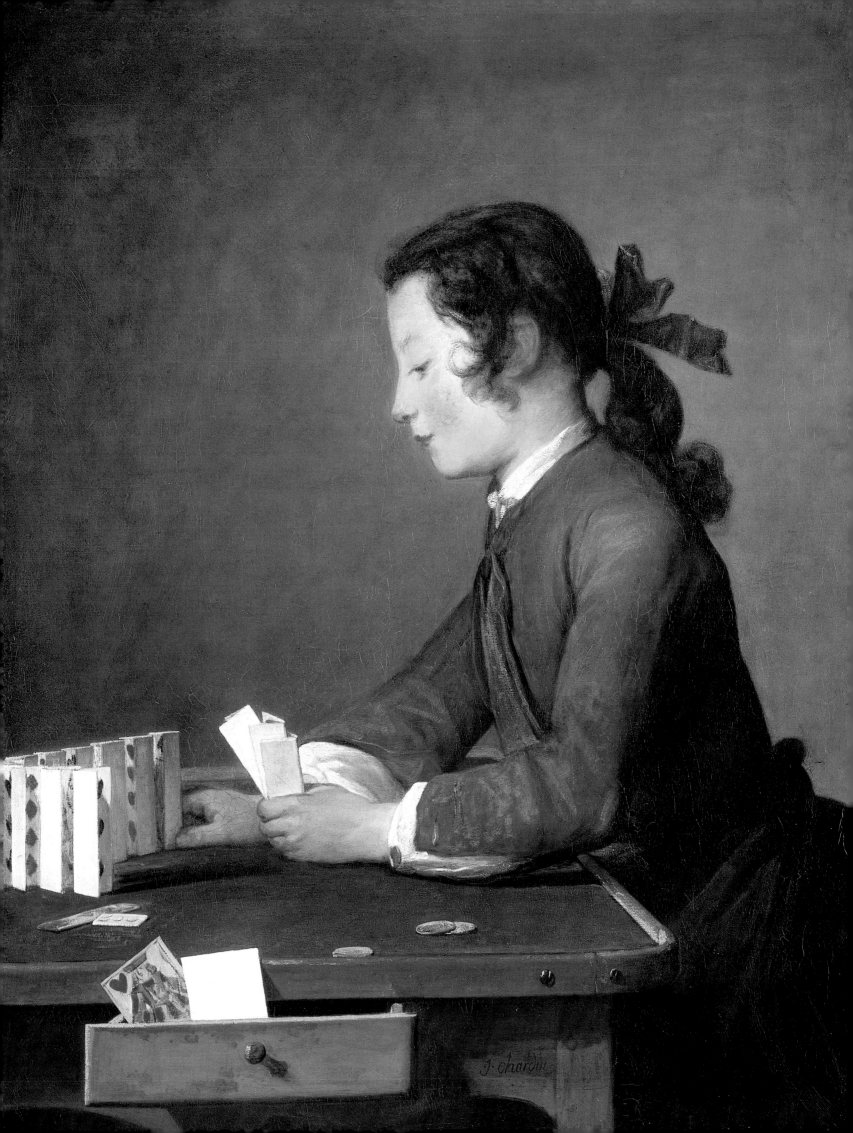

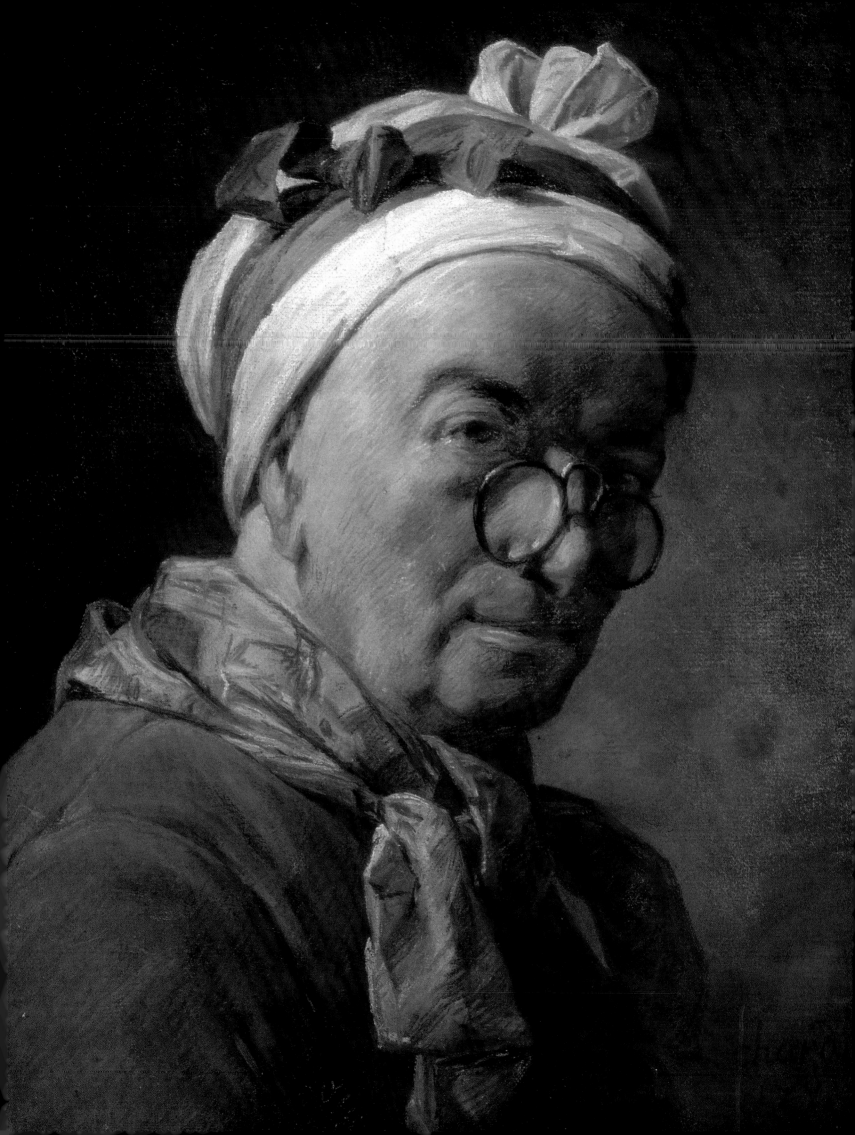

| Jean-Siméon Chardin
SELF-PORTRAIT WITH SPECTACLES
| 1771, pastel, 46 x 37.5 cm
(18 1/8 x 14 3/4 in).
Musée du Louvre, Département
| des arts graphiques, Paris.

Jean-Siméon Chardin |
LA POURVOYEUSE
1739, oil on canvas, |
47 x 38 cm
(18 1/2 x 15 in).
Musée du Louvre, Paris. |

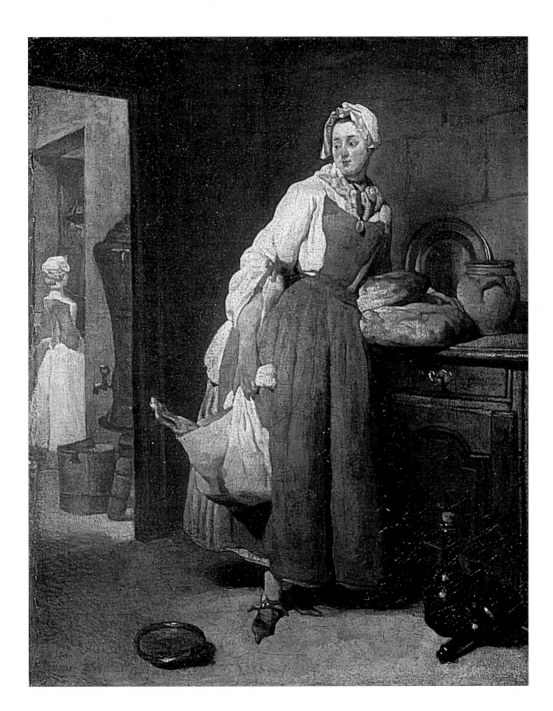

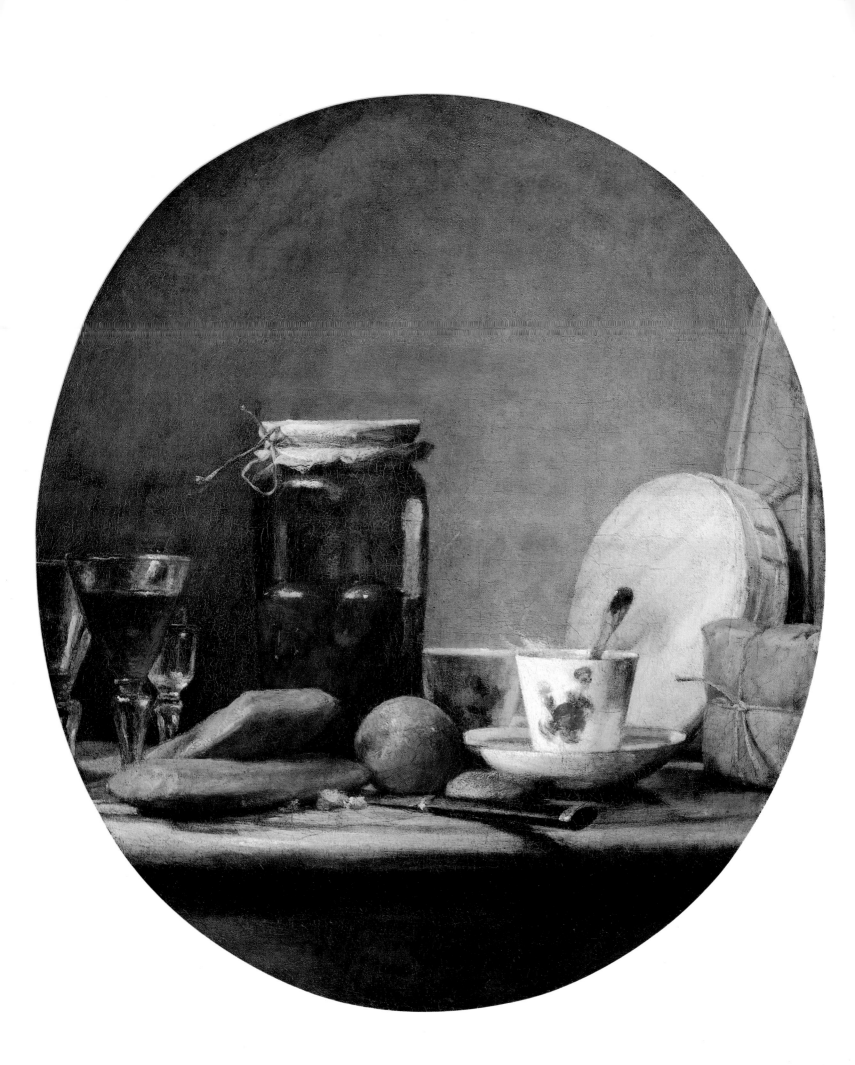

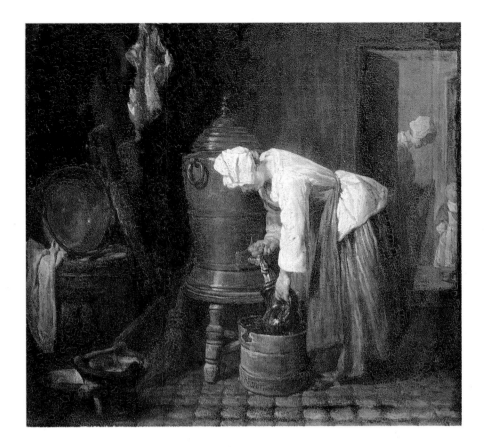

Jean Siméon Chardin |
THE COPPER CISTERN
1733 (?), oil on wood,
38 x 43 cm (15 x 16 7/8 in).
Nationalmuseum, Stockholm. |

| Jean-Siméon Chardin
THE JAR OF APRICOTS
1761, oil on oval canvas,
57 x 51 cm (22 3/8 x 20 in).
| Art Gallery of Ontario, Toronto.

ferent age. Instead of dazzling society portraits or fashionable antique settings, he chose to paint self-portraits in the style of Rembrandt or detailed studies of people closest to him, like the second Mme Chardin (1775, Louvre; 1776, Chicago). Only Jean-Étienne Liotard could match him in the use of pastel to produce a rare naturalness and simplicity.

Greuze and the vagaries of virtue

The dual career pursued by artists like Étienne Jeaurat (1699-1789) or Nicolas-Bernard Lépicié (1735-1784) can be explained by Diderot's theory of the affinity between genre painting and history painting. Both artists liked to think of themselves as history painters but are above all remembered for a few domestic genre scenes. Lépicié depicted the exploits of Portia, Regulus and Mathatias but is best known for his titillating *Lever de Fanchon* (1773). Jean-Baptiste Greuze (1725-1805) was driven by the same ambition. Humiliated by his abortive attempt to be admitted to the Academy as a history painter with his *Septimus Severus*, he set out to portray genre scenes in a heroic, even dramatized vein. He presented extreme emotions, set in a complex web of relationships and pyschological conflict within the context of the family, defined at the time in the *Encyclopédie* as a "civil society established by nature". And this explains the accusation of pomposity levelled at some of his Salon submissions as well as their cloyingly moralizing content. It was considered quite appropriate for St Andrew to reach out to grasp his martyr's crown, or for Belisarius to extend a grateful hand to his benefactor, but not for some villager to make the same gesture towards his daughter and her fiancé. The hierarchy

of genres was not so easily disposed of. In Diderot's opinion, Greuze was "the first among us who dared bring morality into art and depict episodes which could easily form the basis for a novel". And he has never really been pardoned for this pontificating novel, this "mawkish melodrama".[5]

There are however two aspects of Greuze's work which make him highly representative. Although he depicted theatrical bourgeois episodes reflecting Diderot's dramatic ideal in a seemingly realistic manner, he also painted quantities of somewhat sugary portraits and faces, as well as half-sentimental, half-erotic scenes like *The Broken Pitcher* or *The Dead Bird* (1765). Greuze encompassed a whole range of unexplored feelings, ranging from heroism to mawkish sentimentality, but above all new social values, those which Rousseau, the Encyclopédistes, and even the Physiocrats were busy promoting. In his paintings, kind-hearted mothers are surrounded by their loving children, young people are studious, and the benefits of education flourish on fertile soil. The message conveyed by *The Beloved Mother* (1765) was interpreted by pro-birth Diderot as: "Give your wife children, give her as many as you can." But the critic also noted Greuze's "ambiguous" attitude, "this voluptuous blend of hardship and pleasure". In another painting he seemingly promotes Rousseau's campaign in favour of breast-feeding.

| Jean-Baptiste Greuze
THE BROKEN PITCHER
| 1772, oil on wood,
108.5 x 86.5 cm
(42 3/4 x 34 in).
| Musée du Louvre, Paris.

Nicolas-Bernard Lépicié |
LE LEVER DE FANCHON
1773, oil on canvas,
74 x 93 cm
(29 1/8 x 36 5/8 in).
Musée de l'hôtel Sandelin,
Saint-Omer.

Lépicié painted many
historical compositions
but remains above all
famous for this
unaffected domestic scene
which shows affinities
with Chardin and Greuze.

The father as head of the family is a key figure in Diderot's plays and Greuze's painting. In 1758, Diderot published a play entitled *The Head of the Family*; the previous year, he wrote in his *Entretiens sur le Fils naturel*: "The head of the family! What a subject for a century such as ours when apparently no one has the slightest idea what it means." Greuze placed the father in the centre of several of his larger compositions and although the fiancé is the pivotal figure in *L'accordée de village* (1761), the eye is drawn to the father. In 1755, the artist painted *Father Reading the Bible to His Children*, purchased by the renowned collector Lalive de Jully, and, in 1801, *Father Handing Over the Plough to His Son Before the Assembled Family*. The paralytic father is the object of the entire family's devoted attention in *Filial Piety* (1763). *The Paternal Curse* (*The Ungrateful Son*) painted in 1777 and its sequel, *The Son Punished,* painted the following year, two acts in the same drama, are based on the key father/son relationship.

Greuze's art thus involved dramatization: the numerous figures, dynamically expressive gestures and drapes, extremely detailed studies of physical features (Greuze was also an excellent portraitist), predominating central moral theme, low-relief and almost theatrical composition, taken together, reveal an affinity with Poussin, particularly the latter's *Testament of Eudamidas*. This

| Jean-Baptiste Greuze
THE UNGRATEFUL SON
1777, oil on canvas,
130 x 162 cm
(51 1/8 x 63 3/4 in).
Musée du Louvre, Paris.

clearly indicated that his pretensions to be regarded as a history painter – his *Septimus Severus*, it should be recalled, featured a father rebuking a treacherous son – were quite consistent with the overriding logic of his conception. The genre scene was elevated to the status of heroic portrayal of history. The systematic verisimilitude of costumes and interiors was designed to place moral values firmly in a popular setting.

Another, and in this case more ambiguous, aspect of Greuze's sentimentality involves his recurrent use of barely adolescent, yet already sexually provocative, female figures. *The Morning Prayer* (c. 1775-1780) is a good example: although the young girl is engaged in an apparently commendable act of piety, her bared shoulder and hair hanging free, together with the bed, invest the image with sensual connotations. There is a similar ambivalence in the anecdotal scenes in which a dead bird, a broken pitcher (as in *The Broken Pitcher*, once owned by Mme du Barry) or mirror symbolically allude to lost virginity; once again, despite the sincerity of grief, the figure is ambiguous. Greuze introduced a specific type of feminine figures: most often a bust portrait, bathed in a golden light, hair hanging free, eyes half upturned, and crumpled draperies hinting at nakedness. Even his portraits of children feature the same wide-eyed expressions and strange, melancholy gaze: a manner

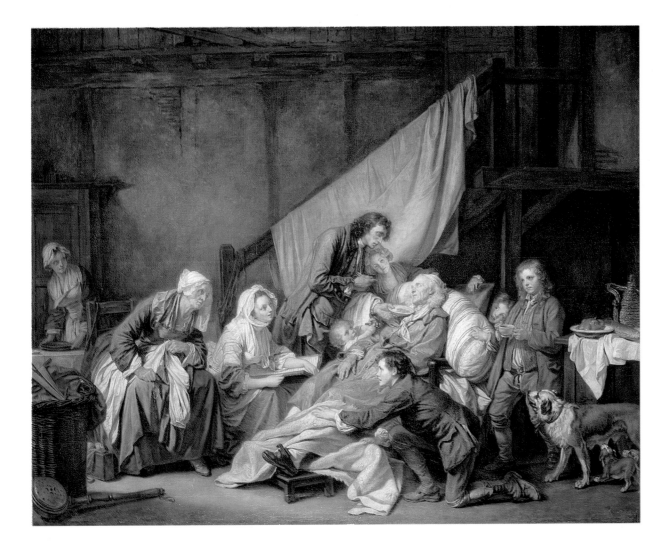

Jean-Baptiste Greuze |
FILIAL PIETY
1763, oil on canvas,
115 x 146 cm
(45 1/4 x 57 1/2 in).
The Hermitage, St Petersburg.

easily imitated, but technically hard to achieve, for Greuze displayed remarkable skill in enhancing the sensuality of his figures with the use of glazes and blended colours.

Many painters adopted the twin facets of this peculiar 18th-century morality, nurtured by a literature in which the edifying spectacle of a virtuous father's misfortunes or the ambivalent sorrows of a provocatively innocent maiden were considered equally moving. The same Diderot who called for a congenial representation of virtue could lay claim to the sorrow of the *Young Girl Crying Over Her Dead Bird* (1765). The second facet indeed gave rise above all to the numerous illustrators of novels and versions of ribald tales who attracted the attention of the Goncourt brothers. But it also produced its minor masters, like Pierre-Antoine Baudouin (1723-1769), Boucher's pupil and son-in-law, who is said to have died from overwork and over-indulgence. Étienne Aubry (1745-1781), with his *Paternal Love* and *Farewell to the Wet-Nurse*, or Pierre-Alexandre Wille (1748-1821) with *Merit Twice Rewarded*, followed in Greuze's moralizing footsteps yet never established a wide reputation. The more successful, and more perceptive, Jean-Baptiste Le Prince (1734-1781) depicted genre scenes based on similar clichés – the 'happy family', for instance – but gave them a Russian setting. To their exotic appeal was

added the contemporary French fascination with the political destiny of Russia[6] where Enlightenment philosophers dreamt of introducing their reforms. Le Prince spent five years in that country and in 1763 returned with picturesque views, the most famous of which is *The Russian Cradle* (1765). His work stood halfway between the pastoral and the portrayal of manners; his subjects were so popular that the artist produced many paintings and executed a series of Beauvais tapestry designs, the *Russian Games*.

Many late 18th-century artists adopted a purely anecdotal approach to the genre scene, with no real moral significance. Although of indisputable historical documentary value, they are less interesting from a pictorial point of view. Léopold Boilly (1761-1845), apart from more official works such as *The Triumph of Marat* (1794), painted carefully observed, realistically executed scenes like *Isabey's Studio*, shown at the 1798 Salon. This particular style, illustrated by the same artist's *Improvised Concert*, heralded the bourgeois painting of the Louis-Philippe period rather than romanticism, the budding signs of which were more discernable in landscape painting.

During the Revolution, particularly under the Directory, the Rousseauesque taste for natural virtue was sustained. At the 1798 Salon, following on in the tradition of Greuze's *Father Handing Over the Plough to His Son*, and in a scene worthy of Rousseau's *Émile*, François-André Vincent (1746-1816)

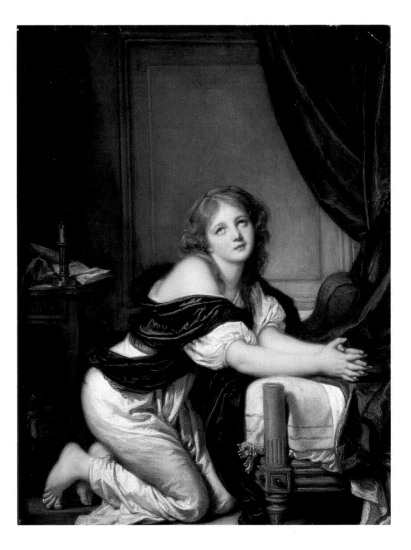

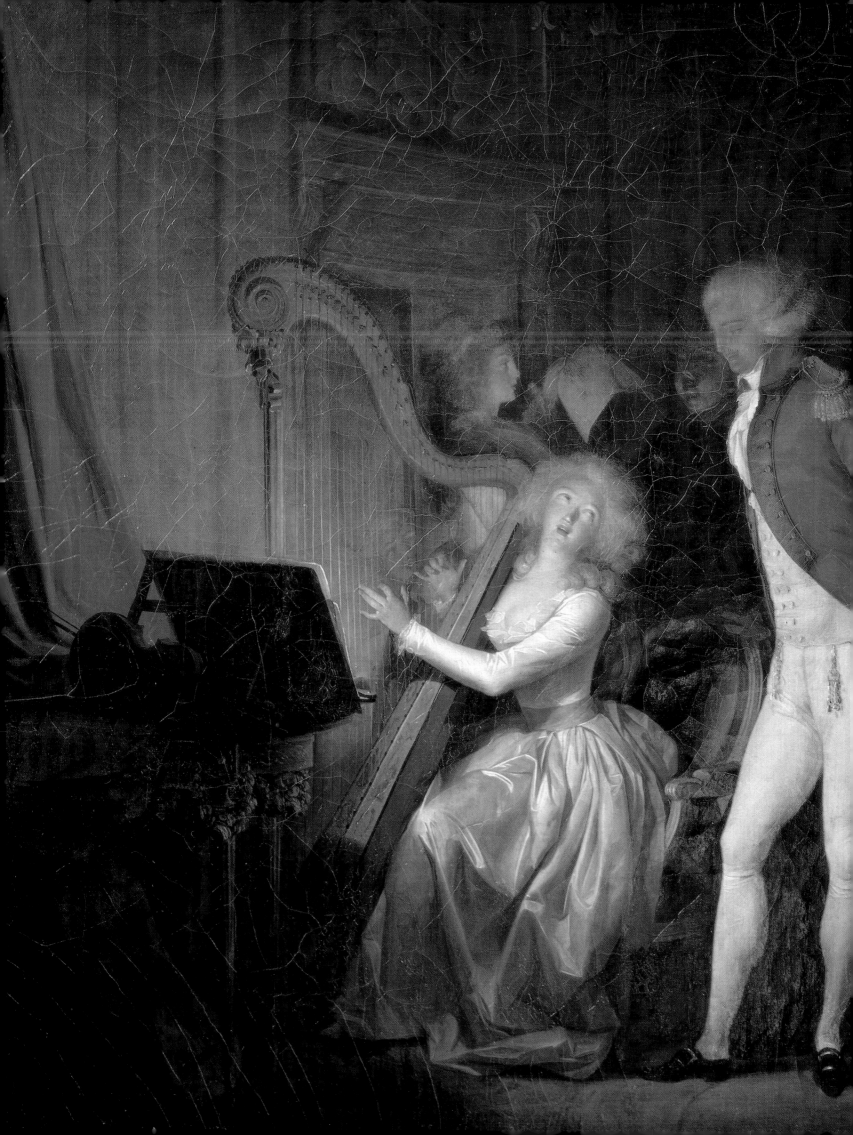

| Louis-Léopold Boilly
THE IMPROVISED CONCERT
C. 1790, oil on canvas,
46 x 55 cm
(18 1/8 x 21 5/8 in).
Musée de l'hôtel Sandelin, Saint-Omer.

Jean-Baptiste Le Prince |
THE RUSSIAN CRADLE
Exhibited at the 1765 Salon,
oil on canvas, 59 x 74 cm
(23 1/4 x 29 1/8 in).
The J. Paul Getty Museum, Los Angeles.

The Enlightenment philosophers'
cherished theme of the
"happy family" transferred to a
Russian setting.

| François-André Vincent
THE PLOUGHING LESSON
Year VI (1798), oil on canvas,
213 x 313 cm
(83 7/8 x 123 1/4 in).
Musée des Beaux-Arts, Bordeaux.

exhibited a *Ploughing Lesson*: an idyllic vision of rediscovered harmony in which peasant and bourgeois commune together in exaltation of manual labour on the land.

Sublime nature and ruins

Despite the accusation of artificiality, the 18th century was also enamoured of the natural world. Nature, not only in the philosophical but also in the everyday sense of the term, was part of the new sensibility. The sublime, that new criterion of aesthetic experience, finally shattered normative conceptions of beauty. And Nature, precisely, was one of its sources.

Watteau had already been described as an "accurate observer" of nature. Desportes had painted landscapes which displayed realistic awareness of interplaying relief and harmonious skies. Oudry painted from nature outdoors at Arcueil. Boucher moved from pastoral scenes to country landscapes (a royal commission of 1756) in the vicinity of Paris… The vogue for Dutch painting fostered a taste for landscape and led to a shift away from its idealized representation. Fragonard, it should be recalled, had been marked by Ruysdael, and this painter's influence carried over to the romantics of the following century. His grandiose vistas and atmospheric skies almost seem to herald the sublime, and even the taste for ruins. The other principal source was of course Poussin's historical landscape painting. And finally, there was the discovery of new landscapes by artists in the course of their travels, particularly in Italy.

It was moreover in travel literature that the term 'romantic' first appeared in its new sense. In 1739, while crossing the Alps, both Thomas Gray and Horace Walpole employed the term to describe waterfalls, cliffs, or a rickety bridge, no longer merely referring to a picturesque vision, but to the awareness of an all-powerful irrational force, to the divine presence which

| Louis-Gabriel Moreau the Elder
RIVERSIDE LANDSCAPE
WITH SHEPHERDS AND FLOCKS
C. 1780 (?), gouache,
59.3 x 84.4 cm
(23 3/8 x 33 1/4 in).
| The Pierpont Morgan Library, New York.

Joseph Vernet |
VIEW OF THE PORT OF BORDEAUX FROM CHÂTEAU TROMPETTE
Exhibited at the 1759 Salon,
oil on canvas, 165 x 263 cm
(65 x 103 1/2 in).
Musée de la Marine, Paris.

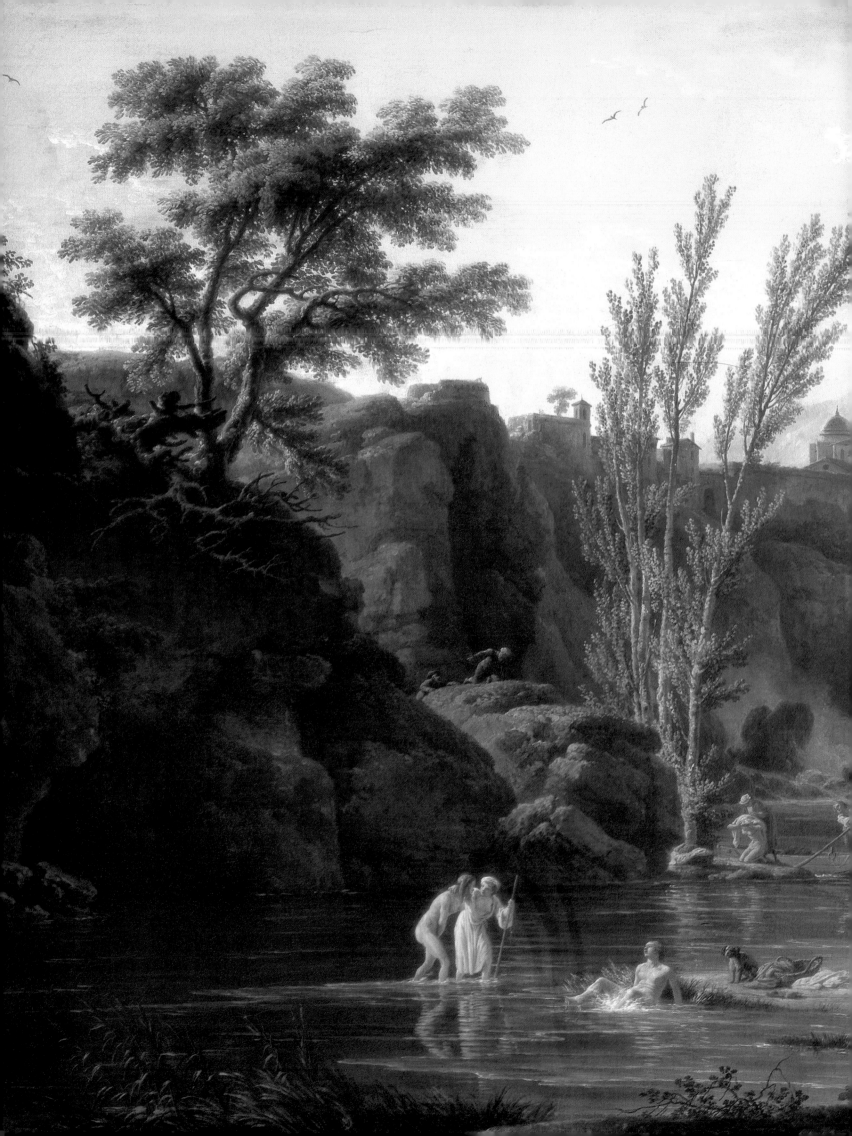

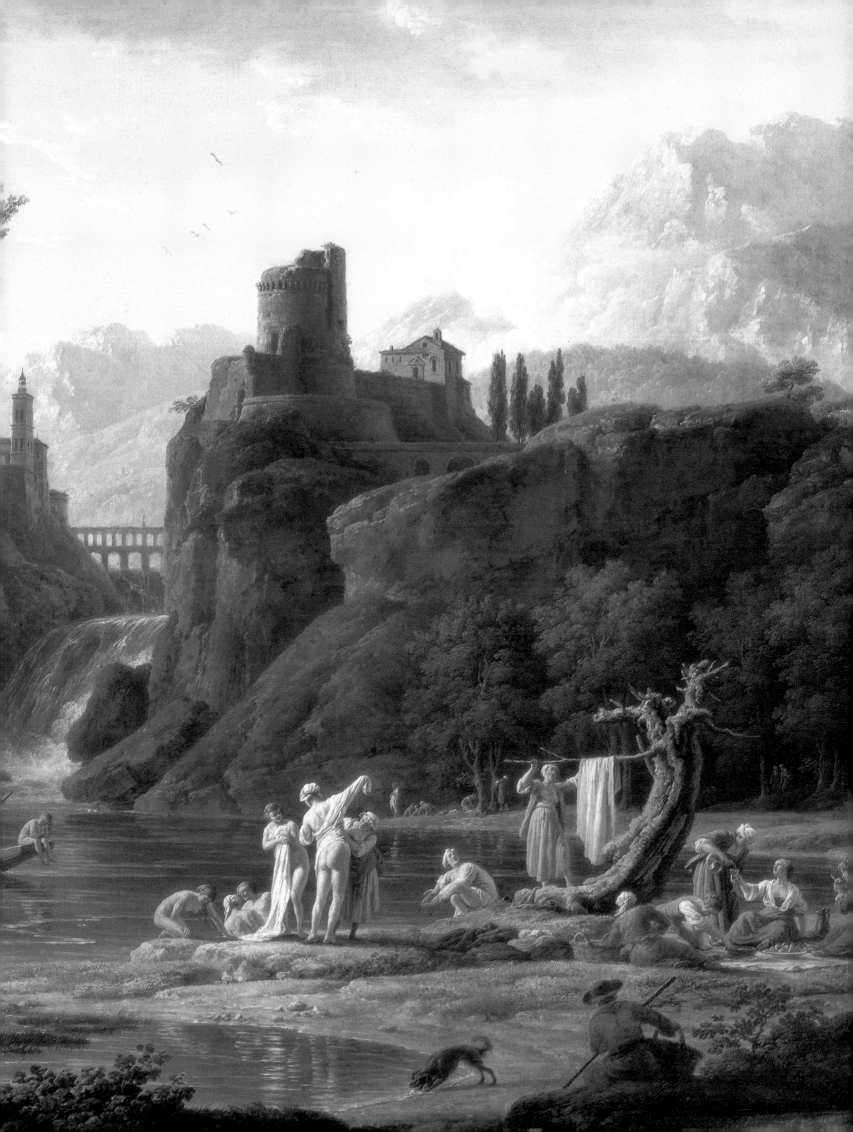

expressed itself through the utter amazement of the enraptured soul. Rousseau's *La nouvelle Héloïse* (1761), which glorified Nature even in a humble garden, provided sensibility with a mouthpiece and paved the way for romanticism.

The change in landscape painting was significant. The genre grew in scope and began to offer a rich variety of historical landscapes and views of ruins, ranging from meticulous topographical sketches to watercolours painted from nature, capturing atmospheric effects. Nevertheless, two distinct approaches materialized: one, picturesque, favoured Italian landscapes and views of idyllic countryside; another, sublime, in tune with Diderot's aspirations, called for mountains, raging torrents, caves and storms. Although Louis-Gabriel Moreau (1739-1805), elder brother of the famous illustrator, confined himself to the first approach, other artists – for instance, Philippe-Jacques de Loutherbourg (1740-1812) who eventually move to England and become one of the first painters of the new industrial landscape – showed themselves capable of handling both.

Claude-Joseph Vernet (1714-1789) personified the new status of landscape painting. In 1753, he was received into the Academy with a *Seascape, Effect of Sunset* and honoured with a prestigious royal commission to paint the ports of France. This project, which was to occupy him until 1765, was a propaganda assignment: Marigny indeed wished to demonstrate the prosperity of French trade, particularly in view of keen Franco-British commercial and colonial rivalry. Thus Vernet's *View of the Port of Bordeaux from Château Trompette* (1759) almost revels in relating the perfect layout of gardens and architecture (including the new Place Royale with the statue of the king) to the bustling activity of the harbour, and at the same time celebrates the programme of major building works undertaken by Superintendent Tourny. As this type of views called for accuracy, Vernet gave free rein to his imagination in more decorative paintings in which he mingled genre scenes – women bathing or washing clothes – seascapes, and different moments of the day. He combined a partiality for moonlight effects with his passion for the fury of the elements. Storms became a recurrent theme, whether depicted as unleashed elements or as dramatic literary-inspired scenes, as in *The Shipwreck of the Virginie at Île de France* which he submitted to the 1789 Salon just before his death. This Salon was his apotheosis: he exhibited fourteen paintings, including four shipwreck scenes. Vernet embodied Diderot's ideal – needless to say,

Pages 150-151
Joseph Vernet
MORNING, BATHING WOMEN
1772, oil on canvas,
98 x 162 cm (38 5/8 x 63 3/4 in).
Musée du Louvre, Paris.

Like the traditional 'seasons',
times of day were combined
with genre scenes in a dramatization of nature.
This work was painted
for Mme du Barry's pavilion at Louveciennes.

Joseph Vernet
NOON, A STORM or
THE WASHERWOMEN
1765, oil on canvas,
108 x 147 cm
(42 1/2 x 57 7/8 in).
Musée du Louvre, Paris.

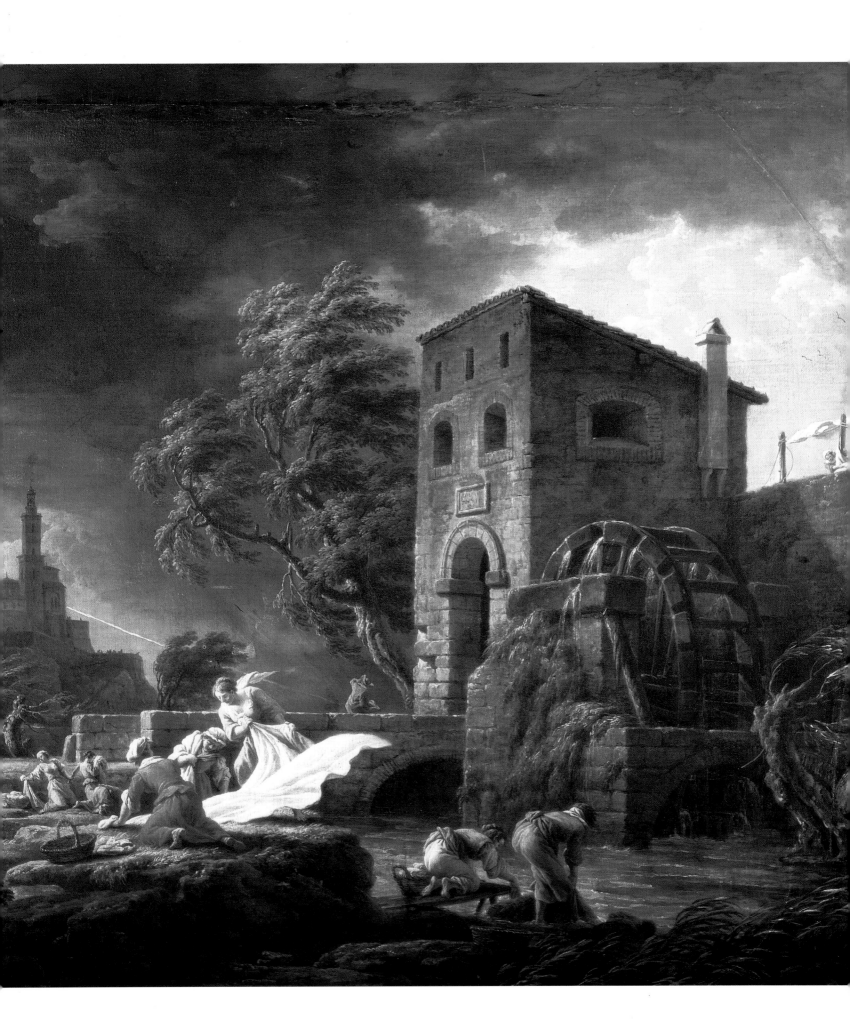

the critic bought a *Storm* – because he sought rapturous emotion in Nature and experimented with fear. Is he not said to have had himself, like Turner later, lashed to a mast to observe the effects of a storm?[7] In his seascapes, Vernet introduced an element which many romantics were to discover above all in mountain scenes. He was responding to the demands formulated by Chateaubriand in his *Letters on the Art of Drawing in Landscapes*, written in exile in London in 1797: "Like the portrait, the landscape has its moral and intellectual side; it also has to speak and its material composition should enable us to experience the reveries and feelings inspired by different places." Besides Vernet another painter, Hubert Robert (1733-1808), might, had he been so inclined, have offered an alternative vision of the sublime using the theme of ruins. Robert had spent some ten years in Rome and on his return to France was accredited and received into the Academy on the same day. Diderot hailed his submission to the 1767 Salon in words which have remained famous: "O the beautiful, the sublime ruins!" But he criticized Robert for not having respected the "poetic dimension" of the genre by introducing too many figures which prevented him from "trembling" before the silence, the solitude, and the darkness of the building. Anticipating Volney, Diderot mused: "The ideas which ruins awake in me are great. Everything is destroyed, everything perishes, everything passes on. Only the world remains. Only time endures." Crags, valleys, crumbling tombs, torrents pouring into the abyss, each feature reminds him that he "is walking between two eternities". Yet the work of Robert, the most famous French painter of ruins, also had less gloomy aspects. Although he was indeed a romantic, painting glowing red depictions of *Fires – Rome, The Opera* (1781) or *The Hôtel-Dieu* – a theme which he explored before Turner, he retained a certain lightness and taste for pleasure which militated against the profundity demanded by Diderot. He drew gardens and painted public events such as the opening ceremony of the Neuilly Bridge (1772) or the demolition of the Bastille, as well as imaginary architectural views. Robert was the heir of Pannini and also painted the monuments of Rome. In 1787, he was commissioned to execute four views of Gallo-Roman antiquities in Nîmes, Orange and the Pont du Gard for the Château de Fontainebleau. Like d'Angiviller's programmes, this commission revealed a sensitive attitude to national history. The sublime aspect of architectural landscapes and ruins was perhaps best captured in works by architects themselves. Piranesi's *Views of Rome* or his

Hubert Robert |
THE PORT OF ROME
1766, exhibited at the 1767 Salon,
oil on canvas,
118 x 145 cm (46 1/2 x 57 in).
École nationale supérieure des Beaux-Arts, Paris.

In the manner of Pannini,
Robert has assembled Roman
monuments – the Pantheon and parts
of the Capitol – in an imaginary view.

Pierre-Henri de Valenciennes
**NARCISSUS GAZING
AT HIS REFLECTION IN THE WATER**
1792, exhibited at the 1793 Salon,
oil on canvas, 54 x 81 cm
(21 1/4 x 31 7/8 in).
Musée des Beaux-Arts, Quimper.

Prisons introduced a more fantastically imaginative note of architectural whim into painting, eventually amplified by the classical revival. Jean-Laurent Legeay (1710-1786), Louis-Jean Desprez (1743-1804) and Louis-Joseph Le Lorrain (1715-1759) created a "paintbrush architecture",[8] teeming with the grandiose effects of Nature on architecture; they invented poetic or pathetic settings, fantasy ruins and gloomy tombs. Their archaeologically-inspired visions paved the way for part of the late 18th-century macabre imagination. The French Revolution made the theme of ruins topical. The title of Volney's *Ruins, given to his Meditations on the Revolutions of Empires* (1791), was inspired by the author's contemplation of the ruins of Palmyra. By then, landscape painting had reached its apogee. In various forms, it dominated the 1793 Salon, acting perhaps as a kind of refuge. Even the traditional historical landscape experienced renewed popularity thanks to Pierre-Henri de Valenciennes (1750-1819), who has been hailed as an '18th-century Corot'. In 1793 he submitted a fascinating *Narcissus Gazing at His Reflection in the Water*, featuring a meticulous study of nature. It breathes a kind of nostalgia, a dream of using a Poussin landscape as a means of escaping from the present. De Valenciennes provided the transition to the

Charles-Louis Clérisseau
THE TIVOLI WATERFALLS
1769, gouache, 70 x 50 cm
(27 1/2 x 19 5/8 in).
Victoria and Albert Museum, London.

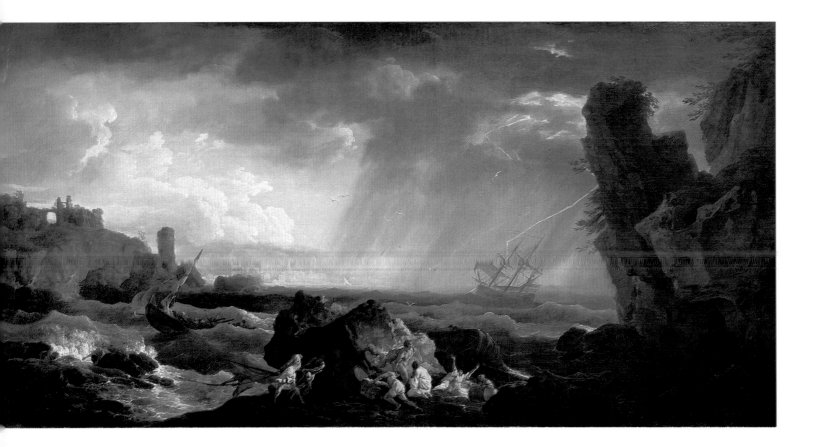

19th century. In 1816, at the newly-founded École des Beaux-Arts, he succeeded in having a 'Grand Prix' for historical landscape painting established... and the very first prize-winner was to be Achille-Etna Michallon (1796-1822), Corot's master!

| Joseph Vernet
SEASCAPE, EVENING OR **THE STORM**
N.d., oil on canvas,
78 x 156 cm
(30 3/4 x 61 3/8 in).
Musée de la Marine, Paris.

1. Ernst Cassirer, *The Philosophy of the Enlightenment*, Princeton University Press, 1951; *Homo Aestheticus. The Invention of Taste in the Democratic Age*, 1990.
2. Régis Michel, *Aux armes et aux arts*, 1988, p. 25.
3. In an introduction to Poussin, included in *Feuillets d'automne*, 1949; Livre de poche, 1971, p. 183.
4. François Chapon, *Jacques Doucet, ou l'art du mécénat*, 1996, p. 91.
5. In his day, he was compared with the famous melodramatic playwright, Nivelle de la Chaussée; quoted by L. Réau, *Histoire de la peinture française au XVIIIᵉ siècle*, 1925, vol. II, p. 18.
6. Perrin Stein, "Le Prince, Diderot et le débat sur la Russie au temps des Lumières", in *Revue de l'art*, n° 112, 1996, pp. 16-27.
7. In 1822, Horace Vernet painted the episode, turning his grandfather – who, if the story was true, was no doubt more interested in accurate observation than extreme sensations – into a romantic hero.
8. Gilbert Érouart, *L'architecture au pinceau. Jean-Laurent Legeay. Un piranésien dans l'Europe des Lumières*, 1982.

4. The Classical Revival and the French Revolution

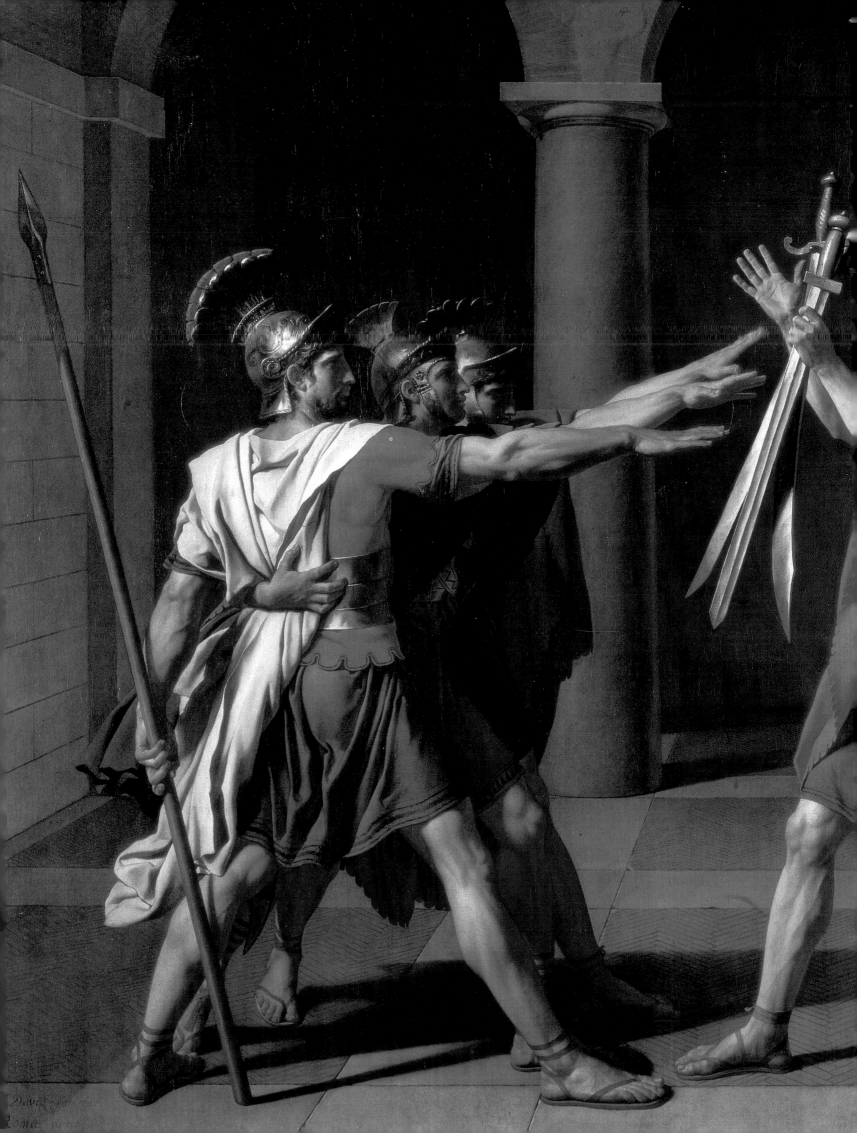

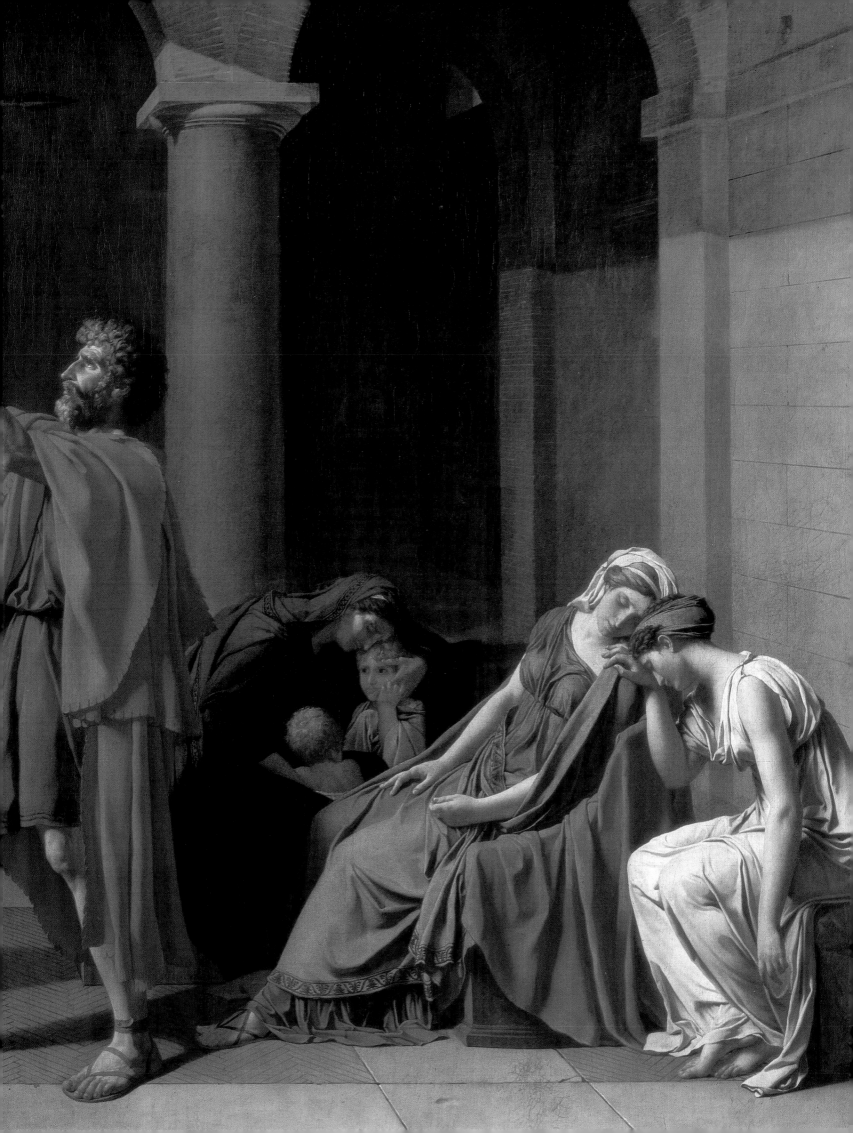

In the 1760s, the change in sensibility towards an embryonic romanticism with the assertion of individual experience, love of Nature, and fascination for the horrific and the sublime, was accompanied by a passion for classical antiquity. Even before Winckelmann arrived in Rome, Marigny made his 'Grand Tour' to Italy in 1750-1751, Soufflot visited Paestum and, in 1754, Cochin and Bellicard published their *Observations on the Antiquities of Herculaneum*. Excavations had been under way at Pompeii and Herculaneum since 1738. Despite the fact that Charles II of Naples founded the Accademia Ercolanense in 1757 in an attempt to reserve rights of publication of the discoveries for the *Pitture antiche d'Ercolano* (1757-1792), archaeological knowledge spread swiftly, together with a 'Greek' fashion which assumed two facets – in fact corresponding to the antagonism between increasingly moralizing history painting and often still 'galant' genre painting.

The first facet was to manifest itself in a tendency to delve into the past in order to forge national identity, and in the effects of the French Revolution, which felt duty bound to associate rococo with Ancien Régime immorality. History was treated in the sublime manner, death and terror encroached upon art. Buttressed by a new ideological purpose, the Revolution revitalized history painting while echoing Greuze's moralizing tone. Its new institutions, competitions and incentives merely perpetuated the modes of production of the Ancien Régime. The Salon, for instance, continued to be held, even during the darkest days of French history; similarly, 'galant' themes survived in mythological guise. Only the academic structure itself was to topple, symbolically felled by David. Born out of the aspirations of the Enlightenment, the Revolution also revealed darker elements which lurked in the imagination of the new citizens. The result was an inextricable mingling of neo-classical aesthetics which advocated a return to the antique, and a romantic aestheticism which glorified the present, subjectivity, and new myths.

'Greek' rococo?

In 1754, Cochin published his amusing *Plea to Goldsmiths, Carvers, Wood Sculptors, etc.*: "May it be humbly submitted to these gentlemen, that despite all the efforts the French Nation has made for several years to adapt its faculty of reason to the quirks of their imagination, it has not entirely succeeded…" Cochin was attacking incongruities, "S-shaped contours", and "this plethora of convoluted, extravagant ornamentation". There could be no better illustration of anti-rococo reaction, but the aesthetic issue was coupled with a moral dimension. The move back to the antique and to Poussin saw itself as a moralization of society. Despite the fact that Louis XV cared little for moralizing art,[1] it was nevertheless during his reign, and not that of his successor, better known for his moral sensitivity, that the reaction took place. It has been pointed out forcefully that, from the 1760s, Louis XV himself had to adapt to what was in effect the Louis XVI style!

Can, however, Comtesse du Barry's preference for Vien's Greek-costumed amorous playlets be interpreted as the introduction of neo-classicism? Had some profound change in spirit taken place between Fragonard's *Lover*

Pages 160-161
Jacques-Louis David
THE OATH OF THE HORATII
1784, exhibited at
the 1785 Salon,
oil on canvas,
300 x 420 cm
(118 1/8 x 165 3/8 in).
Musée du Louvre, Paris.

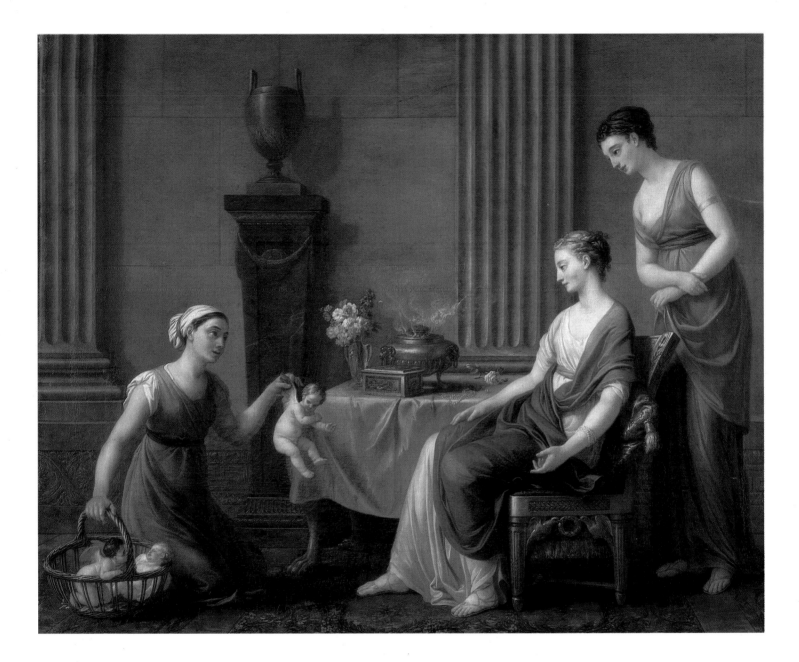

| Joseph-Marie Vien
THE CUPID SELLER
1763, oil on canvas,
117 x 140 cm
(46 x 55 1/8 in).
Musée national du château,
Fontainebleau.

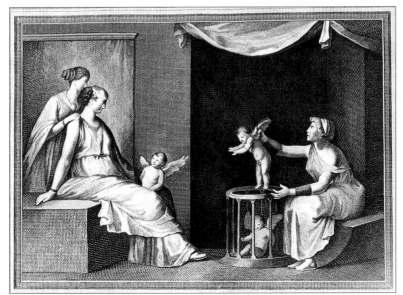

| C. Nolli
THE CUPID SELLER
1762, etching
from the album
Pitture antiche d'Ercolano.
Bibliothèque nationale de France,
Cabinet des estampes, Paris.

This engraving represents
a Roman painting discovered
in 1759 at Gragnano.
The original is
in Naples Museum.

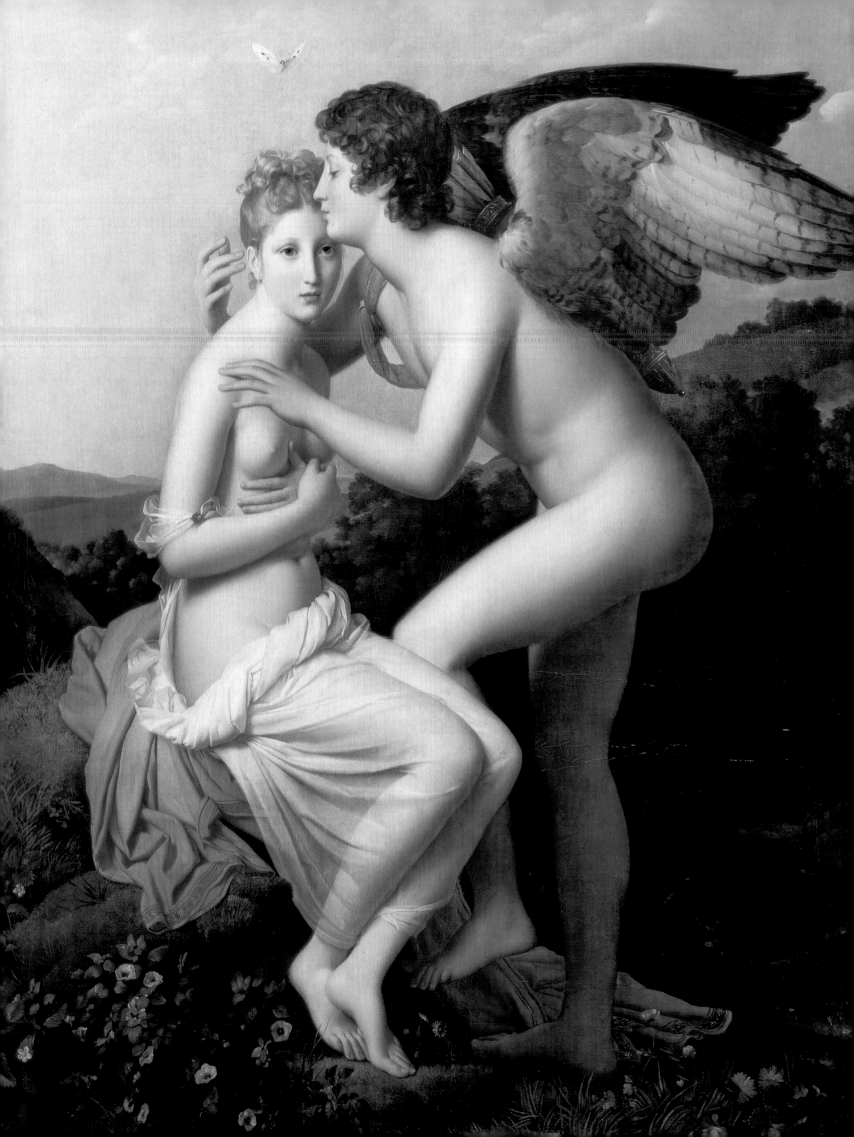

Crowned and Vien's depiction of lovers before Hymen's altar? Since the 1750s, the antique had enjoyed undeniable popularity, coupled with a reaction against the 'minor manner' and even a demand for morality. We have already seen Diderot's ambitions, although he was wary of an over-standardized 'antique' model and, in the name of genius, unhesitatingly preferred "a humble original" to "an accomplished copyist". But the classical revival was gathering impetus.

During the 1750s Rome, and all Italy, became the seedbed for neo-classicism. The German painter Anton Raphael Mengs (1728-1779) moved there in 1751; four years later he was joined by Joachim Winckelmann who was to become librarian to the famous collector Cardinal Alessandro Albani and subsequently (in 1765) Prefect of Antiquities in Rome. These men, along with others such as the Scots painter and archaeologist Gavin Hamilton (1723-1798), were to attempt an artistic revival based on archeology, and formulated idealistic theories in reaction to the sensualism spread by French painting and the rococo style.

Winckelmann published his famous *Reflections on the Painting and Sculpture of the Greeks* in Dresden in 1755, and his seminal *History of Ancient Art* in 1764. Meanwhile, Comte de Caylus (1692-1765), author of an *Anthology of Egyptian, Etruscan, Greek and Roman Antiquities* (1752-1757) had, in 1755, advised artists to devote themselves to 'antique' genre painting: "The simple dress of Greek girls," he wrote in his *New Subjects for Painting and Sculpture*, "the nobility of their attitudes, the elegance of their forms, the beauty of their features, all that, together with requisite research into costume, will highlight the painter's spirit and talent to the greatest advantage." Antique works were therefore to serve as an inspiration, to be used as a format, rather than as something to be imitated. In France, neo-classicism first went through an anacreontic stage before reviving the grand manner and reaching its climax with David – who himself painted conventional amorous subjects as *Cupid and Psyche* or *Paris and Helen*.

The works of Joseph-Marie Vien (1716-1809) best illustrate the taste for the antique. When, in 1799, already an old man, he was made a senator by the Consulate, the pupils of his pupil, David, organized a celebration dinner for the painter whom the poet Ducis was to hail as "the great regenerator of the French School".

Although Jean Locquin has brilliantly shown that 1747 marked the onset of a revival in history painting, that very year Vien painted a *Lot and His Daughters* – a pendant for *Susanna and the Elders* – which still bore the stamp of the generation of Boucher and Natoire. Influenced by Caylus, his first work 'in the Greek style' was a bust portrait of *Minerva* (1754) using an encaustic wax technique derived from antiquity which the scholar was attempting to reintroduce; the same year, he was admitted to the Academy with *Daedalus Attaching Icarus' Wings*, a subject which combined classical antiquity… and the use of wax! Vien achieved fame in 1763 with *The Cupid Seller*, a painting inspired by a fresco discovered at Gragnano (Stabiae) in 1759 and engraved in 1762 by C. Nolli in Volume 3 of *Pitture antiche d'Ercolano*. The lascivious

François Gérard
PSYCHE AND CUPID
Exhibited at the 1798 Salon,
oil on canvas,
186 x 132 cm (73 1/4 x 52 in).
Musée du Louvre, Paris.

subject-matter is set in a simple composition rhythmically partitioned by a pair of pilasters; the young women are draped in antique robes, and an archaeological note is added by objects such as the incense-burner and vase. All these features were already present in earlier works – the extremely sensitive *Sweet Melancholy*, painted in 1756, and the 'seasons' series executed in 1762. Vien indeed discovered his personal manner in Italy: his *Melancholy* is reminiscent of the works of Pompeo Batoni (1708-1787), a painter who advocated a return to antique grace; by 1763, the lesson had been triumphally assimilated. That same year Grimm, in his *Literary Correspondence*, reported on this craze: "Ornamentation and decoration had reached the height of absurdity in France: perpetual change was necessary since that which is not reasoned can only appeal by its novelty. For some years, antique ornamentation and forms have been sought after; this has led to a considerable improvement in taste and the fashion has become so widespread that nowadays everything is done in Greek style." It was thus initially a question of 'fashion': the goal was antiquity, but combined with the graceful touch of Correggio. From the point of view of technique, the change was above all expressed in the taste for design and contour, the use of precise tones, and a rejection of touch.

Diderot's interpretation of *The Cupid Seller* underlined the ambivalence of such a reaction. While acknowledging the antique-style treatment of the "anacreontic ode", which resulted in "formal elegance, grace, ingenuity, innocence, simplicity", he could not help but regard the merchant woman as a "strumpet" and detect indecency in the little Cupid's gesture; Vien painted "feet, hands and arms to be kissed a thousand times"... And yet change was manifest in the importance which Vien attached to restraint and moderation, revealing his aptitude, as a history painter, to portray saints and great men – albeit less successfully, as his art was gracious rather than grand. Among the many great figures he painted, including St Martha (Tarascon), Marcus Aurelius (Choisy), and St Louis (the École Militaire chapel), only that of St Denis (Saint-Roch Church) was of above-average quality. Despite such commissions for paintings in the grand manner and a series of ambitious works depicting episodes from the Trojan War (1783-1793), Vien remained faithful to his more light-hearted 'Greek' subjects; in 1789 he painted *Cupid Fleeing Slavery*, a pendant to *The Cupid Seller*. In another initiative in keeping with the contemporary mood, from 1780 he executed series of drawings of *Nymphs and Cupids at Play*, the *Vicissitudes of War* and, in particular, in a similar vein to Greuze he painted *The Joy of Life* or *The Marriage of Hymen and Cupid* (1797-1799), a subject suited to the Revolutionary concept of morality – marriage as the key to happiness was an ideal theme of social regeneration, in tune with the rejection of rococo degeneracy, and set in an idyllic past. The anacreontic treatment of antiquity did not end with Vien, as is shown by the incredible success enjoyed by the theme of Psyche, a myth reinterpreted by a host of painters and sculptors who found in it the opportunity to indulge in the visual representation of attractive adolescent physiques, rather than any philosophical significance. For instance, Canova's *Psyche Brought to Life by Cupid's Kiss* was matched by the chaste brush of lips in *Psyche and*

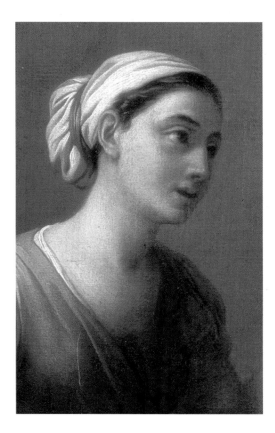

| Joseph-Marie Vien
THE CUPID SELLER
| Detail.

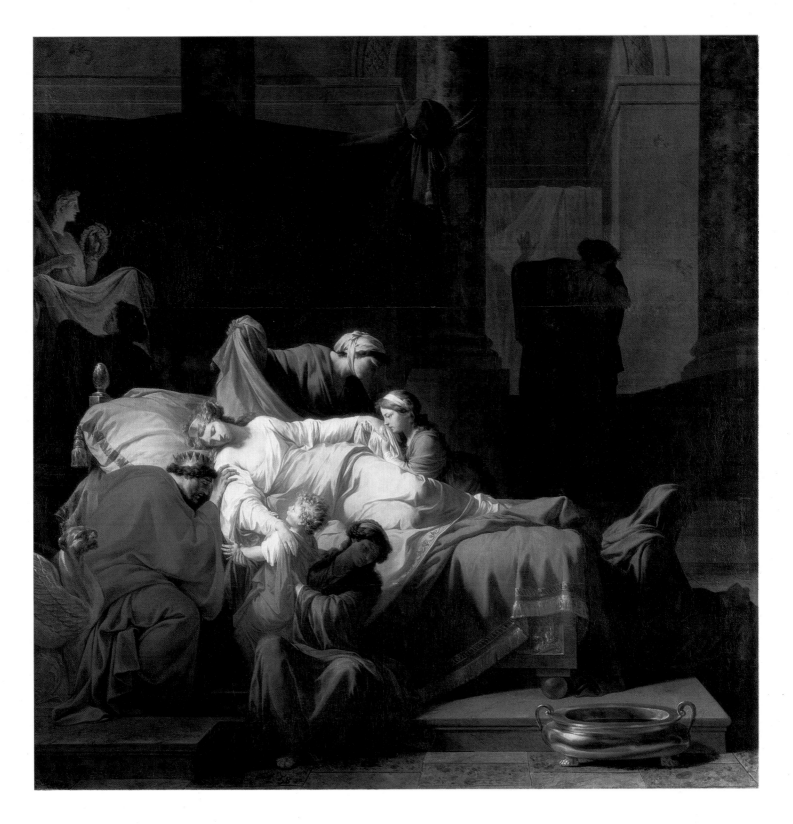

Pierre Peyron |
THE DEATH OF ALCESTIS or
THE HEROISM OF CONJUGAL LOVE
1785, oil on canvas,
327 x 325 cm (128 3/4 x 128 in).
Musée du Louvre, Paris.

Cupid (1798) by François Gérard (1770-1837), an artist who contributed to the First Empire vogue for this light-hearted antiquity, the great exponent of which was to be Pierre-Paul Prud'hon. An unbroken tradition ran from François Le Moyne down to the Napoleonic period.

David and neo-classical heroization

While Vien applied neo-classical aesthetics to the genre scene, history painters, anxious to pursue the grand tradition, meanwhile produced works in which a dramatically reconstructed vision of a violent and virtuous classical antiquity lent itself to complex compositions borrowed from the Bolognese masters. Vien's earliest works were in this vein, like those of the King's First Painter, Jean-Baptiste Pierre, who painted *The Death of Harmonia* in 1751. Their real inspiration was Il Guercino rather than antiquity; the same applied to Jean-Baptiste Deshays (1729-1765) who, although Boucher's son-in-law, applied an austere style to pathetic themes such as that of his reception piece, *Hector Exposed on the Banks of the River Xanthus* (1759). This taste for dramatization, often serving civic morality, passed on to French neo-classical painting; from 1760, compositions became more rigid and theatrical; some drew their inspiration from antique bas-reliefs or paintings by Poussin. Artists were no longer content with a sentimental, anecdotal approach to history; its tragic grandeur was now depicted for its contemporary relevance.

It was with the generation of Vien's pupils – the most talented of whom won the Prix de Rome, including François-Guillaume Ménageot in 1766, François-André Vincent in 1768, Joseph-Benoît Suvée in 1771, Pierre Peyron in 1773, Jacques-Louis David in 1774, and Jean-Baptiste Regnault in 1776 – that neo-classicism triumphed, revealing a profound relationship between an antique ideal, an often tragic iconography, and the reformist aspirations of men who were to embrace the Revolution. But their art was not solely the serene vision of a "noble simplicity and quiet grandeur", as advocated by Winckelmann, enthralled by the *Apollo Belvedere*; it was also what some authors have called a "horrific neo-classicism",[2] that is to say permeated with romantic aspirations, a sublime vision of history and expressive violence. Hero's lamentation before the "visually too perfect" corpse of Leander in the painting on this theme by Jean-Joseph Taillasson (1745-1809), another of Vien's pupils, was indeed romantic, even if both subject and conventions belonged to classical culture.

Painting now cultivated *exemplum virtutis*, symbol of the rejection of rococo sensualism. Heroes laid down their lives for their country, for values which were soon to be deemed 'republican', for their family, and so on. Widows became paragons of virtue. As in Greuze's *The Inconsolable Widow*, Portia, in the eponymous painting by Nicolas-Bernard Lépicié (1777), declares to her husband Brutus that she will not live on after his death, while David depicted Andromache mourning Hector (1783). Each protagonist seemed prepared to die for a cause: in 1782, Peyron (1744-1814) painted *The Funeral of Miltiades* (in which a son has himself clapped in irons in place of his father's corpse so that the father, the victor of Marathon, can be buried) followed, in

Jacques-Louis David |
PORTRAIT OF COUNT STANISLAS POTOCKI
Exhibited at the 1781 Salon, oil on canvas, 304 x 218 cm (119 5/8 x 85 7/8 in).
National Museum, Warsaw.

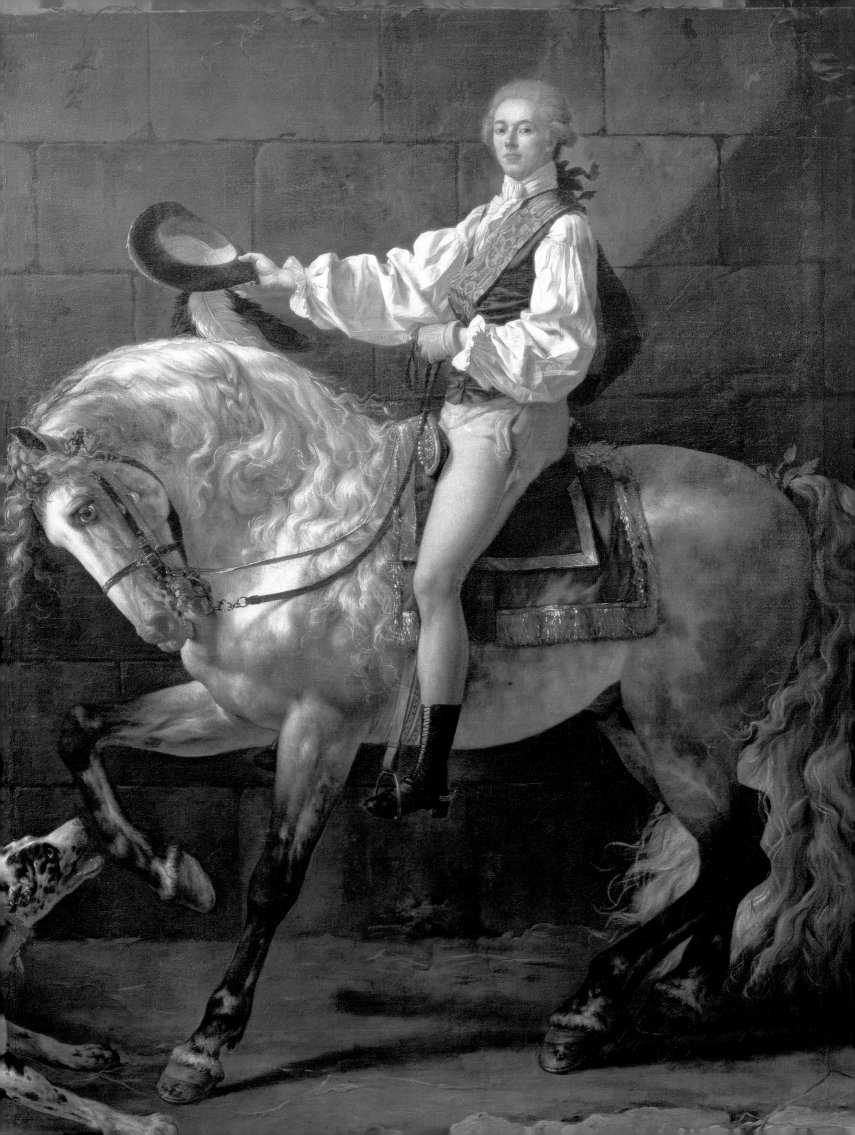

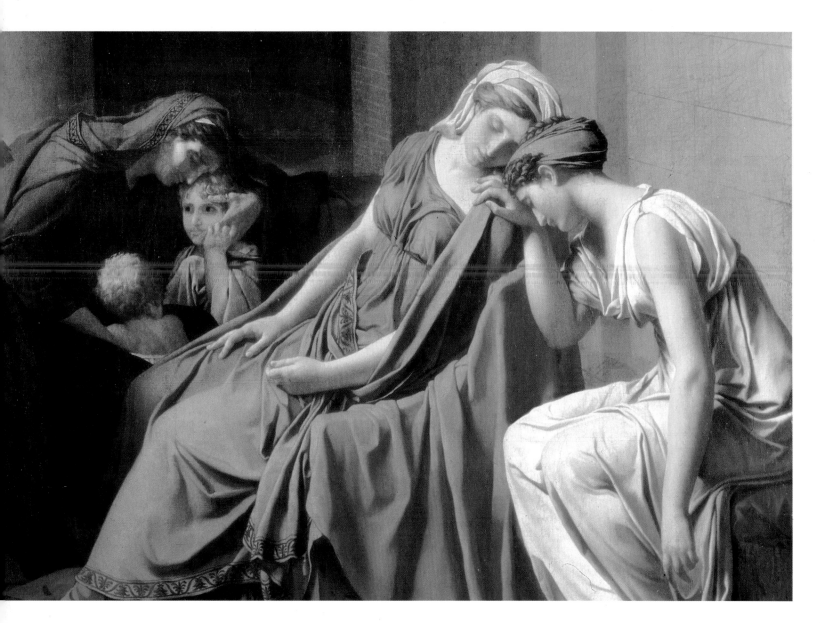

| Jacques-Louis David
THE OATH OF THE HORATII
| Detail.

Jacques-Louis David |
**THE LICTORS BRINGING BRUTUS
THE BODIES OF HIS SONS**
Detail. Exhibited at the 1789 Salon,
oil on canvas, 325 x 425 cm
(128 x 167 3/8 in).
Musée du Louvre, Paris.

1785, by *The Death of Alcestis* or *The Heroism of Conjugal Love*. Fathers condemned their children if they disobeyed or betrayed the homeland. In 1789, David chose such a theme and painted the harrowing episode of *The Lictors Bringing Brutus the Bodies of His Sons*. This magnificent painting features a compositional scheme already used for *The Oath of the Horatii*, contrasting a group of grief-stricken women bathed in light with the awesome figure of the stoical father who remains in the shadows. In 1785, for his part, Jean-Simon Berthélemy (1743-1811) painted a gesturally dramatic version of the Cornelian dilemma of *Manlius Torquatus Condemning His Son to Death*. This evolution was perfectly mirrored in the pictorial career of David (1748-1825). From the dazzling *Portrait of Potocki* (1781) to *The Death of Marat* (1793) and *The Intervention of the Sabine Women* (1799), David, the most brilliant painter of his generation, turned away from the school of Vien – one of whose followers was the unfortunate Peyron who painted a rival version of *Belisarius* to David's in 1781 – towards a neo-classicism imbued with revolutionary experience. Moreover, from 1786 this style was

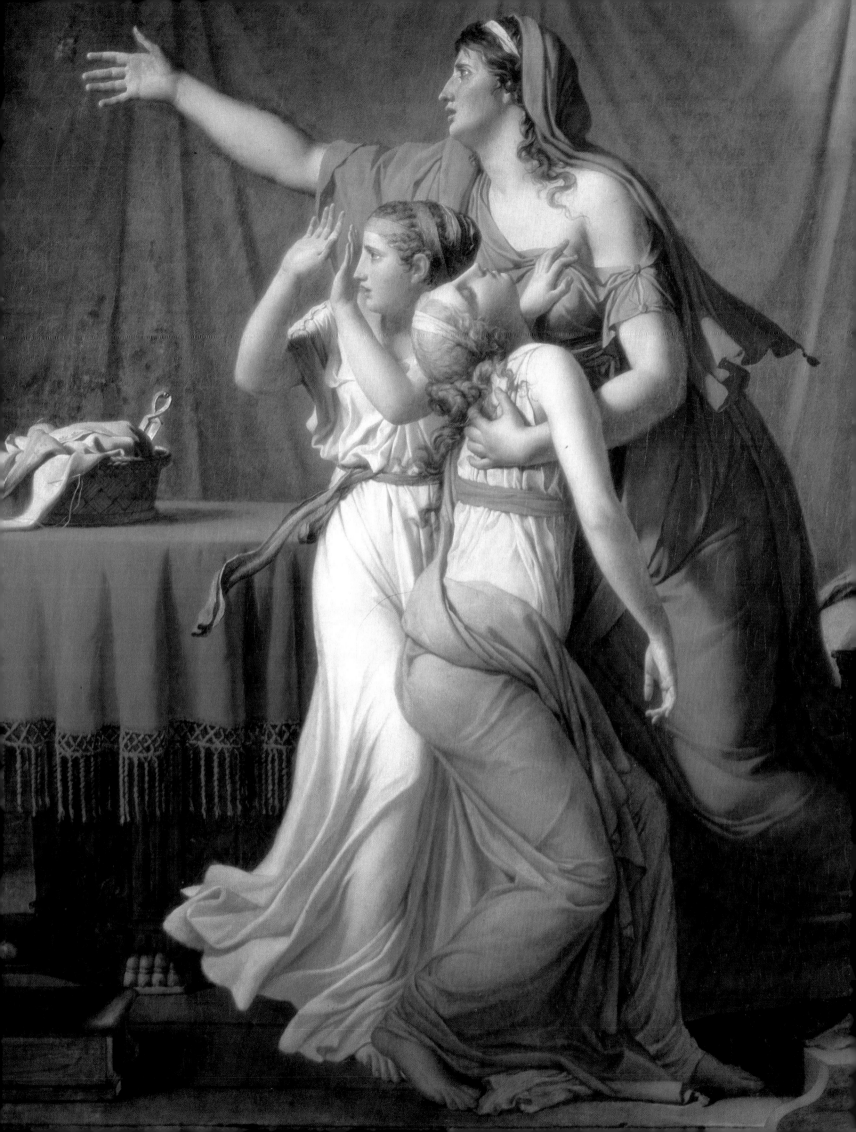

disseminated by many of David's pupils who won the Prix de Rome, including Girodet (prize-winner in 1789) and Ingres (prize-winner in 1801), to whom the master's torch was handed on.

Among David's pre-revolutionary works, in which the treatment of history was carried to perfection, particular mention should be made of *The Oath of the Horatii* and *Brutus* because both illustrated the skills acquired during his first stay in Rome,[3] the spartan life associated with his archaeological research, and his decision to return swiftly to Paris and reveal his full talent. At the 1781 Salon, he exhibited *Saint Roch*, commissioned by the Marseilles Health Department, the *Portrait of Count Stanislas Potocki*, begun in Rome and completed in Paris, along with *Belisarius*, his reception piece, "the first major truly neo-classical work painted in France".[4] He was clearly anxious to demonstrate his expertise in the noble genres; the equestrian portrait was opulently treated on a truly historical scale, and was to be matched in 1801 by his *Napoleon Crossing the Alps*. *The Oath*, which David insisted on going to Rome to paint, displayed a remarkable convergence of simple and grandiose effects. The tripartite composition emphasized by the arcades, the unity of action, the stark Etruscan setting, the rigorous design and drawing, and the balance between the group of male figures symbolizing duty, and the group of women representing love, all combined to create a truly Cornelian grandeur, even though the subject was not borrowed directly from Corneille's famous tragedy, *Horace*. And underlying all was the heritage of Poussin. Set alongside Peyron's *Death of Alcestis*, a work exhibited at the same 1785 Salon and which pales in comparison, David's austere version of the classical revival can be seen to have triumphed. It should be recalled, however, that in 1789 he exhibited both *Brutus* and *Paris and Helen*, a somewhat compromising commission for the Comte d'Artois (the future Charles X). He thus proved himself capable of treating, as one critic has remarked, both "the graceful and the sublime". His *Paris*, the antithesis of *Andromache Mourning*, revealed a much less confident David than another commission, *The Death of Socrates* (1787), where the visual language was perfectly adapted to the subject-matter. The date at which *Brutus* was painted endowed it with symbolism; d'Angiviller is even said to have dreaded presenting the picture at the Salon because of its inflammatory content. Brutus, after all, was the Roman hero who overthrew the monarchy of the Tarquins! Painted on the eve of the fall of the Bastille, it is tempting to read a political message into the work; this, however, would be to overlook the fact that David had already painted the themes of the Rape of Lucretia and Brutus, and that in this case he had selected the subject several months before the Salon which opened on 25 August. Although he did indeed begin after 14 July, this date only assumed its historic significance much later. Nevertheless, the subject did to some extent conjure up opposition to absolutism, and had been used by Voltaire as early as 1730. Moreover, David would soon vent his anti-academicism and play a more active part in the change of regime. He was to vote for the execution of Louis XVI and could thus be more readily compared to some latter-day Brutus.

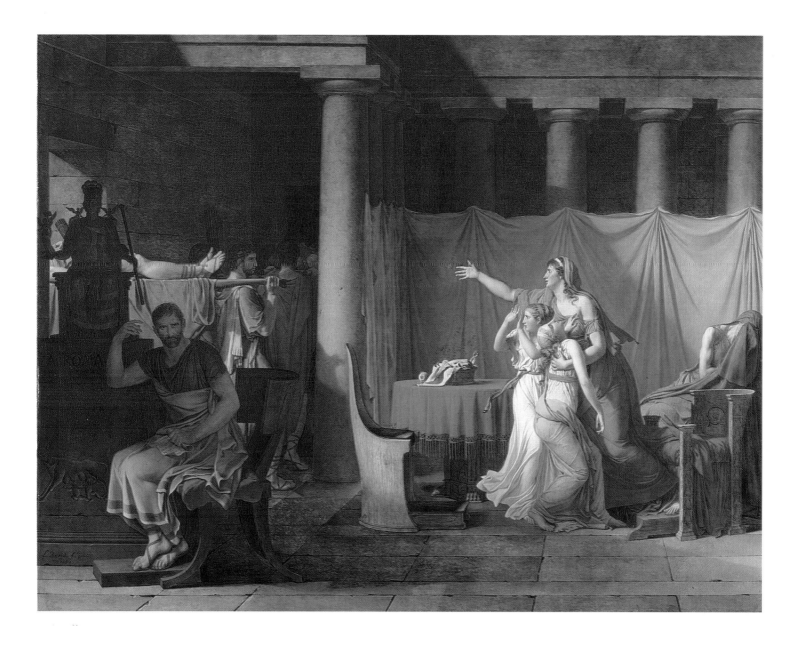

One may speculate about the sheer number of heroic deaths, solemn oaths, grieving figures, crimes and assassinations in David's work. In part this derived from his pursuit of the sublime, drawing on the work of classical historians and tragedians, but also from his artistic commitment. Initially it involved outraged moralization, followed by a politicization which invested the acts of bravery, self-denial or public-spiritedness represented with new meaning. The Revolution sharpened this tendency by the parallel between classical antiquity and the events of the day. Many commentators, as is well known, have attributed revolutionary merit to the famous *Oath of the Horatii* (1784); but this merit was conferred upon it by subsequent history. Is it essentially all that different from the painting by Nicolas-Guy Brenet (1728-1792), *Piety and Generosity of The Roman Ladies* (1785) which four years later was to inspire patriotic women to donate their jewellery[5] for the defence of the homeland? Brenet's painting, much more explicitly patriotic (to the extent that it was, like David's *Horatii*, re-exhibited at the 1791 Salon

Jacques-Louis David |
THE LICTORS BRINGING BRUTUS THE BODIES OF HIS SONS
Exhibited at the 1789 Salon, oil on canvas, 325 x 425 cm (128 x 167 3/8 in).
Musée du Louvre, Paris. |

as an act of allegiance) is nowadays forgotten. The difference obviously lies in the extraordinary quality of David's work, but also in its powerful message: Brenet's work remains somewhat anecdotal, while David's has become symbolic.

This intense patriotism, which was to express itself during the Revolution, also drew on another source: the national aspiration that had been forged since the 1770s.

Forging national identity

The moralizing recourse to *exempla virtutis*, along with the concern to update the ideological messages of history painting, explain a shift towards the emergence of a more assertive national awareness – an essential aspect of the last quarter of the 18th century, and one which the Revolution was to inherit. National themes began to appear alongside Graeco-Roman or biblical subjects.

Already in 1753, La Font de Saint-Yenne was advocating the use of moral themes drawn from French history; but it was not until the Comte d'Angiviller was appointed Director of Buildings in 1774 that such a programme was systematically pursued. 1773 had indeed seen an initial prestigious commission for the École Militaire chapel – a series of paintings relating the life of the king Saint Louis as a symbol of Christian, monarchist and national values, a project involving all the history painters of Pierre's generation, including his friends or pupils, Lagrenée the Elder, Hallé, Doyen, Brenet and Vien. Although medieval scenes were to play a key role in fostering a new taste for what was later called the 'troubadour' style, the Saint Louis cycle was still religious history painting.

Seeking, in his turn, to promote grand art, in 1776 and 1778 d'Angiviller commissioned two series of paintings "susceptible of rekindling virtue and patriotic feelings". The link between history and morality, in a revived style of Plutarch's *Parallel Lives*, was patently obvious in the list of subjects: Du Guesclin, Bayard, Eustache de Saint-Pierre – one of the Burghers of Calais – or President Molé were treated as the peers of Cimon, Fabricius refusing Pyrrhus' gifts, or Agrippina bearing Germanicus' urn.

The programme revealed veritable specialists. At the 1777 Salon, Brenet submitted, in the category *Roman Incentive to Work*, "Cressinus Clears Himself of the Accusation of Sorcery by Exhibiting His Farm Implements in Good Condition to the Aedile", and in the category *Respect for Virtue*, "Honours Bestowed on Constable Du Guesclin by the Town of Randon". Louis-Jacques Durameau (1733-1796), in the category *Respect for Moral Behaviour* exhibited "The Knight Bayard Saves the Honour of His Lady Captive; He Returns Her to Her Mother and Provides Her with a Dowry", and in the category *Greek Religious Piety*, a picture showing Biton and Cleobis harnessing themselves to their mother's chariot to bring her to the temple in time for the sacrifice! At the 1779 Salon, Berthélemy exhibited *Eustache de Saint-Pierre's Courageous Deed*, introducing the Burghers of Calais, later a cherished theme in 19th-century art.

| Nicolas-Guy Brenet
**RESPECT FOR VIRTUE:
HONOURS BESTOWED
ON CONSTABLE DU GUESCLIN
BY THE TOWN OF RANDON**
| Exhibited at the 1777 Salon,
oil on canvas, 383 x 264 cm
(150 3/4 x 103 7/8 in).
| Musée national du château, Versailles.

**One of the first national history
subjects launched by
Superintendent d'Angiviller.**

D'Angiviller pursued this type of commissions until 1789. He launched a series of "Great Frenchmen" commissions for sculptors, including portrait busts of *Bossuet* by Pajou, *Tourville* by Houdon, *Montesquieu* by Clodion, and *Molière* by Caffieri. In this way, alongside the glorification of stock Greek and Roman heroes and their examples of courage and virtue, he sketched out the pantheon of patriotic images which schools would disseminate in the course of the following century to buttress national awareness.

Heroes such as Bayard, Du Guesclin, and above all Henri IV, who was the subject of some fifteen paintings between 1777 and 1785, attained a popularity which was to be endorsed in romantic iconography and even in popular cheap prints – the 'images d'Épinal'. In 1783, a series of six wall hangings on the theme of Henri IV was woven at the Gobelins to designs by Vincent A further consequence of the promotion of such patriotic, and often medieval or Renaissance themes, was the development of a kind of painting located between the genre scene and history painting featuring men of letters or artists. A veritable hero-cult of artists was established which not only accounted for the awareness they themselves had acquired of their social status but also for their role in the elaboration of national values and culture. In 1781 Ménageot (1744-1816) painted *The Death of Leonardo da Vinci*. It was a painting which played on several different interpretations: not only did it illustrate the grandeur of the Kings of France, and François I's artistic sensitivity, but also the exceptional status of artists themselves, in this case embodied by the dying Leonardo at Amboise. To be honoured or grieved by a sovereign was clear acknowledgement of the artist's genius. The death of Leonardo now rivalled those of Socrates or Germanicus. This theme was to be greatly expanded in so-called 'troubadour' painting and even had its own specialists such as Nicolas-André Monsiau (1755-1804), who exhibited *The Death of Raphael* in 1804, and Pierre-Nolasque Bergeret (1782-1863) who, two years later, began a lengthy career with *Honours Rendered to Raphael after His Death*, a work purchased by Napoleon.

D'Angiviller was responsible for another initiative involving art and its social function, one which actually came to fruition during the Revolution. This was the concept of a Museum, the inevitable complement of an enlightened despotism which felt duty bound to make the royal art collections available to the public for educational purposes; the project thus also acted as a patriotic leaven. As early as 1776, d'Angiviller envisaged setting up a museum in the Galerie du Louvre and submitted the project to architects, meanwhile pursuing a policy of purchasing works, notably Flemish and Dutch paintings. Artistic continuity between the end of the Ancien Régime and the revolutionary period was not merely due to the large number of artists who accepted to serve the new authorities (for every artist like Élisabeth Vigée-Lebrun who chose exile, how many more took advantage of the democratization of the arts? The 1789 Salon exhibited eighty-eight painters; two years later, two hundred and fifty were on show) but also to the adaptation of artistic language to the demands of the new ideology.

| Louis-Jacques Durameau
RESPECT FOR MORAL BEHAVIOUR: THE KNIGHT BAYARD SAVES THE HONOUR OF HIS LADY CAPTIVE; HE RETURNS HER TO HER MOTHER AND PROVIDES HER WITH A DOWRY

Detail. Exhibited at the 1777 Salon, oil on canvas, 323 x 227 cm (127 1/8 x 89 3/8 in).
Musée des Beaux-Arts, Grenoble.

Bayard enters the national pantheon of patriotic imagery.

The Museum in the Louvre

This pillar of national revival, the museum of which d'Angiviller had dreamed as early as 1777 when he launched his commissions designed to give artistic expression to national values, was founded as a "National Museum" in September 1792. In line with the Revolutionaries' project to safeguard and nationalize artistic heritage, the royal palace became the museum of the nation. While other buildings were being demolished, the idea of preserving works of art led to the creation of a provisional depot under the directorship of Alexandre Lenoir. In October 1795, this depot became the Musée des Monuments Français. It was to provide a major inspiration for the romantics and whet their taste for national history. Hubert Robert, who had been associated with the museum project from 1778, became a member of the Museum Conservatoire after Thermidor and the fall of Robespierre, along with Fragonard, Pajou, De Wailly and others.
He proposed a new layout for the Grande Galerie in the Louvre with glazed toplighting, but also enjoyed depicting it as an imaginary ruin.

| Hubert Robert
LAYOUT PROJECT FOR THE GRANDE GALERIE IN THE LOUVRE
| Exhibited at the 1796 Salon,
oil on canvas,
112.3 x 143.2 cm
(44 1/4 x 56 3/8 in).
| Musée du Louvre, Paris.

Hubert Robert |
VIEW OF A ROOM IN THE MUSÉE DES MONUMENTS FRANÇAIS
N. d., oil on canvas, |
38.5 x 47 cm
(15 1/8 x 18 1/2 in).
Musée du Louvre, Paris. |

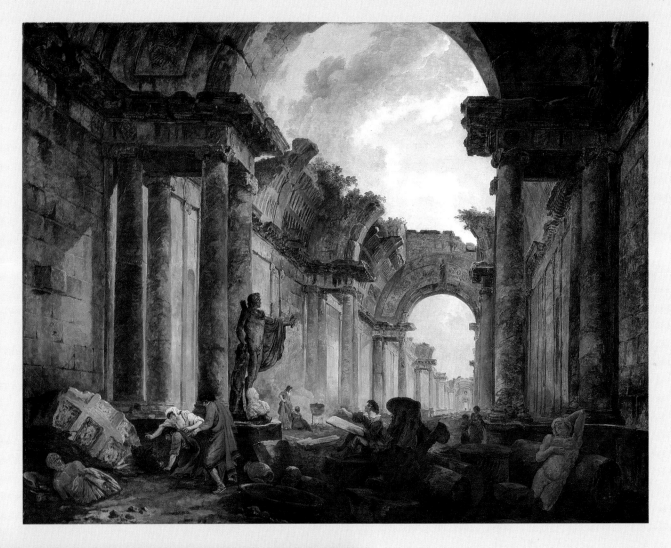

*" The Museum will have so much influence
on minds, it will elevate souls and warm
hearts to such a degree that it will be one
of the most powerful means of rendering
the French Republic illustrious (…).
This Museum should attract foreigners and
focus their attention, nourish appreciation
of the fine arts, entertain artlovers,
and instruct artists. (…) This monument
will be national; not one single person
will be denied the right of enjoying it."*

Letter from Roland,
Minister of the Interior,
to David, 1792.

François-Guillaume
Ménageot
**THE DEATH OF
LEONARDO DA VINCI**

Exhibited at the 1781
Salon, oil on canvas,
278 x 357 cm
(109 3/8 x 140 1/2 in).
Musée de l'hôtel de ville, Amboise.

**One of the first pictures
to portray the painter
as a hero.**

| Jean-Simon Berthélemy
**EUSTACHE DE SAINT-PIERRE'S
COURAGEOUS DEED**

Exhibited at the 1779
Salon, oil on canvas,
319 x 315 cm
(125 5/8 x 124 in).
Musée municipal, Laon.

The revolutionary decade

The Academy could not remain unperturbed by the flurry of events; in 1789, it was swept by a wave of protest over the hierarchy and its privileges. Its very principle was challenged, and in 1791 the Salon was opened to all artists without distinction. Finally, in 1793, the Academy was abolished as a 'royal' institution. From the outset, David was the leading figure in this challenge to tradition. He soon threw himself into politics and was elected to the Convention in September 1792. Having proved his revolutionary credentials he had previously, in October 1790, been commissioned to commemorate *The Tennis Court Oath* (20 July 1789). The work was a sort of historically realistic duplication of *The Oath of the Horatii*. A preparatory sketchbook even shows antique figures with swords and helmets who became Deputies in the *Oath* and later reappeared in *Leonidas at Thermopylae*! Given his art and his commitment to the cause, the choice of David seemed inevitable. His Jacobin friends regarded him as "this French patriot whose genius preceded the Revolution". The drawing was favourably received but was however never to be completed as a painting on the huge canvas long installed for this purpose in the Church of the Feuillants which had been allotted to David as a studio. Nor indeed was his project for a portrait of Louis XVI instructing his son in the constitution; a project which subsequently caused the artist some difficulties. It was a period when David also painted a large number of highly original portraits, presenting his sitters in natural postures against stark, scumbled backgrounds.

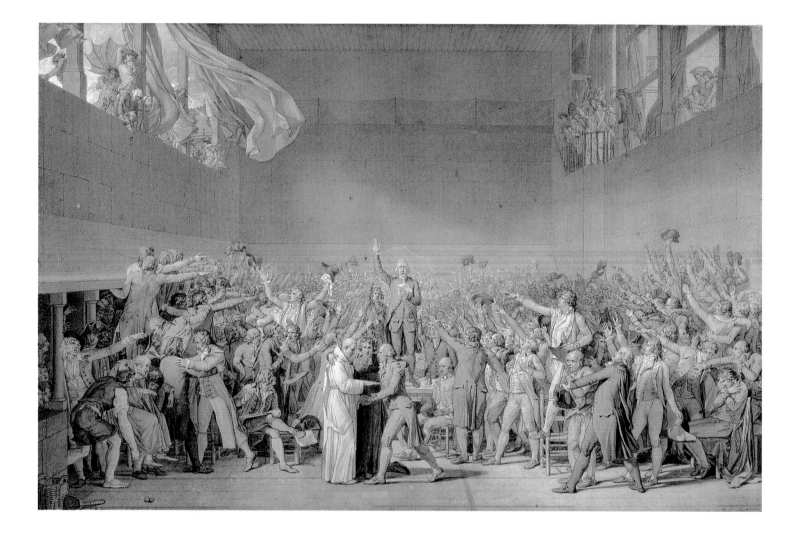

Yet the Commune des Arts, founded by artists themselves, inherited the essentials of royal patronage since it disposed of incentive prizes and launched competitions. In fact, some commissions dating back to the Ancien Régime were finally completed thanks to such prizes! The 'incentives' were avowedly propagandist. For instance, during the deliberation for the 1794 prize, one member of the Arts Jury, the deputy public prosecutor Fleuriot, explained: "We are not called upon to judge a Prize but to regenerate the Arts," adding, "I have a duty to fulfil here, that of bringing the arts into the fold of the revolution." It was surely no coincidence that the first incentive prize was awarded in April 1792 to David himself, who had the nobility to decline. That same year, Regnault, Vincent, Taillasson and Vernet also won prizes. And it is worth noting that although some prizes were awarded to genre painters, most still went to historical compositions.

Not all artists placed themselves at the service of revolutionary ideology like Regnault (1754-1829), who painted *Liberty or Death* (only a small-scale version has survived) in which the motto of the 1793 Constitution was represented allegorically. The Genius of France (with the flame of intellect) pointed to the alternative – on the one hand, Liberty with a Phrygian cap, a set square (symbolizing equality) and a fasces (symbolizing fraternity) and, on

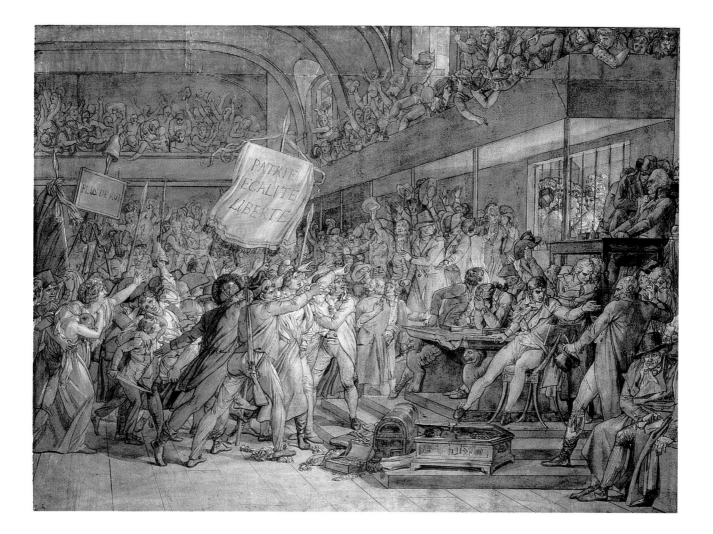

the other, Death with its scythe and tricolour wings! On the contrary, some used their prize money to paint antique subjects; Taillasson, for instance, painted *Seneca's Wife Pauline Brought Back to Life*.

The competitions held in Year II were marked by more openly political or commemorative submissions. On that occasion, François Gérard obtained the first prize for *The French People Demanding the Tyrant's Deposition on the Tenth of August*. Vincent also won a first prize for his *Bravery of the Saint-Milhier Citizeness*, and Taunay a second prize for his *Bravery and Patriotism of Several Imprisoned French Soldiers*. The majority of the forty prize-winning sketches featured similar subjects – indeed, updated versions of the themes of courage and virtue promoted by d'Angiviller. In Year VII (1798-1799), by which time militant zeal had considerably abated, some thirty prizes were awarded to a variety of works ranging from earlier paintings such as Girodet's *Endymion's Sleep* (1793) and Peyron's *Belisarius*, to entries submitted to that year's Salon such as Taillasson's *Hero and Leander*, or *Death of Caius Gracchus* by Jean-Baptiste Topino-Lebrun (1764-1801). The celebrity of the latter work, begun in 1792 by David's pupil and, due to its size (3.87 x 6.15 metres, or 12 1/2 x 20 feet), painted in the Feuillants studio, was not so much due to its morbid subject-matter as to the fate of the artist. Topino-Lebrun,

François Gérard |
THE FRENCH PEOPLE DEMANDING THE TYRANT'S DEPOSITION ON THE 10TH OF AUGUST
Grand Prix at the Year II (1794-1795) Competition, pen, ink and white highlights, 67 x 91 cm (26 3/8 x 35 7/8 in).
Musée du Louvre, Département des arts graphiques, Paris.

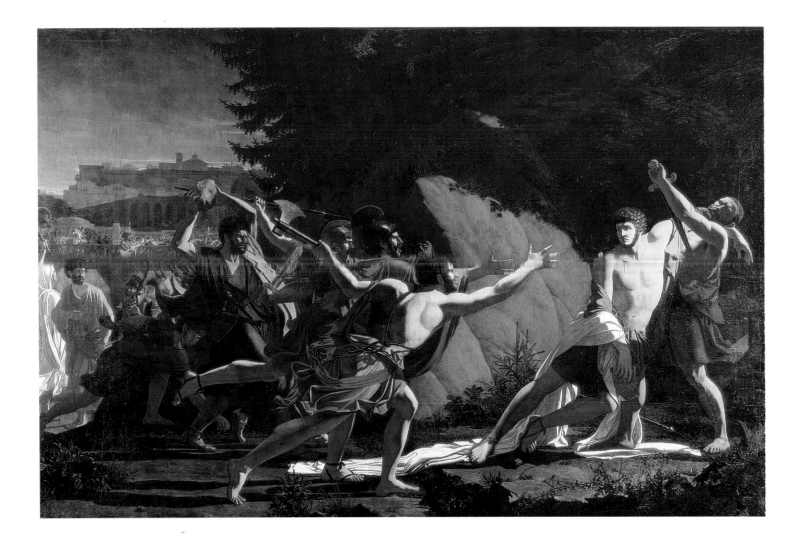

unlike his master, remained a Jacobin and was guillotined as an accomplice to an assassination attempt against Napoleon. A bond was established between the Roman hero who defended the interests of the plebeians and the revolutionary Gracchus Babeuf, guillotined in 1797 and with whom Topino-Lebrun was linked.[6]

Alongside paintings with dramatic light effects which remained faithful to the more extreme neo-classical features, there appeared others in which the artists resorted to an allegorical language, for the Revolution was fuelled by a never-ending spate of Liberties, Republics, Constitutions, Declarations of the Rights of Man and various triumphant values. Accordingly, some tended to adopt a less austere approach, even rediscovering early 18th-century models influenced by Rubens, and a taste for colour and movement is found in numerous works. At the competition held in Year II (1794-1795), Charles Meynier (1768-1832), for instance, submitted *Triumphal France Encouraging the Sciences and the Arts in the Midst of War Having Crushed Federalism*, a sketch full of vivacity, with the hybrid federal monster in the foreground. This tendency was even more to the fore in the work of the Arles painter Jacques Réattu (1760-1833), a veritable specialist in the genre, who received a commission in 1794 to decorate the Convention Chamber with a *Triumph of Liberty*. His *Triumph of Civilization* (1794-1798) achieved even greater richness and complexity.

| Jean-Baptiste Topino-Lebrun
THE DEATH OF CAÏUS GRACCHUS
1792, exhibited at the 1798
Salon, oil on canvas,
387 x 615 cm
(152 3/8 x 2452 1/8 in).
Musée des Beaux-Arts, Marseilles.

Jean-Baptiste Regnault |
LIBERTY OR DEATH
Exhibited at the 1795
Salon, oil on canvas,
60 x 49 cm
(23 5/8 x 19 1/4 in).
Kunsthalle, Hamburg.

In this revolutionary allegory, Regnault, who had won the Prix de Rome, was nevertheless inspired by Raphael. The figure of the Genius of France was borrowed from the master's Mercury in the Villa Farnesina.

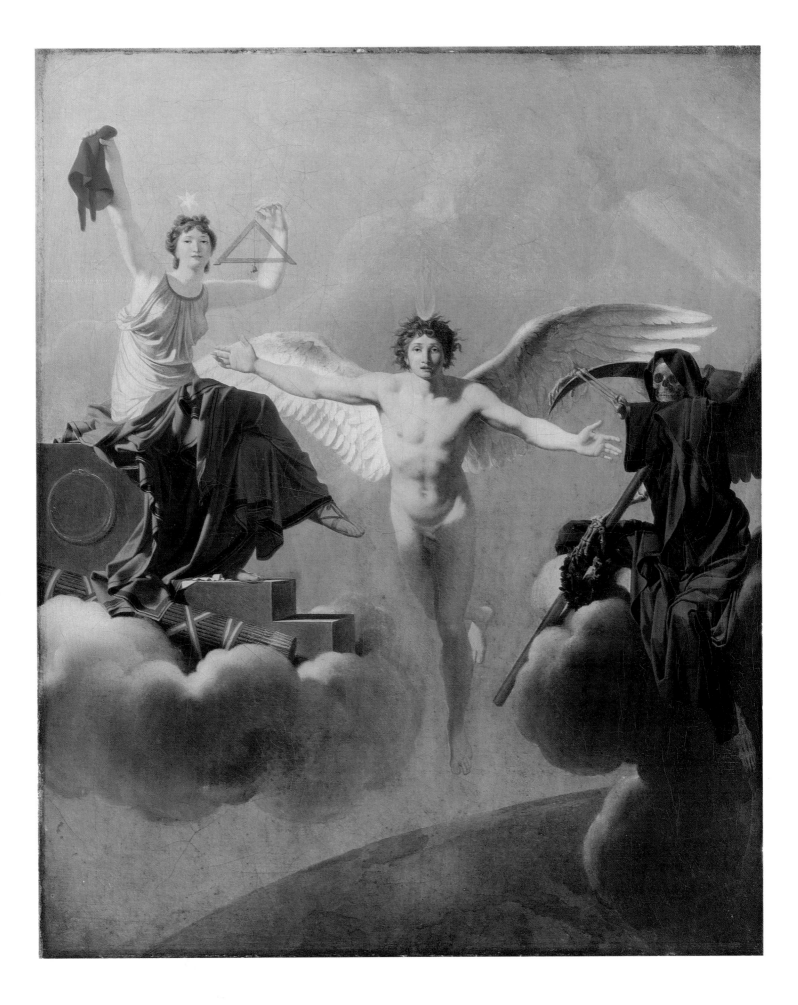

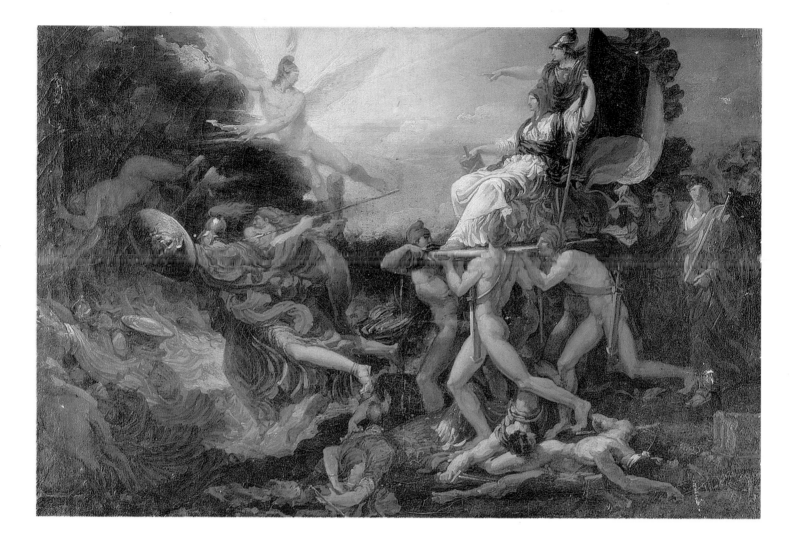

In reality, despite official incentives, history painting was languishing and certain Salons held during the revolutionary decade were monopolized by genre and landscape painting. At the 1799 Salon, *A Young Woman Out in the Country Finds Herself Caught in a Storm*, a strange, romantic painting by Féréol de Bonnemaison (c. 1770-1827), won an incentive prize, along with a *Laundress* painted on porcelain by Droling, and various portraits and landscapes.

Although David was organizing festivities and funerals, designing costumes, and attempting to carry through numerous projects, constantly modified in response to the breakneck pace of events, he nevertheless remained the greatest painter of the day. To serve the Revolution, he even introduced an extraordinary development: the transposition of classical heroic grandeur into the present. He moved on from *The Tennis Court Oath* to the deaths of Le Pelletier de Saint-Fargeau, Marat and Bara. These revolutionary martyrs were elevated to the rank of heroes like Hector or Patroclus, not by means of some hollow, sycophantic, allegorical or mythological process, but by stark, rigorous and realistic presentation. Paradoxically, heroic portrayal sprang from a painstaking attention to reality.

Le Pelletier, who, like David, had just voted for the execution of the king, was assassinated on 20 January 1793. His mortal remains were publicly exhibited

| Jacques Réattu
THE TRIUMPH OF LIBERTY
Year II (1794-1795),
oil on canvas, 31 x 46 cm
(12 1/4 x18 1/8 in).
Musée Réattu, Arles.

Féréol de Bonnemaison |
**A YOUNG WOMAN OUT IN THE
COUNTRY FINDS HERSELF
CAUGHT IN A STORM**
Exhibited at the 1799 Salon,
oil on canvas,100 x 80 cm
(39 3/8 x 31 1/2 in).
Brooklyn Museum, New York. |

**This painting was long
attributed to Prud'hon.**

Du 13. juillet, 1793.
Marie anne Charlotte
Corday au citoyen
Marat.
il suffit que je sois
bien Malheureuse
pour avoir Droit
a votre bienveillance.

À MARAT.
DAVID.

on the plinth of the statue of Louis XIV in the former Place Vendôme; as early as the following 29 March, the artist presented a commemorative painting (now lost) in which he repeated the same arrangement of the deathbed used in *Andromache Mourning*, portraying the naked corpse in a somewhat Christ-like manner. The names of both the martyr and the artist appeared in an inscription, a feature which re-appeared in his indisputable masterpiece, *The Death of Marat*, also painted in 1793.

Although as an actual historical figure Marat was much more ambiguous, as a martyr for the new faith he became a symbol. Never before had David's art achieved such a degree of simplicity and formal perfection. Through Marat, he extolled the virtue, idealism, morality and exemplary poverty of the Revolutionary heroes. There was no longer any need to refer back to the Greeks for the *exemplum virtutis*, Marat had given everything to the people, even his life. Yet the detail of the rapidly-executed technique was just as important as the serene, balanced compositional features, barely perturbed by death. Everything – the naked body, the drapes, the blood-reddened water, the various objects such as the knife, quill pen and letters, and above all the monastically austere wooden box which emphasized the sanctity of the martyr – was bathed in a light which located the historic scene simultaneously in reality and in an ideal dimension. Suddenly, the sublime was no longer dependent on a somewhat grandiloquent terror or on macabre theatrical effects, but on simplicity, gentleness and genuine emotion.

As for the young Bara, he became a legendary figure thanks to Robespierre who presented him as the embodiment of patriotism and requested David to immortalize the symbol in art. Although the events of 9 Thermidor prevented completion of the painting, again its unfinished state added in itself to its grandeur and refined conception. The naked body – David's portraits of contemporary figures always respected academic principles – was merely sketched, its pale features merging into the background, and only the tricolour cockade, the venerated object for which the child had chosen martyrdom, introduces a touch of colour, slightly echoed by the lips which are said to have famously uttered in dying: "Vive la République!".

Following 9 Thermidor, David was imprisoned, narrowly escaping the guillotine. Thanks to the amnesties granted under the Directory, he managed to resume his painting and teaching activities, and was even elected to the new Institute, founded in 1795. He then returned to classical compositions, sketching out a *Homer Reciting His Poetry* and beginning *The Sabine Women*, a painting conceived in prison. He also painted a magnificent series of portraits including that of his brother-in-law, Pierre Sériziat (1795), and the famous *Madame Récamier* (1800). *The Sabine Women* ushered out the century with an ambitious reassertion of the historical genre. Unlike Poussin, David did not choose the episode of the abduction, but the point at which the Sabine mothers intervened between the combatants. Despite having selected a Roman theme, David wished to return to the Greeks and he attempted to give concrete expression to this in *Leonidas at Thermopylae*, begun in 1799. Although only completed in 1814, after the First Empire, it

Jacques-Louis David |
PORTRAIT OF PIERRE SÉRIZIAT
Exhibited at the 1795 Salon,
oil on wood, 129 x 96 cm
(50 3/4 x 37 3/4 in).
Musée du Louvre, Paris.

| Jacques-Louis David
THE DEATH OF MARAT
1793, oil on canvas,
165 x 128 cm (65 x 50 3/8 in).
Musées royaux des Beaux-Arts, Brussels.

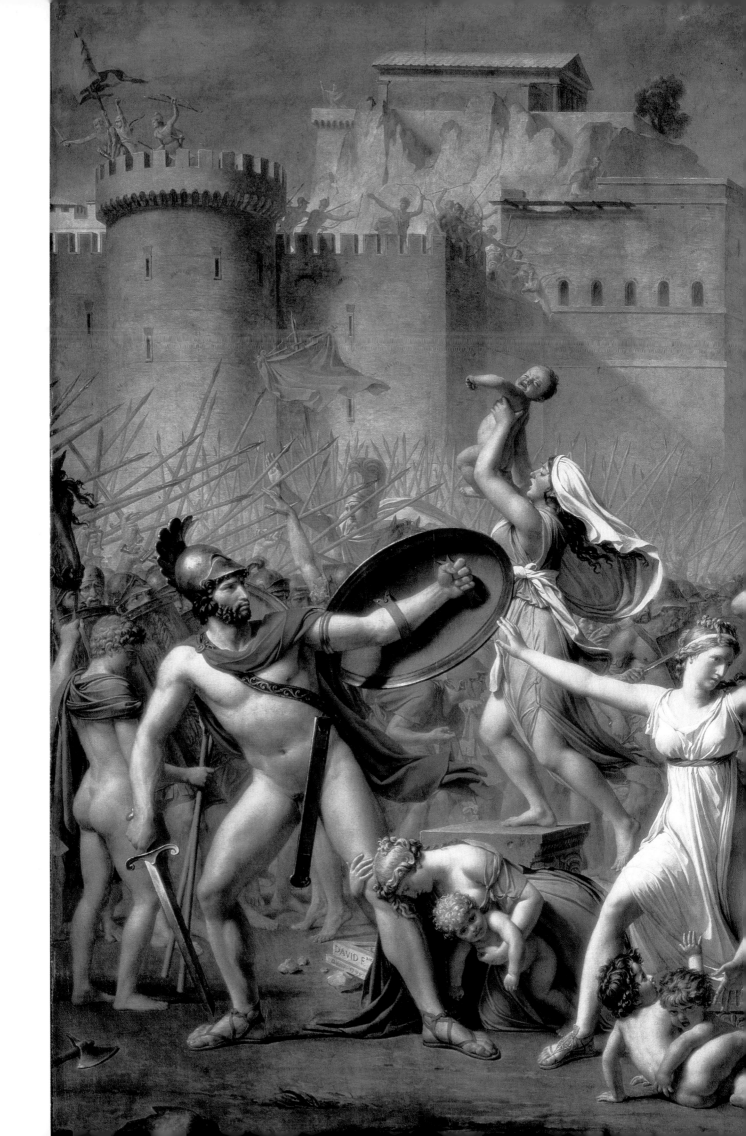

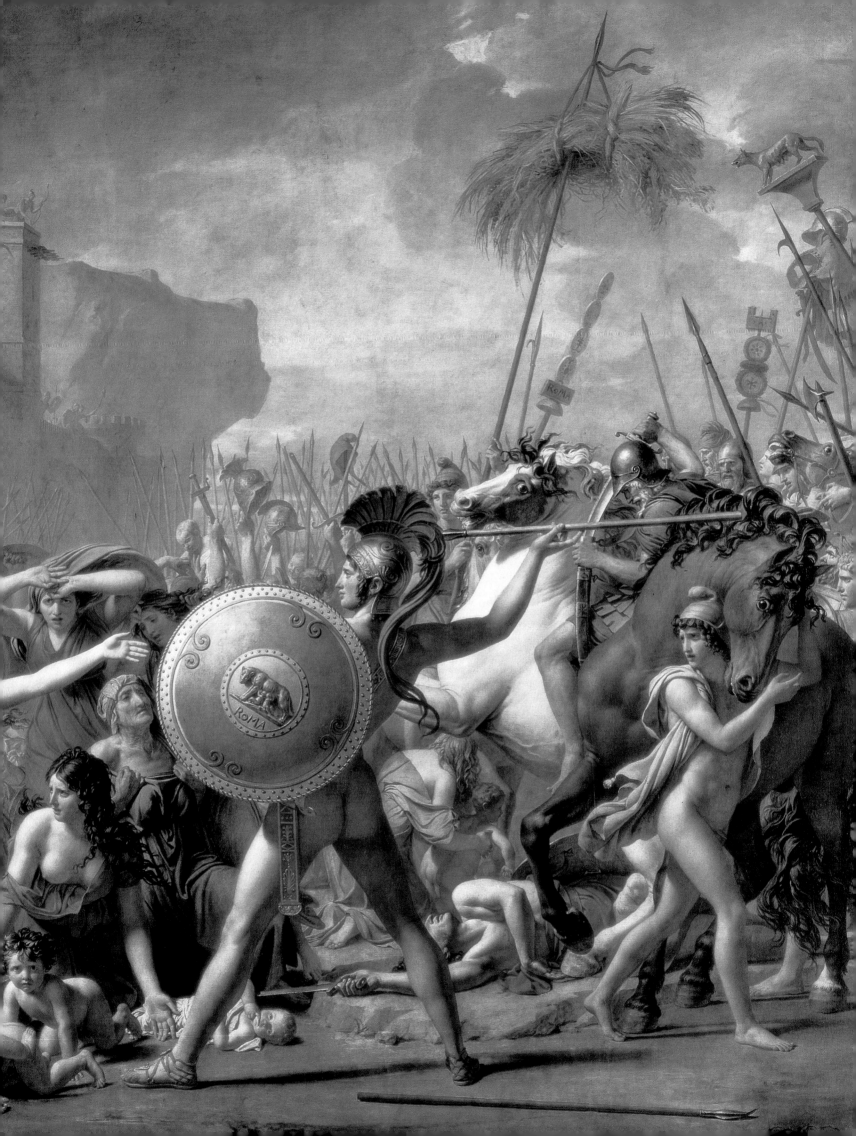

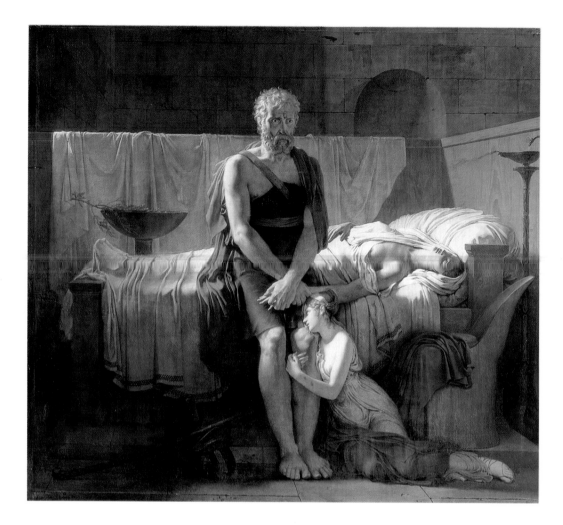

Pierre-Narcisse Guérin
THE RETURN OF MARCUS SEXTUS
Exhibited at the 1799 Salon,
oil on canvas, 217 x 243 cm
(85 3/8 x 95 5/8 in).
Musée du Louvre, Paris.

Pages 190-191
Jacques-Louis David
**THE INTERVENTION
OF THE SABINE WOMEN**
Exhibited at the 1799 Salon,
oil on canvas, 385 x 522 cm
(151 5/8 x 205 1/2 in).
Musée du Louvre, Paris.

Pages 192-193
Guillaume Guillon,
known as Lethière
THE HOMELAND IN DANGER
Exhibited at the 1799 Salon,
oil on canvas, 59 x 100 cm
(23 1/4 x 39 5/8 in).
Musée de la Révolution française, Vizille.

Faced with the threat of the triple
alliance between Austria, Britain
and Russia, artists were exhorted
to represent "the homeland
in danger". This depiction of
volunteers enlisting was inspired
by David's *Sabine Women*.

belonged to another century. The return to the Greeks was expressed by the naked combatants, the appearance of the horses and the more scrupulous imitation of classical sculpture. The painting was evidently perceived as a message of reconciliation; the classical episode was used to nurture present-day aspirations. This was no doubt also the reason behind the success of the work by a young painter exhibiting at the 1799 Salon, Pierre-Narcisse Guérin (1774-1833), whose *Return of Marcus Sextus*, an imaginary episode set in the period after Sulla's proscriptions, was interpreted as "a pathetic vision of returning émigrés".[7] The dramatic composition and the chiaroscuro led all who had witnessed revolutionary turmoil to identify with the grief of the banished Roman and hinted at the need to restore civil peace.

Similarly, the heroic message of David's *Leonidas* – a handful of men resisting – was probably prompted by the growing threat on the French frontiers. Guillaume Guillon, known as Lethière (1760-1832), echoed the same preoccupation with *The Homeland in Danger* (1799) which attempted to renew mythology by evoking the voluntary enlistments of 1792; here again, as in *The Sabine Women,* women brandished their children to move the combatants to pity and fire their courage. These were the parting shots of revolutionary painting. History painting was to place itself at the service of a modern hero, whose impending triumph was already glimpsed in the closing Salons of the 18th

century. Bonaparte, flushed with his Italian victories and home from the Egyptian campaign, would seize power, profiting from the French people's desire for order and reconciliation. He would subject painting to his own law, both by force and by the fascination he exercised over artists. David swiftly rallied to the Napoleonic cause and launched out on a new career, carrying along in his wake both his pupils and history painting.

Romantic nocturnes

In the opening pages of his *Nuits de Paris* (1788), Restif de la Bretonne describes visiting, like some "sad, solitary owl", the tip of the Île Saint-Louis: "Amidst the shadows, I wandered alone in this vast capital; the light of the street lamps cut through these shadows, heightening their effect rather than casting them away: it was the chiaroscuro of the great Masters! I wandered alone in search of Man…"

The image of chiaroscuro, which the novelist borrowed from painting, was a sign of the times, perhaps even the symbol of a profound awareness of belonging to a generation in which man revealed the full extent of his ambivalence. The Enlightenment engendered shadows and people delighted in nocturnal and other lugubrious scenes. D'Angiviller himself had been alarmed by the sombre nature of the subjects submitted by artists in the Salons prior to the Revolution. Crime and Love alike called for moonlit settings: Topino-Lebrun's *Death of Caius Gracchus* is bathed in a greenish light, Selene visited *Endymion* as he slept… Pierre-Paul Prud'hon (1758-1823) was to paint this type of vision right up until 1808 with his *Justice and Divine Vengeance in Pursuit of Crime*, one of the finest nocturnes painted during the First Empire.

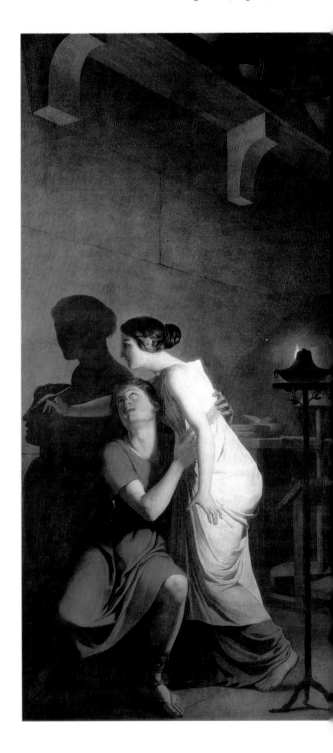

Many artists seemed to be applying the precepts on the sublime quality of night which Diderot, in his *Salon de 1767*, borrowed from Burke: "Darkness heightens terror", the critic explained. Twilight or darkness increasingly featured in death scenes like Guérin's *Return of Marcus Sextus* (1799), in allegories such as *The Triumph of the French People* by Philippe-Auguste Hennequin (1763-1833), or in intimate genre scenes such as *The Improvised Concert* (c. 1790) by Léopold Boilly. Again, unsurprisingly, in 1804 Regnault's pupil, Pierre-Auguste Vafflard (1774-1837), chose *Young and His Daughter*, a theme combining paternal love, death and night, and taken from the English poet Edward Young's *Night Thoughts*.

Although the Revolution indeed had its own sun myth – inherited from the monarchy and also from theology and philosophy, as Jean Starobinski has clearly demonstrated in his *1789, Les emblèmes de la raison* (1979) – darkness predominated in the art of the period. Romantic night pervaded Piranesi's subterranean chambers, the architect Boullée's design for a Newton cenotaph, the literary works of Senancour and Sade, and what was soon to be called the 'macabre' or 'Gothic' novel. Aristocratic privileges were abolished during "the night of 4 August", the fleeing Louis XVI was intercepted at Varennes by night – the very events were shrouded in a nocturnal atmosphere!

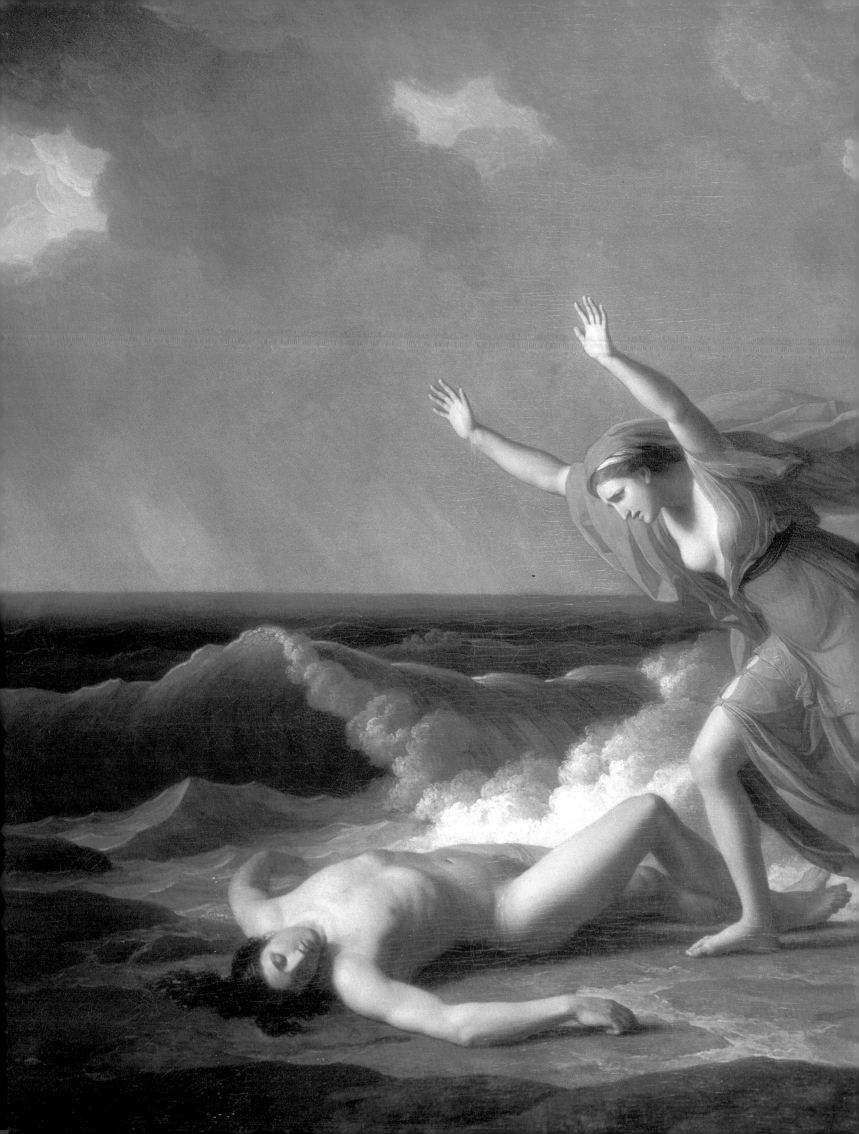

Jean-Joseph Taillasson
HERO AND LEANDER
Exhibited at the 1798 Salon,
oil on canvas, 253 x 318 cm
(99 5/8 x 125 1/8 in).
Musée des Beaux-Arts, Bordeaux.

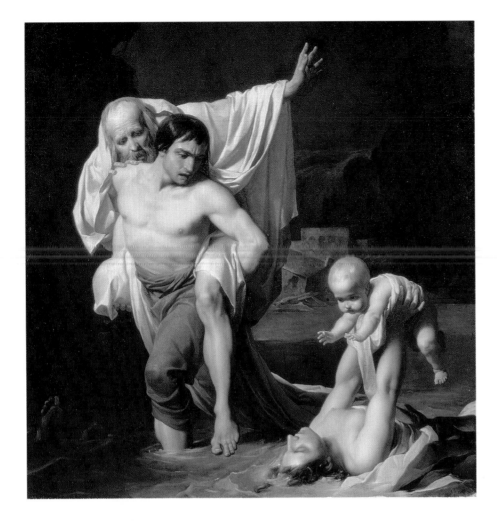

It is true that France boasted no Füssli or Goya, but a predilection for nocturnes featured in works by pupils of Vien and David (although not in the work of the master himself); one of the most striking was exhibited by Anne-Louis Girodet (1767-1824) at the 1793 Salon during the height of the Terror. His *Endymion*, subtitled *Moon Effect*, depicted the beautiful youth bathed in moonlight streaming through foliage symbolically parted by Cupid. The painting has been interpreted as a quasi-initiatory image, the illustration of a vanishing era, or even the very myth of romantic inspiration.[8] For in the cultural context of the times, influenced in particular by Freemasonry, night played a positive role; as in Mozart's *Magic Flute*, written in 1791, it was to be passed through, like some ordeal, in order to reach a new world. But would the Queen of the Night not defeat positive forces? She brought Death, the key to rebirth like the Flood, an omnipresent theme in the imagination of the period: the example of Poussin played its part, but night's symbolism no doubt expressed an acute awareness of the need for regeneration. In 1787, Sénac de Meilhan wrote: "In this state of languor into which man is dragged by the course of things, he will perhaps have no other option in ten or twelve generations than a deluge which will plunge everything once more into the night of ignorance. New races will then undertake to accomplish the cyclical journey on which we are perhaps farther advanced than we

imagine." The philosopher thus sensed the coming deluge which Jacques Gamelin (1738-1803) had already depicted ten years before. A nocturnal setting added to the horror of the scene in *The Flood* (1789) by Jean-Baptiste Regnault, and *Flood Episode* (1802) by Henri-Pierre Danloux (1753-1809), while the theme was taken up again in 1806 by Girodet. In Taillasson's *Hero and Leander*, painted in 1798, the protagonists' tragic love affair ended in death and night: the lover drowned when the light by which the young priestess guided him as he swam the Hellespont from Abydos was extinguished. Primeval night even infiltrated into depictions of art's amorous origins. In the painting by Joseph-Benoît Suvée (1743-1807) representing the famous anecdote in which Dibutada draws her lover's profile on the wall, the scene is no longer bathed in dazzling Greek sunlight but in the shadowy flicker of a lamp. At a time when Poussin had once more gained the upper hand on Rubens, the ancient myth seemed to vindicate the triumph of design and contour; moreover, artists like Gagnereaux, or the Englishman John Flaxman, were successful practitioners of linear drawing inspired by Greek vase painting.

Anne-Louis Girodet |
ENDYMION. MOONLIGHT EFFECT
Exhibited at the 1793 Salon,
oil on canvas, 198 x 261 cm
(78 x 102 3/4 in).
Musée du Louvre, Paris.

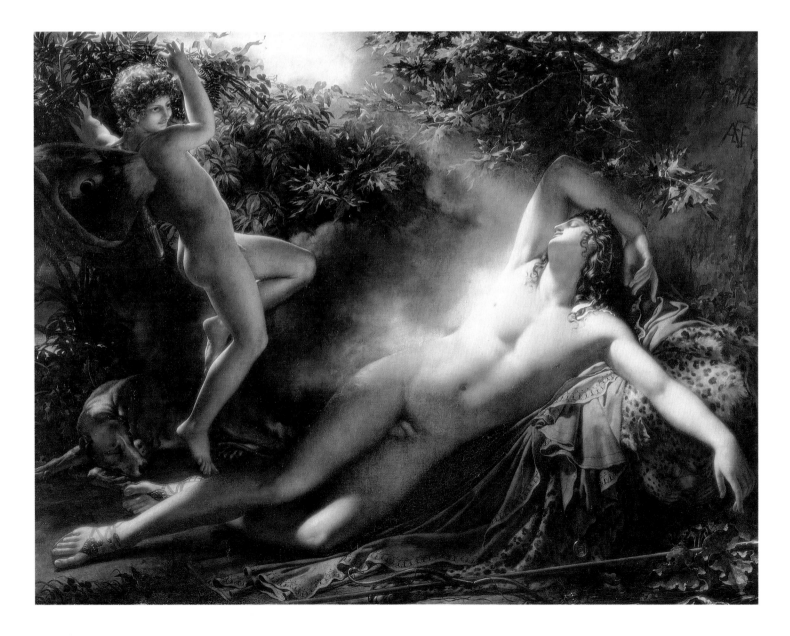

This generation, whose art, thanks to the flexibility of neo-classical conventions and forms, managed to adapt to the Revolution then to the Empire, was also profoundly romantic. Whereas David, seeking to revive a luminous, brightly-coloured vision of classical antiquity, stripped of the excessive chiaroscuro of Revolutionary and Empire painters, produced an anacreontic version of Sappho in his *Phaon, Sappho and Cupid* (1809) painted for a Russian prince, Taillasson portrayed her at the moment of despair, about to leap into the void (1791); Nature heightened the heroine's inner turmoil. But the finest romantic nocturne, painted as the old century gave way to the new, remains *Sappho at Leucadia* by Antoine-Jean Gros (1771-1835). The painting, begun in Italy where Gros had accompanied Napoleon, was exhibited at the Français, to the 1001 Salon. With its moonlit setting, intertwining veils, unreal colouring (little appreciated by its contemporaries) and the expression of despair worthy of Werther himself, it achieved an unparalleled degree of romanticism, or even anti-classicism,[9] found again in the artist's *Portrait of Bonaparte at Arcole*, shown at the same Salon: the classical hero was superseded by the modern hero. Beyond the artistic and political agenda of Gros, however, the iconography of the former painting was all the more original in that, according to historians, those who actually committed suicide by leaping off the cliff at Leucadia did so by day in the course of a public ceremony. Disregarding the classical model, Gros – who was to take his own life in 1835 – chose solitude and night; only Chassériau and Gustave Moreau could match the sublime pathos of his composition. Like the closing century itself, the figure of the amorous poetess poised over the abyss seems to us suspended between neo-classicism and romanticism, between nostalgia for an immutable order and a foothold in history, between the enlightened ambiguities of a challenged universal ideal and the dreams of a sombre epoch which gave birth to modernity.

1. He had the paintings commissioned by Marigny and displaying the virtuous qualities of the Emperors Augustus, Titus, Trajan and Marcus Aurelius removed from the Château de Choisy and had Boucher paint a replacement series!
2. Quoted by R. Rosenblum in one of the best approaches to the shift towards neo-classicism: *Transformations in Late Eighteenth-Century Art*, Princeton, 1967, p. 28.
3. David only won the Prix de Rome in 1774. When he arrived in Italy, aged twenty-seven, he initially imagined he would resist the Roman influence; *David et Rome/David e Roma*, French Academy in Rome, 1981–1982.
4. A. Schnapper, *David témoin de son temps*, 1980, p. 61.
5. Mme David was one of the twenty-one patriotic ladies involved.
6. A. Jouffroy and Ph. Bordes, *Guillotine et peinture. Topino-Lebrun et ses amis*, 1977.
7. R. Michel, *Aux armes et aux arts!*, p. 88.
8. J. H. Rubin, "Endymion's Dreams as a Myth of Romantic Inspiration", in *Art Quarterly*, Spring 1978, pp. 47–84.
9. According to the interpretation by Derin Tanyol, "A Napoleonic Death Sentence: Classical Execution in Gros, *Sappho at Leucadia*", in *Gazette des Beaux-Arts*, July-August 1996, pp. 51–62.

Antoine-Jean Gros |
SAPPHO AT LEUCADIA
Exhibited at the 1801 Salon,
oil on canvas, 118 x 95 cm
(46 1/2 x 37 3/8 in).
Musée Baron Gérard, Bayeux.

In this painting, Gros conveys
his melancholy in one
of the finest nocturnes
and the suicide of the poetess
abandoned by her lover.

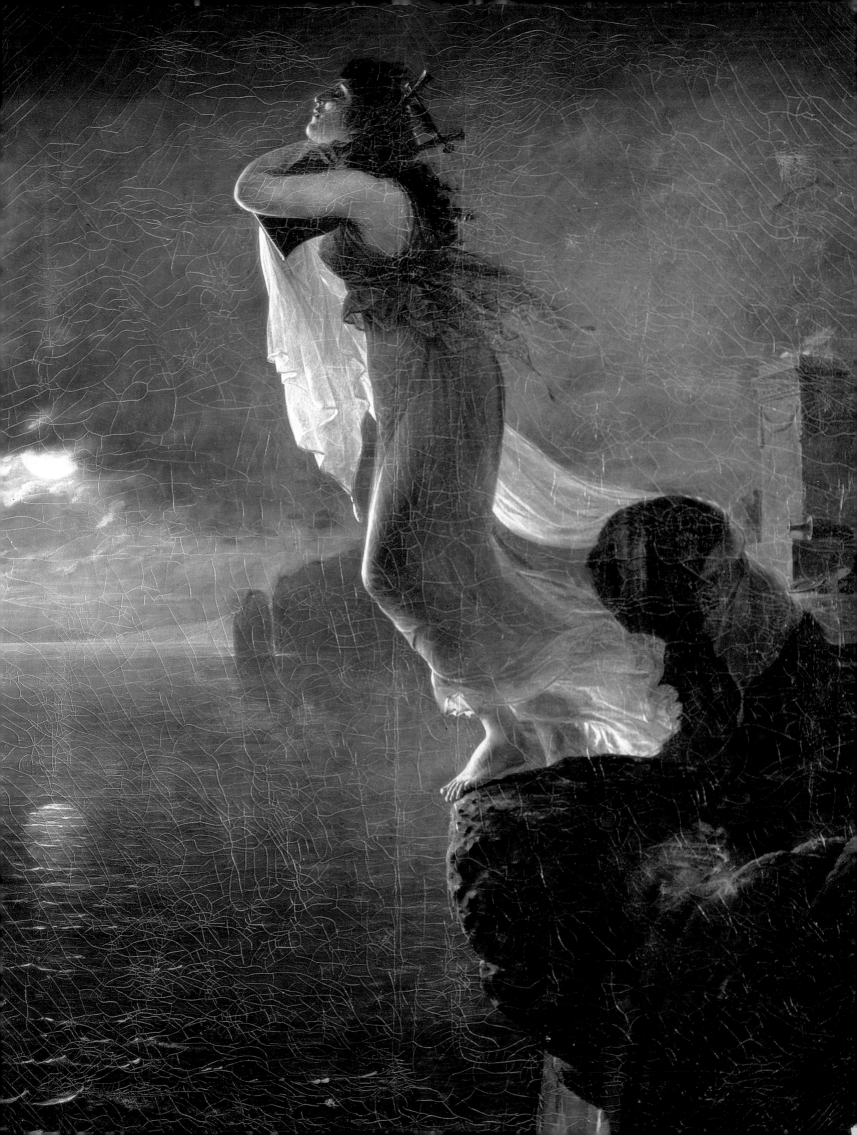

| Jean-Honoré Fragonard
LES CURIEUSES
| N. d., oil on wood,
| 16.5 x 14.5 cm
| (6 1/2 x 5 3/4 in).
| Musée du Louvre, Paris.

Eighteenth-Century Taste

During the last four decades of the 18th century and under the Revolution the rococo art and 'peinture galante' of painters from Watteau to Fragonard had been condemned to oblivion; it was therefore no coincidence that it was through these very painters that the 19th century initially 'rediscovered' its predecessor, narrowing it down to the sole reign of Louis XV in the process. On closer inspection, it can be seen that the eclipse of painting from Watteau to Greuze had never been total, and that the heritage had been preserved in genre painting. The romantic generation, however, was influenced by a rapidly spreading vogue for the 18th century, to such an extent that the period featured prominently in major collections.

Around 1830, the young romantics living in Rue du Doyenné were swept by enthusiasm for Watteau's art. Among these were Gérard de Nerval,[1] who owned a *Swing* and a *Blind Man's Buff* by Fragonard, Arsène Houssaye, director of the review *L'Artiste* which published the first texts on 18th-century art (including the Goncourts' "Watteau's Philosophy" in 1856), Théophile Gautier and others.

Scholars such as Charles Blanc who, in 1859, founded the *Gazette des Beaux-Arts* which frequently presented 18th-century artists, and especially the brothers Jules and Edmond Goncourt, not only rehabilitated a taste and style, they wrote highly detailed monographs collected under the general title of *The Art of the 18th Century* and accompanied by engravings by Jules Goncourt. Their role however should be placed in perspective: despite their assertions, they were not pioneers and their 18th century remained above all that of the illustrators and aristocratic ladies. Yet the mythical vision of the century which they cultivated played a full part in the 19th-century imagination; moreover, they introduced a model – that of a world in which the work of art was an integral part of a way of life and a form of sensibility.

The extent of this enthusiasm was attested by the fact that Watteau figured among Baudelaire's *Phares*, or that a publishing house like Goupil,[2] for instance, popularized 18th-century art in the form of prints and imitations. These were so eagerly sought after by a middle-class public that many artists, including Camille Roqueplan, Ernest Meissonnier, Eugène Fichel and others, specialized in what virtually became a sub-category of genre painting at the Salon.

Collectors played a key role in the 18th-century revival, a trend pioneered in the first half of the 19th century by enlightened amateurs, followed in the latter half of the century by financiers who could still compete in what had become a market beyond the reach of most pockets.

Dr. La Caze, who bequeathed his huge collection to the Louvre, belonged to the first category. His was the finest donation of paintings ever made. Besides works from all periods, he had collected eight Watteaus (including *L'indifférent, La Finette, Jupiter and Antiope* and *Gilles*), thirteen Chardins, nine Fragonards (including famous fantasy portraits), and four Bouchers, along with works by de Troy, Lancret, Charles Coypel, Le Moyne, Raoux, Nattier, and Robert. On the other hand there were only a few neo-classical paintings. Laden with aristocratic Ancien Régime connotations, 18th-century painting was highly coveted by new wealth: the first painting acquired by James de Rothschild was a *Dairywoman* by Greuze. The well-known Rothschild family passion for such painting continued in each succeeding generation, as can be witnessed by any visitor to Béatrice Ephrussi's villa at Saint-Jean-Cap-Ferrat. Eighteenth-century art also features prominently in several Parisian museum collections, where painting is always exhibited along with the decorative arts, both indissociable elements in any reconstruction of the spirit of the century. Among others, Édouard André and his wife Nélie Jacquemart built up a magnificent collection of works by Chardin, Nattier, Greuze and Fragonard; Ernest Cognacq did likewise and endowed Paris with a collection that has recently been reinstalled in new premises; Moïse de Camondo specialized in the decorative arts and bequeathed his mansion and collection to the Union Centrale des Arts Décoratifs. Enthusiastic foreign, especially American, collectors swiftly followed suit.

Thus it would seem that History has not confirmed the Comtesse du Barry's choice. Fragonard has triumphed over Vien, and, thanks to the former, the reign of Louis XV still exercises greater appeal than that of his successor as far as painting is concerned. Despite the contributions of art history, which has brought to light entire chapters of an alternative 18th century, and which has attempted to delve beyond the illustrious names to rediscover the many history painters who, although greatly admired in their own day, have been forgotten by posterity, we remain attached to the masters rediscovered by the 19th-century revival. In the first place, perhaps, because their painting introduced the paramount importance of pure visual delight, and because, contemplating so many masterpieces, such grace, profundity, freedom and love of painting, our sheer pleasure makes mock of objective reasoning.

Jean-Honoré Fragonard |
THE LOCK
Before 1784,
oil on canvas,
73 x 93 cm
(28 3/4 x 36 5/8 in).
Musée du Louvre, Paris.

1. The poet recalled the period in *Bohême galante*, relating how salvaged Nanteuil overdoors, a *Watteau* by Vattier, and *Bacchantes* by Chassériau had provided an 18th-century decor in their shared accommodation. The *Embarkation for Cythera* features in several short stories.
2. *Mémoires du XVIIIᵉ siècle* Exhibition, Bordeaux, Musée Goupil, 1998.

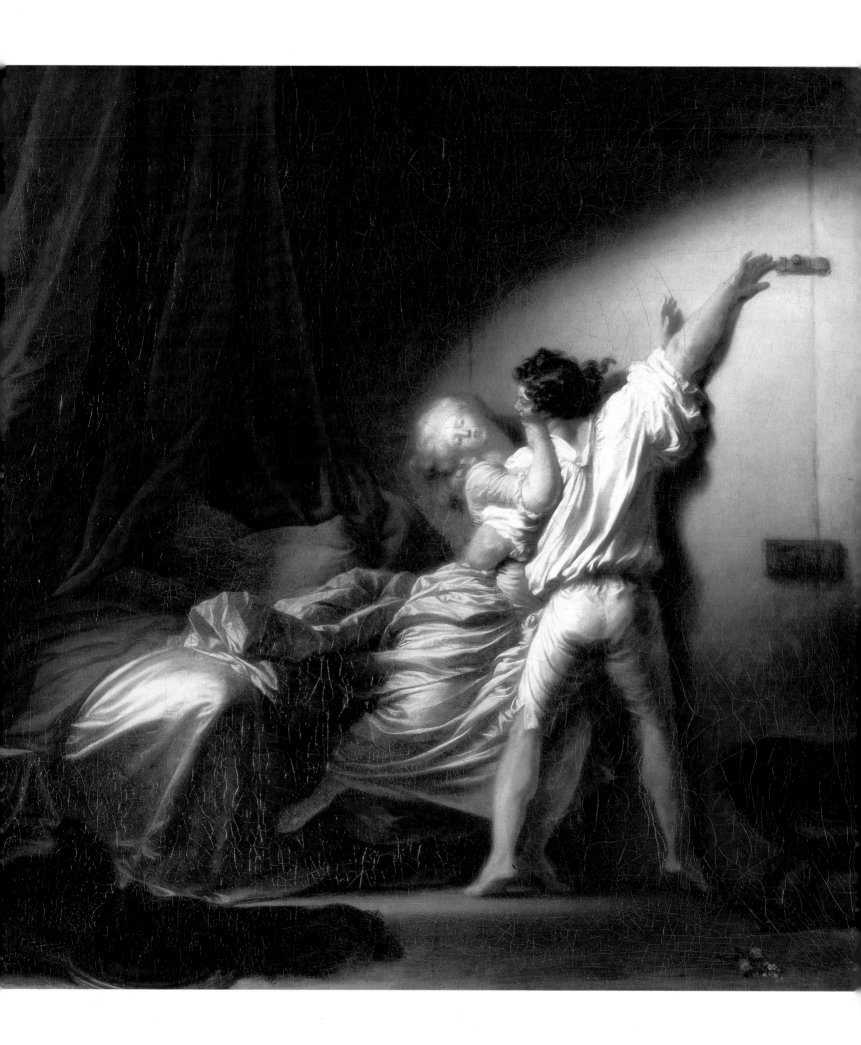

Bibliography

PRIMARY SOURCES

Fontaine, André, *Conférences inédites de l'Académie royale de peinture et de sculpture, d'après les manuscrits des archives de l'École des Beaux-Arts*, Paris, 1903.

Jouin, Henry, *Conférences de l'Académie royale de peinture et de sculpture recueillies, annotées et précédées d'une étude sur les artistes écrivains par Henry Jouin*, Paris, 1883.

Montaiglon, Anatole de, *Procès verbaux de l'Académie royale de peinture et de sculpture, 1648-1793*, Paris, 1875-1909.

GENERAL WORKS

Aux armes et aux arts! Les arts de la Révolution 1789-1799, ed. Régis Michel and Philippe Bordes, Paris, 1989.

Conisbee, P., *Painting in Eighteenth-Century France*, London, 1981.

Craske, Matthew, *Art in Europe 1700-1830*, Oxford, 1997.

Fontaine, André, *Les doctrines d'art en France: peintres, amateurs, critiques de Poussin à Diderot*, Paris, 1909; new edition, Slatkine, Geneva, 1970.

Levey, Michael, *Eighteenth-Century Art: Painting and Sculpture in France, 1700-1789*, Harmondsworth, 1975.

Levey, Michael, *Rococo to Revolution, Major Trends in Eighteenth-Century Painting*, London, 1992.

Locquin, Jean, *La peinture d'histoire en France*, 1912; new edition, Paris, Arthéna, 1978.

Rosenblum, Robert, *Transformations in Late Eighteenth-Century Art*, Princeton, 1967.

Saint-Girons, Baldine, *Esthétiques du XVIIIᵉ siècle. Le modèle français*, Paris, 1990.

Thuillier, Jacques, and Châtelet, Albert, *La peinture française au XVIIIᵉ siècle*, Geneva, 1964.

EXHIBITIONS

L'âge d'or du petit portrait, Bordeaux-Geneva-Paris, 1995.

Bailey, Colin. B., *Loves of the Gods, Mythological Painting from Watteau to David*, Paris-Philadelphia-Fort Worth, 1991.

De David à Delacroix. La peinture française de 1774 à 1830, Paris, 1974.

Diderot et l'art de Boucher à David. Les Salons 1759-1781, Paris, 1984.

Louis XV, un moment de perfection de l'art français, Paris, 1974.

Rosenberg, Pierre, *The Century of Louis XV. French Painting from 1710 to 1774*, National Gallery of Canada, Ottawa, 1976.

Salmon, Xavier, *Les chasses exotiques de Louis XV*, Amiens-Versailles, 1995.

MONOGRAPHS

Bordeaux, Jean-Luc, *François Le Moyne (1688-1737) et sa génération*, Paris, Arthéna, 1985.

Boyer, Ferdinand, *Catalogue raisonné de l'œuvre de Charles Natoire, Archives de l'art français*, nᵉˡˡᵉ période, XXI, 1949, pp. 31-106.

Brookner, Anita, *Greuze. The Rise and Fall of an Eighteenth-Century Phenomenon*, London, 1972.

Cayeux, Jean de, *Hubert Robert*, Paris, Fayard, 1989.

Conisbee, Philip, *Joseph Vernet, 1714-1789*, exhibition catalogue, Paris, 1977.

Cuzin, Jean-Pierre, *Jean-Honoré Fragonard: vie et œuvre, catalogue complet des peintures*, Fribourg, 1987.

David, J. L. Jules, *Le peintre Louis David, 1748-1825,* 2 vol., Paris, 1850-1852.

Delécluze, Étienne-Jean, *Louis David, son école et son temps*, 1855, new edition by J. P. Mouilleseaux, Paris, 1983.

Dimier, Louis, *La peinture au XVIIIᵉ siècle. Histoire des vies et catalogues des œuvres*, Paris-Brussels, 1928 and 1930.
> Vol. 1: Watteau, Lemoine, A. Coypel, Gillot, Galloche, Tournières, Vleughels, Delyen, Trémollières, Van Schuppen, B. Debar, Arnulphy, Oppenord, Pineau Père, Toro, B. Picart.
> Vol. 2: Detroy, Subleyras, Nattier, Oudry, Grimou, N. Coypel, Dumont le Romain, Dumont de Tulle, Frontier, Collin de Vermont, Raoux, Belle, Pesne, Goudreaux, Octavien, Quillard, Lajoue, Meissonnier, Servandoni.

Gaehtgens, Thomas, and Lugand Jacques, *Joseph-Marie Vien, 1716-1809*, Paris, Arthéna, 1988.

Garnier, Nicole, *Antoine Coypel (1661-1722)*, Paris, 1989.

Jean-Baptiste Greuze, 1725-1805, exhibition catalogue, Hartford-San Francisco-Dijon, 1977.

Laing, Alastair, and Rosenberg, Pierre, *François Boucher, 1703-1770*, exhibition catalogue, New York-Detroit-Paris, 1986-1987.

Lefrançois, Thierry, *Charles Coypel (1694-1752)*, Paris, Arthéna, 1994.

Manœuvre, Laurent, and Rieh, Éric, *Joseph Vernet. Les ports de France*, Paris, 1994.

Michel, Olivier, and Rosenberg, Pierre, *Subleyras, 1699-1749*, exhibition catalogue, Paris-Rome, 1987.

Opperman, Hal, *Jean-Baptiste Oudry (1686-1755)*, exhibition catalogue, Paris, 1982.

Passez, Anne-Marie, *Adélaïde Labille-Guiard: biographie et catalogue raisonné de son œuvre*, Paris, 1973.

Roland-Michel, Marianne, *Chardin*, Paris, 1994.

Roland-Michel, Marianne, *Lajoue et l'art rocaille*, Paris, Arthéna, 1984.

Roland-Michel, Marianne, *Watteau: un artiste au XVIIIᵉ siècle*, Paris, 1984.

Rosenberg, Pierre, *Chardin, 1699-1779*, exhibition catalogue, Paris, 1979.

Rosenberg, Pierre, *Fragonard*, exhibition catalogue, Paris-New York, 1987-1988.

Rosenberg, Pierre, *Tout l'œuvre peint de Fragonard*, Paris, 1989.

Rosenberg, Pierre, ed., *Vies anciennes de Watteau*, Paris, 1984.

Rosenberg, Pierre, *Watteau, 1684-1721,* exhibition catalogue, Washington-Paris-Berlin, Paris, 1985.

Rosenberg, Pierre, and Schnapper, Antoine, *Jean Restout*, exhibition catalogue, Rennes, 1970.

Rosenberg, Pierre, and Van de Sandt, Udolpho, *Pierre Peyron (1744-1814)*, Paris, Arthéna, 1983.

Rosenfeld, Myra Nora, *Largillierre, portraitiste du XVIIIᵉ siècle*, exhibition catalogue, Montreal, 1982.

Sahut, Marie-Catherine, *Carle Van Loo*, exhibition catalogue, Nice-Clermont-Ferrand-Nancy, 1977.

Sahut, Marie-Catherine, *Le Louvre d'Hubert Robert*, Paris, 1979.

Sandoz, Marc, "Gabriel-Antoine Doyen, peintre d'histoire (1726-1806)", in *Bulletin de la Société d'histoire de l'art français*, 1959, pp. 75-88.

Schnapper, Antoine, *David témoin de son temps*, Paris, 1980.

Schnapper, Antoine, and Serullaz, Arlette, *J.-L. David*, exhibition catalogue, Paris-Versailles, 1989.

Schnapper, Antoine, *Jean Jouvenet (1644-1717) et la peinture d'histoire*, Paris, 1974.

Schnapper, Antoine, and Guicharnaud, Hélène, *Louis de Boullogne*, Paris, 1986.

Simons, Katrin, *Jacques Réattu (1760-1833)*, Paris, Arthéna, 1985.

Volle, Nathalie, *Jean-Simon Berthélemy (1743-1811), peintre d'histoire*, Paris, Arthéna, 1979.

Wildenstein, Georges, *Fragonard*, Éditions Phaidon, 1960.

Wildenstein, Georges, *Lancret*, Paris, Les Beaux-Arts, 1924.

Willk-Brocard, Nicole, *François-Guillaume Ménageot (1744-1816)*, Paris, Arthéna, 1978.

Photo Credits

Agence AKG, Paris: pp. 75 (top and bottom), 187. Agence Artothek, Peissenberg, photographer J. Blauel: pp. 83, 99. Agence Bulloz, Paris: pp. 181-182. Agence Explorer, Vanves, photographer P. Willi: pp. 64, 66. Agence Giraudon, Paris: pp. 37, 80-81, 88, 106 (top), 139, 144-145. Agence Giraudon, Paris/Bridgeman Art Library, London, Wallace Collection, London: pp. 86-87, 93. Agence Josse, Paris: p. 129 (top). Agence Roger Viollet, Paris: pp. 26, 104, 126. Agence Siny Most, Paris: pp. 128 (bottom), 141. Agence photographique de la Réunion des musées nationaux (RMN), Paris: pp. 58-59, 102, 119 (top), 143 (top), 148-149, 158, 163 (top), 166, 181, 184. RMN, photographer D. Arnaudet: pp. 12, 13, 24, 25, 35, 84, 97, 122-123, 127, 138, 150-151, 152-153, 202. RMN, photographer M. Beck-Coppola: p. 124. RMN, photographer M. Bellot: pp. 57, 77, 120, 142, 183. RMN, photographer J.G. Berizzi: pp. 23, 30, 85, 110, 134. RMN, photographer G. Blot: pp. 2, 6, 22-23, 39 (top), 43, 46, 47 (left), 54-55, 96, 106 (bottom right), 112, 130, 135, 164, 182, 189. RMN, photographers G. Blot and C. Jean: pp. 160-161, 170, 171, 173. RMN, photographers G. Blot and J. Schormans: pp. 178, 179 (top). RMN, photographers G. Blot and Arnaudet: p. 179 (bottom). RMN, photographer C. Jean: p. 198. RMN, photographer H. Lewandowski: cover, pp. 28, 78, 103, 114-115, 119 (bottom), 204-205. RMN, photographer R. G. Ojeda: pp. 34 (left and right), 44, 45, 65, 74-75, 101, 108-109, 118, 125, 140, 167, 174, 175, 190-191, 194, 199. RMN, photographer Popovitch: p. 201. RMN, photographer J. Schormans: pp. 5, 21, 48, 50, 51, 61, 76-77, 90-91, 92. Erich Lessing Archives, Vienna: pp. 70-71, 169. Art Gallery of Ontario, Toronto, photographer C. Catenazzi: p. 136. Bibliothèque nationale de France, Paris: pp. 20, 163 (bottom). Cooper-Hewitt Museum, National Design Museum, Smithsonian Institution, New York: p. 129 (bottom). The Detroit Institute of Arts, Detroit: p. 36 (Founders Society Purchase, Mr and Mrs Benjamin Long Fund). Dulwich Picture Gallery, London: pp. 68-69. École nationale supérieure des Beaux-Arts, Paris: pp. 32-33, 154-155. The Fine Arts Museum, San Francisco: p. 60 (Mildred Anna Williams Collection). The Frick Collection, New York: pp. 10, 11. The J. Paul Getty Museum, Los Angeles: pp. 146 (top), 147. Kunstakademiets Bibliotek, Copenhagen: p. 128 (top). Hamburger Kunsthalle, Hamburg: p. 185. The Metropolitan Museum of Art, New York: p. 107 (Gift of Julia A. Berwind). Musée d'art et d'histoire, Geneva: p. 111. Musée des Beaux-Arts d'Angers: p. 31. Musée des Beaux-Arts de Brest: pp. 16-17. Musée de la Révolution française, Vizille: pp. 192-193. Musée Fabre, Montpellier: pp. 32, 143 (bottom). Musée des Arts décoratifs de Bordeaux: p. 105. Musée des Beaux-Arts de Bordeaux, photographer L. Gauthier: pp. 146 (bottom), 196-197. Musée des Beaux-Arts de Dijon: pp. 49, 106 (bottom left). Musée des Beaux-Arts de Grenoble: p. 176. Musée des Beaux-Arts de Nancy: pp. 38, 39 (bottom), 82 (top). Musée des Beaux-Arts de Quimper: p. 156. Musée des Beaux-Arts de Rouen, photographers D. Tragin and C. Lancien: p. 121. Musée des Beaux-Arts de Tours, photographer P. Boyer: p. 47 (right). Musées d'Arles, photographer M. Lacanaud: p. 186. Musée de la Ville de Strasbourg: p. 18. Musées royaux des Beaux-Arts, Brussels: p. 188. National Gallery, London: p. 98. National Gallery of Art, Washington: pp. 62-63, 95, 133. Nationalmuseum, Stockholm: pp. 79, 117, 137. New Orleans Museum of Art, New Orleans: p. 27 (Purchase through Bequest of Judge Charles F. Claiborne). Photothèque des musées de la Ville de Paris: p. 82 (bottom). Pierpont Morgan Library/Art Resource, New York: pp. 72, 148 (bottom). The Philadelphia Museum of Art, Philadelphia: pp. 40-41. Schloss Charlottenburg, Berlin/Bridgeman Art Library, London/Artephot, Paris: p. 67. Stedelijke Museum, Bruges: p. 195. Victoria and Albert Museum, London/Bridgeman Art Library, London/Artephot, Paris: p. 157. The Wallace Collection, London/Bridgeman Art Library, London/Artephot, Paris: p. 100.

N.B.: Some paintings featured in full-page reproductions have been slightly recentred.